ACROSS ARABIA

ACROSS ARABIA
THREE WEEKS IN 1937

Geraldine Rendel

Photographs by
George and Geraldine Rendel

Biographical introduction by
William Facey

𝒜P
Arabian Publishing

Across Arabia
Three Weeks in 1937

Text of *Arabian Journey: Three Weeks Crossing Saudi Arabia*
by Geraldine Rendel © the Rendel family
Introduction and notes © William Facey/Arabian Publishing Ltd 2018

Produced and published in 2021 by
Arabian Publishing Ltd

AP
Arabian Publishing

www.arabian-publishing.com
a division of Medina Publishing Ltd
www.medinapublishing.com

Medina Publishing

Editing and picture research: William Facey
Design: Kitty Carruthers
Additional research: Frances Topp
Maps: Martin Lubikowski, ML Design
Printed and bound in Turkey by Imago

All rights reserved. No part of this publication may be reproduced, stored in a retrieval system, or transmitted in any form or by any means, electronic, mechanical, photocopying, recording, or otherwise, without the prior permission of the copyright owners.

A catalogue record for this publication is available from the British Library

ISBN: 978-0992980856

Frontispiece Geraldine Rendel in *ca.* 1940, shortly after her Arabian journey. The pearl necklace is perhaps one of those given to her by the Saudi royal family in honour of her visit (see p. 208 n. 94: p. 212 n. 156).

I stepped off the quay into the boat feeling that adventure had begun. I was walking right out of my life into another of which I had no real conception, and the present alone had reality. I had passed through a magic door and it had shut behind me setting my fancy free. My everyday world grew dim; it was like slipping into another dimension and finding surprisingly that one fitted in.

Geraldine Rendel (see below, p. 64)

CONTENTS

Foreword and acknowlegements		ix
Maps		41–43

Introduction — 1
Through a Magic Door: The Life and Travels of Geraldine Rendel
by William Facey

Geraldine Rendel: birth and background		3
A young diplomatic family		9
Britain and the Arab world between the wars		11
Saudi Arabia in the 1920s and '30s		12
First Middle Eastern journey, 1932		16
Britain and Saudi Arabia, 1932–36		17
The Rendels' 1937 Middle Eastern journey		20
Anglo-Saudi tensions, 1937–39		33
The Rendels: the Second World War and after		35
George and Rosemary Rendel visit the Kingdom, January 1964		39

Arabian Journey: Three Weeks Crossing Saudi Arabia — 45
by Geraldine Rendel

	Foreword		46
1	From Basra to Kuwait		47
2	Bahrein		59
3	From Bahrein to Hasa		63
4	Hasa Oasis		73
5	From Hasa to 'Uraira		91
6	To Rumaya		101
7	Arrival at Riyadh		107
8	With Amir Saud in the Palace at Riyadh		125
9	Riyadh to Duwadmi		135
10	Qai'iya, Afif, Dafina, Muwaih and Ashaira		145
11	Taif		155
12	To Jidda to Meet the King		171
13	The Queens' Palace at Jidda		185
14	Departure		191

Notes		193
Sources and References		213
Picture credits		219
Index		221

FOREWORD AND ACKNOWLEDGEMENTS

I FIRST CAME ACROSS George and Geraldine Rendel in 1986, while carrying out research for my book, *Riyadh: The Old City*. David Warren, then in charge of the photograph archive at the Royal Geographical Society in London, drew my attention to two grey boxes, marked G9, on the shelves. These, he said, might contain items of interest. To my surprise and delight, they contained an excellent series of photographs of Riyadh, among many other images taken during a journey by the Rendels across Saudi Arabia in 1937. It turned out that they had been deposited in 1982, together with their original negatives, by the Rendels' younger daughter, Rosemary, with whom I then made contact. A dozen or so of the historic images of Riyadh were published in *Riyadh: The Old City* in 1992. Subsequently, in 1998, I sorted through all the Rendels' Saudi Arabian images, which turned out to be more than 280 in number, matching negatives to prints and amplifying the Rendels' caption information. This new catalogue I shared with the RGS, with no particular expectation that it would come in useful again.

The Rendels' photographs are of striking historical importance as a graphic record of Saudi Arabia on the brink of modernization. Both Rendels were excellent photographers with an acute visual appreciation of their surroundings and a natural eye for composition. So vivid and coherent is the sequence of images of their journey that I had often thought of it as a collection in search of a publication. Imagine, then, how exciting it was in 2017 when a grandson, Jonathan Rendel, sent Medina Publishing a hitherto forgotten travelogue by his grandmother Geraldine, entitled 'Arabian Journey: Three Weeks Crossing Saudi Arabia'. Might we be interested in publishing it? A quick inspection was enough to confirm the quality and interest of the lively and elegantly written 39,000-word text. The chance to combine her travelogue with the photographs of the trip, and to set both in the context of the Rendels' lives and of Anglo-Saudi relations in the 1930s, was one not to be missed. The result is this book, in which text and image amplify and complement each other in a remarkable and satisfying way.

Above all I would like to thank Jonathan Rendel for offering Geraldine's text to us. This would not have happened without the suggestion of our mutual friend, the Arabist Dr Peter Clark, to whom Jonathan had happened to show Geraldine's typescript and who immediately spotted its significance. Peter thus qualifies for equal gratitude. Further thanks are due to Jonathan and Christopher Rendel for entrusting me with the editing, notes and biographical Introduction, and for providing pictures, documents and genealogies from their family archives, and also to Philip Rendel for his interest and co-operation.

Joy Wheeler, of the Royal Geographical Society's Picture Library in London, deserves special thanks for giving me renewed access to the Rendels' photographs and fielding my constant enquiries. I am also grateful to Alasdair Macleod, Head of Enterprise and Resources at the Royal Geographical Society, for permission to publish them. And, as ever, I owe a debt to Eugene Rae, Jan Turner and Julie Carrington for their all-round helpfulness in the excellent RGS library.

Piecing together what little could be found on Geraldine's life and background would have been impossible without information from Jonathan and Jane Rendel and their cousin Lindy Wiltshire. They were refreshingly open to the debunking of family myths and shared many memories of conversations with their aunt, Rosemary Rendel. Jonathan Rendel spared me much inconvenient legwork by making available copies of the relevant Rendel papers deposited at the National Library of Wales, Aberystwyth. Others too contributed to my account of Geraldine's life: Peter Clark, who also alerted me to Elie Kedourie's assessments of George Rendel in his *Islam and the Modern World*, and provided useful pointers to the family of Lucy Wickham of Frome, Geraldine's mother; Prof. Troy J. Bassett, of Indiana University-Purdue University Fort Wayne, who first put me on the track of the novels of Gerald Beresford FitzGerald, Geraldine's father; and my wife, Marsha, who provided much perceptive literary criticism based on a reading of some of these novels, as well as insights into Geraldine's background and character.

Frances Topp carried out useful documentary research at the National Archives of the UK at Kew into, among other things, the papers of Sir Colin Crowe, Sir George Rendel's friend, fellow-diplomat and UK ambassador to Saudi Arabia during 1963–64. Debbie Usher at the Middle East Archive, St Antony's College, Oxford, kindly gave me access to the forty-one colour slides of Sir George and Rosemary Rendel's visit to Saudi Arabia in 1964. My thanks to both.

It will come as no surprise to biographers that some avenues of research led to dead ends. Most notable was my vain attempt to establish whether Mount Offaly House in Athy, Co. Kildare, had ever been in the possession of Geraldine's branch of the FitzGerald family. I am none the less grateful to the Revd Olive Donohoe of Athy, and to Margaret Walsh and Clem Roche of the Athy Heritage Centre Museum, for putting up with my tiresome enquiries and going to the trouble of investigating the history of the house. Warm thanks to all.

Presentation of the text

The text of Geraldine Rendel's typescript is published here word-for-word, without abridgement. The very few editorial interventions are confined to the addition of the chapter titles (using her spellings of place names), correction of a very few obvious typographic errors, and some adjustments to the punctuation. The author's sometimes eccentric spellings of Arabic words and names have been left in the text as she wrote them, and are identified and presented in a properly transliterated form, where desirable, in the notes and index. In the Introduction and picture captions and on the maps, Arabic words and names are presented in the same transliterated form, but shorn of macrons and diacritics.

<div style="text-align: right;">
William Facey
Arabian Publishing
London, 2020
</div>

Geraldine Rendel enjoying the sea air on board a British steamer in the Gulf, February 1937.

INTRODUCTION

Through a Magic Door

The Life and Travels of Geraldine Rendel

At the end of March 1937, having crossed Saudi Arabia with her husband, Geraldine Rendel found she had achieved a trio of unintended distinctions. As the first Western woman to travel openly across the Peninsula as a non-Muslim, she had joined Lady Anne Blunt, Gertrude Bell, Rosita Forbes, Freya Stark and Lady Evelyn Cobbold in a tiny coterie of pioneering British women travellers in Arabia. She had also become the first Western woman to be received in public by King 'Abd al-'Aziz Ibn Sa'ud, and to be received at dinner in the royal palace in Riyadh.

The Rendels' visit to the Kingdom was a semi-official one, and Geraldine had played no part in its planning. Its chief aim was to enable her husband George, at the time head of the Eastern Department of the Foreign Office, to familiarize himself with the new Kingdom of Saudi Arabia and to hold face-to-face discussions with its monarch. In those days, personal relationships played a vital part in the conduct of Anglo-Saudi diplomacy. The Saudis invited George to bring along his wife, and organized the visit in such a way that official business could be combined with the pleasures of travel and social encounter. It was a trip that clearly appealed to Geraldine's adventurous nature. Her interest and excitement are palpable on every page of the handwritten diary she and George kept and, on her return to England, she set about typing up a more polished version that she intended for publication.[1] In the event, her husband felt, perhaps for reasons of diplomatic confidentiality, that this typescript should not be published in full, and Geraldine was only able to put into print a short, illustrated article that appeared in the *Geographical Magazine* of 1938. The full version languished for decades in a folder, more or less forgotten but, happily, preserved by the family. The only book that Geraldine ever wrote, it is published here for the first time.[2]

A striking quality of the Rendels as travellers is that they were both excellent photographers with a natural eye for composition. Unlike Geraldine's text, their photographs have been known about since they were deposited at the Royal

Geographical Society in London in the early 1980s.[3] Their images of Persia and Arabia in the 1930s are of outstanding historical importance. The rediscovery of Geraldine's travelogue created a wonderful opportunity to marry it with the Arabian sequence of pictures and, as presented here, text and image illuminate each other in a way that was previously impossible. We are fortunate to have such a vivid depiction of Saudi Arabia on the cusp of modernization.

Geraldine's crossing of Arabia prepared the way for the very similar one made the following year, in the opposite direction, by HRH Princess Alice, Countess of Athlone, whose journey attracted much greater publicity.[4] Though another Englishwoman, Dora Philby, had been driven across Arabia in 1935, unlike Geraldine she had not been able to travel openly as a non-Muslim. Dora's journey had been made with her husband, Harry St John Philby, who had converted to Islam in 1930, and she had been treated accordingly as a Muslim wife, being confined to the women's quarters in Riyadh. Geraldine, by contrast, though obliged to wear a veil when among Arabs, was allowed much greater social freedom.[5] The progressive

Geraldine and George in Kensington, on their wedding day in April 1914.

easing of the customary restrictions under which these three women were able to travel is a measure of how quickly central Arabia was opening up to access by foreigners during the 1930s.

In 1937, the Rendels had been married for twenty-three years and had raised four children.[6] Geraldine was fifty-three, four years older than George. Their wedding on 21 April 1914, just a few months before the outbreak of the First World War, had been a hasty one. George, a young diplomat back from his brief first posting in Germany, was just embarking on his career. The Diplomatic Service preferred its recruits to be single and, when George announced his determination to marry, he was abruptly transferred from Berlin to Athens. He seized his brief moment in transit through London to arrange the wedding, a Catholic ceremony conducted in the lady chapel of Westminster Cathedral.[7] At twenty-nine, Geraldine was old for a bride in those days; nor, as we shall see, had she been brought up as a Catholic. Such obstacles clearly point to the couple having married for love. George's admiration for his enterprising, artistic and sociable wife seems never to have waned: he expresses it with obvious sincerity whenever he mentions her in his memoirs.[8]

George William Rendel (1889–1975) would go on to achieve great distinction in the foreign service. He was born into a notable Victorian engineering dynasty, his father being the eminent naval designer George Wightwick Rendel (1833–1902), manager of Armstrongs and, latterly, a civil lord of the Admiralty. George Wightwick had married his second wife, Licinia Pinelli (1846/47–1934), in Italy, while serving on a design committee for the Italian ministry of marine, and had three sons by her.[9] George William was thus half Italian and was brought up as a Roman Catholic. He was sent to school at Downside, the Benedictine abbey and boarding school in Somerset, and would remain a devout Catholic for the whole of his life.[10]

Capable and clever, with a flair for organization and a fluent mastery of French and Italian, he graduated in modern history from The Queen's College, Oxford, in 1911, and fixed his sights on a career in diplomacy. By then he had probably already met his future wife on the Isle of Wight, where the Rendels had a home at Sandown.[11] Geraldine happened to be living on the other side of the island, by Totland Bay, having been compelled by adverse family circumstances, as we shall see, to take employment as secretary to the Wards, a prominent Catholic family. The spacious and stylish Ward residence, Weston Manor, still preserves the beautiful private chapel designed by the Catholic architect George Goldie, with a fine interior by Peter Paul Pugin. According to Rendel family tradition, it was in this setting, at once religious and romantic, that George proposed to Geraldine.[12]

Geraldine Rendel: birth and background

Geraldine Elizabeth de Teissier Rendel (1885–1965) was born in Kensington, the third of five children of a minor Victorian novelist of Irish descent, Gerald Beresford FitzGerald (1849–1915).[13] Her father, henceforth referred to as GBF, belonged, as George Rendel records, to a branch of the FitzGeralds of Kildare which "had long been established in England".[14]

According to family tradition, Geraldine and her two sisters were born not in

England but in Dublin where, allegedly, GBF sold his tumbledown Irish castle to finance moving to London to educate his daughters and marry them off.[15] This may preserve a memory of some such event elsewhere in the family, but the truth was more prosaic. GBF was born in 1849 in Southampton, the only son of the Revd Gerald Stephen FitzGerald (1810–79), Anglican curate of All Saints church, and his wife, Susan Anne née Beresford, of the Lord Decies family of Waterford and Kildare.[16] Despite the Irish connections, there is no evidence to show that either GBF or his father ever lived in Ireland. GBF's father went on to become vicar of Highfield, a suburb of Southampton (1852–64), and then rector of Wanstead, in north-east London. The 1871 Census shows the family to be in residence in Wanstead, so he was not an absentee cleric, as was commonly the case in those days.

GBF's grandfather was Vice-Admiral Sir Robert Lewis FitzGerald (1766–1844), who was buried with other members of his family in Bath, Somerset.[17] GBF's branch had thus been based in England for some time, while maintaining their Irish connection. The FitzGeralds as a whole could cite a long and distinguished pedigree in Ireland extending back to the early 12th century, when their Norman-Welsh ancestors had conquered swathes of Irish territory. Over time, they became deeply assimilated into the local Irish aristocracy in which, as Lords of Offaly, Earls of Kildare and Desmond and, later, Dukes of Leinster, they would play a notable role in Irish history.[18] By the 19th century, the FitzGeralds were well embedded in the dominant Anglo-Irish class known as the Protestant Ascendancy.[19] It might certainly have been possible, therefore, for FitzGeralds based in England to provide for their advancement in society by selling property in Ireland. However, we have no evidence to corroborate the dubious family story that this was the case with GBF.

A portrait of Vice-Admiral Sir Robert Lewis FitzGerald, Geraldine's great-grandfather.

Outwardly, GBF was destined for the life of conventional Victorian respectability that typified the upper-middle-class FitzGeralds. At eighteen, he went up to Oxford: he is on record as having been at Balliol College in 1867–68, at a time when his father is listed as being 'of Southampton'. His tutor was 'B.J.', who turns out to be no less a figure than the celebrated classicist, theologian and university reformer Benjamin Jowett, who would become Master of Balliol in 1870. Why GBF lasted only a year in this exalted academic sphere is not recorded. One may speculate that he owed his place at Balliol to the influence of his father's younger brother, Revd Augustus Otway FitzGerald (1813–97), Archdeacon of Wells Cathedral in Somerset, who had himself entered Balliol in 1831. Geraldine would later recall this man as her great-uncle. It may also be significant that in 1867, the very year that GBF went up, the Archdeacon's son and GBF's first cousin, Gerald Augustus Robert FitzGerald, was elected a Fellow of St John's College, adjoining Balliol.[20]

For reasons unknown, GBF failed to sit his exams and obtain a degree. He next took a government job in the Home Office in London, where he worked as a clerk between 1869 and 1881. We do not know what exactly his job entailed, but

his fellowships of the Royal Geographical Society, Royal Historical Society and the Society of Antiquaries testify to wide and cultured interests outside his employment.[21] More significantly, he was embarking on what he was clearly coming to regard as his proper career as a novelist. His first two works of fiction were published in the 1870s: *As The Fates Would Have It: A Novel* (1873), and *Lilian: A Story of the World* (1877).

GBF's father died in 1879 and, shortly after, his life took a dramatically different turn. It is not known whether his father left him anything, but in 1880 his wealthy and childless paternal uncle, Charles Robert FitzGerald, a resident of Marylebone, also died, bequeathing his nephew £50,000.[22] Whether or not GBF was expecting this windfall, the acquisition of such a sum – the equivalent of almost £6 million today – was life-changing. He very soon landed a bride, and gave up his employment.

His wife-to-be was Lucy Adelaide Wickham, daughter of Francis Wickham of Frome, in Somerset.[23] The Wickhams were a prominent local Tory family of well-to-do lawyers and Anglican clerics. The Somerset connection again points to the influence of GBF's uncle, the Archdeacon of Wells. The couple were married in January 1881. Two sons and three daughters followed between 1882 and 1888 including, in 1885, Geraldine. Now a wealthy man, GBF would have had no need to sell property in Ireland, if such existed, to fund the upbringing of his children and their entry into society. He installed his growing family in a stylish part of London: Geraldine was born in South Kensington, and in 1904 he gave his addresses as 63 Eaton Square, Belgravia, and Rosary Gardens, South Kensington. He then set about conjuring up a literary career. Between 1881 and 1904 he produced a string of eleven more novels, with titles such as *Clare Strong*, *An Odd Career*, *A Fleeting Show*, *The Fatal Phial*, and *The Minor Canon*.[24] As contemporary social fiction, these narratives quite obviously draw on GBF's own background and life, and so are of interest insofar as they shed light on the lifestyle, attitudes and expectations amongst which Geraldine grew up.

Their author intended his novels as popular fiction aimed at an educated female readership, and seems to have funded their publication. Though written with a certain patrician panache, they are slight productions, marred by slipshod construction, abrupt transitions and inconsistent characterization, as if dashed off in a hurry. These days they languish unread and unregarded, even by the family, but the Victorian market for melodrama ensured a more positive reception. In 1899, a reviewer in a highly respectable journal such as *The Scotsman* could describe *Beyond These Dreams* as "a powerful story, [which] should confirm its author's reputation as a strong and clever writer". As for *Clare Strong*, it commended the "personal observation of a thoughtful, candid and cultured mind". *The Athenaeum*, the *Morning Post*, the *Illustrated London News* and the *Guardian* all chimed in with favourable reviews.[25]

Clare Strong and *An Odd Career* are typical, being set among the London upper-middle class of moneyed professional and military men with access to country seats. Many of the characters have names common in Ireland.[26] The stories are driven by themes such as the nature of success and the life well lived. These and inheritance, wealth and class, the shame of illegitimacy, and political ambition and patriotism are the focus of much high-minded philosophizing. However, the

most frequently recurring narrative thread in the books is a preoccupation with marriage, with an emphasis on the differences between men and women and what they want out of life. Clare Strong, for example, is a well-to-do, cosmopolitan young man in search of matrimonial fulfilment. GBF's last novel, *The Marriage Maze: A Study in Temperament*, was published in 1911 – around the time when Geraldine and George first met – and is an exploration of the ingredients of a satisfactory union. On this score, the author is generally a pessimist, even a cynic: "What we all desire to explore, and so many are anxious to find a way out of," reads the epigraph. The story is a melodrama of miscommunication; just as misunderstandings are resolved and relations restored, tragedy strikes in the person of a drunken Irish chauffeur, and the wife is killed in a car accident. The widower, by now an MP, is left to bring up their baby in "the joy of perfect love" for his deceased spouse – only attainable, so the message seems to be, without the inconvenience of an actual woman on the scene.

The central character in *An Odd Career*, Sir Roderick Damer, perhaps represents an ideal of what GBF himself would have liked to be. Damer lives a comfortable bachelor existence, away from the annoyance of "a wife with whom you have no sympathy [and is] always with you". He is able to enjoy the best of everything and to indulge his taste for books and original works of art. He combines an agnostic outlook with lofty moral views about social inequality, snobbery, self-denial and wasted lives. The chapters open with philosophical quotations from English and Latin writers, and in one case even from the ancient Greek poet Anacreon. However pretentious one may judge these to be, they are at least evidence that Geraldine was brought up in a highly cultured household. Apart from this, we have no record of her education. Nor is there any direct evidence about her parents' relationship, though GBF's views on marriage suggest that it was perhaps not an easy alliance. The fact that *The Marriage Maze* was written in collaboration with a young Irish author still in her twenties, Olive Lethbridge, is perhaps a symptom that all was not well.[27]

A young Edwardian: Geraldine in the decade before the First World War, perhaps aged about twenty.

Alas, GBF's pursuit of a literary reputation brought him neither fame nor fortune. He later claimed to have made a loss totalling £440 from his publishing efforts.[28] His lavish lifestyle was intended, according to his descendants, to confer social status on his family, provide a good education for his children, and attract suitable husbands for his daughters. But he was funding this costly project by frittering away his capital – a lack of realism that suggests an improvident, even feckless, nature. Despite acting as executor from time to time for other

deceased connections, and no doubt thereby gaining some financial benefit, by 1904 he had tumbled into insolvency.[29] His petition for bankruptcy attracted some gleeful attention in the press, under such headlines as 'A Novelist's Extravagance', and 'Vanished Fortune'. The *London Evening Standard* of Friday 10 June 1904, for example, reported as follows:

> Court of Bankruptcy (before Mr Registrar Hope)
>
> A Novelist's Expenditure
>
> Re G.B. Fitzgerald – This was a sitting for the public examination of Gerald Beresford Fitzgerald, who filed his own petition describing himself as of Rosary-gardens, South Kensington, of no occupation. The statement of affairs showed liabilities amounting to £8,355 10s 7d, of which £2,483 10s 7d were returned as unsecured, and an estimated surplus in assets of £923 11s. – The Debtor, prior to 1880, was a Civil servant, and he states that since then he has had no occupation except that of novel writing. It appeared that the Debtor, under the will of a relative who died in 1880, became entitled to £50,000, of which he brought £10,000 into an antenuptial settlement, and had gradually expended the balance. He estimates that his household and personal expenditure since the 22nd April 1901 has amounted to £11,072. – In reply to the Senior Official Receiver, the bankrupt acknowledged that his failure was due to extravagance. He had kept up a considerable establishment, and estimated that his expenditure during the last three years had amounted to £3,690 per annum. His creditors included £526 for ladies' millinery; tailors and hosiers, £181; wine merchants' accounts, £425, &c. He had, therefore, lived in good style.

Reporting on the same day, the *Globe* confirms that since 1880 he had had "no occupation except that of novel writing", while the *Morning Post* goes into more detail on his spending and the reasons for it:

> Soon after coming into his fortune, he, on marriage, settled £10,000, with life interest to himself, from which an income of about £400 a year was received. … His failure was due to extravagance, but not personal extravagance; he having a wife and large family to bring up. The securities forming the balance of his fortune he had realised from time to time, and had lived on the proceeds. He had lost nothing through betting or gambling.[30]

The FitzGerald family fortunes plunged to their nadir with the sale in July of the household effects of 63 Eaton Square, among them "walnut, satinwood and ash bedroom suites, brass and iron French bedsteads, … a carved oak dining-room suite, handsome ebonised and ormolu-mounted china cabinets, Chesterfield couch, settees &c., easy and arm chairs, oil paintings and engravings signed by Sir F[rederick] Leighton, coloured engraving by Thomas Landseer".[31]

How humiliating this social and financial disaster must have been for his family

can only be imagined. The blow would have been softened slightly by the fact that the £10,000 in trust for his wife would have remained inviolate, giving the family some £400 per annum (equivalent to £45,000 today) to live on. His daughters' marriage prospects would have nosedived, however, though there was one minor success to report: Mary Susan's wedding to a much older man, on 22 January 1906.[32] Geraldine would have to wait until her late twenties, in those days deemed very late for a young woman.

GBF eventually moved into a flat in Kensington where, in 1915, he died at the age of sixty-six. His wife, Lucy, would outlive him by almost thirty years.[33] Geraldine later recalled how her father had been unable to cope with his reversal of fortune and, bizarrely, failed even to fully appreciate the reasons for it.[34] Certainly it had been a sharp lesson in the precariousness of life, but it seems to have had the opposite effect on his independent and practical daughter, who clearly found much in her father's character to react against. Realizing that she would need to rely on her own resources, she looked for a job, and found employment as secretary to the Wards on the Isle of Wight. Her choice of employer suggests that she was already drawn to Catholicism before she met George Rendel who, up to 1911, would have been spending some of his Downside and Oxford vacations at home in Sandown.[35] Exactly how or when they met is a matter of speculation, but most probably it was through mixing in Catholic social circles on the island. Above all, she had met a man who, as her husband, would appreciate her qualities and greatly value her as his life's companion.

Broadlands, the Rendel home at Sandown on the Isle of Wight, where the young George Rendel would have spent his vacations from school and Oxford.

A young diplomatic family

In April 1914, the newly-weds went straight off to George's new posting in Athens, stopping only for a day at his mother's villa on the Riviera.[36] Geraldine would play a very supportive part in her husband's diplomatic career, joining him whenever possible and juggling her travels with the need to provide a home and education for their four children in England. She picked up languages quickly and had an easy

Geraldine indulged her taste for adventure by taking arduous holidays in Greece. Here she is shown travelling in Crete in 1915.

Left A studio portrait of Geraldine taken in about 1914.

sociability, whether among peasants or diplomats and royalty. But she also undertook difficult and dangerous assignments on her own initiative, bearing them with a fortitude that belied her somewhat fragile physical appearance. She showed her taste for adventure from the very beginning of married life in Greece, going on lone, intrepid excursions to hike or sketch ancient ruins. She seems to have been undaunted by hardship or the gruelling conditions of life abroad during the war.

In 1916, she went by sea to Salonika with Princess Demidoff to help organize camps for Serbian refugees. This was perhaps an adventure too far, for at the end of that same year, back in an almost equally dangerous Athens, she lost her first baby.[37] Soon after, George was posted to Rome, Lisbon and then Madrid, where their eldest child, David, was born in 1918. In 1919, George was sent briefly to Paris, where his talent for organization was put to good use in overhauling the embassy filing system. For safety, he left Geraldine on the Franco-Spanish border at Hendaye. She had been carried there, undaunted as always, by mule for part of the way, while still nursing her six-month-old baby.

After two enjoyable Iberian years, the Rendels were happy to return home to find that, in the first of several reorganizations, the Diplomatic and Foreign Office Services were being merged. George took the opportunity to transfer to the Foreign Office in Whitehall, enabling the couple to set up home in London, where they

Early married life in Greece: George and Geraldine relax over tea on the terrace of their Athens house in 1915.

Geraldine makes her way to Hendaye with six-month-old baby
David in a donkey pannier.

would spend the 1920s and '30s. Their first home was at 25 Draycott Place, Chelsea, and three more children followed in due course – Anne (1920), Rosemary (1923) and Peter (1925). The family albums are full of happy holiday snaps taken in France and at south coast resorts such as Eastbourne and Swanage. As they grew up, the children would be sent to prominent Catholic boarding schools – the boys to Downside, the girls to St Mary's, Ascot.

George spent the 1920s working in the FO's Eastern Department on Turkish, Persian, Syrian and Arabian affairs. It was during this time, in 1926, that George and Geraldine first met the young Saudi Amir and future King, Faysal bin 'Abd al-'Aziz, during his second visit to London. A natural and persuasive committee man of firm opinions, George was adept at seeing the big picture and formulating policy accordingly. His talent for administration and skill at handling committees were recognized in 1930 by his appointment as head of the Department, succeeding Sir Lancelot Oliphant, and it was during his tenure, in 1932 and 1937, that he made his two Middle Eastern journeys. On both of these, he saw to it that Geraldine accompanied him, despite the FO's traditional opposition to overseas travel.

Britain and the Arab world between the wars

As head of the Eastern Department, Rendel's remit covered what today we think of as the Middle East – the Arab countries, Turkey and Persia. But chiefly he had to deal with issues arising from the complex pattern of disparate arrangements by which British control was exercised over a large part of the Arab world.

In the wake of the Ottoman Empire's collapse at the end of the First World War, the responsibility for its Arab provinces fell to Britain, with the exception of Syria and Lebanon, where the vacuum was filled by France – in fulfilment of the terms of the secret Sykes–Picot Agreement of 1916 between the two powers. During the interwar years, Britain's dominance of the region reached its zenith, its so-called 'moment in the Middle East', but its supremacy faced a rising tide of challenges from emerging nationalist aspirations.

British power in the 1920s seemed monolithic, but had in fact grown organically by means of an untidy patchwork of *ad hoc* arrangements, no two of them precisely the same, and by the end of the 1930s the structure was creaking. Egypt, though nominally independent, was still effectively under uneasy British occupation. Palestine was administered by Britain under a League of Nations Mandate, while Transjordan had been created in 1921 as a British protectorate linked to Palestine. Iraq too was initially administered under a League of Nations Mandate, not directly from London but by the Government of India. This arrangement met with stiff opposition from Iraqi nationalists, and was modified by the Anglo-Iraqi Treaty of 1922, which placed the Hashimite Amir, Faysal I, on the throne and conceded a measure of autonomy under British supervision. This was superseded in 1930 by a new Anglo-Iraqi treaty, conferring still greater independence while attempting to maintain British interests.

Within Arabia, Oman and the various small shaykhdoms on the Arab shore of the Gulf were still controlled by the simple protectorate treaties with British India that had evolved during the course of the 19th century. Each was supervised by a Political Agent reporting to the Political Resident based at Bushire on the Persian coast, who in turn reported to Bombay; and two of them, Muscat and Bahrain, were put under even closer supervision by the appointment of permanent Special Advisers to their rulers. Aden and the Aden Protectorate were likewise still being administered from British India, though in 1937 Aden itself would be converted into a Crown Colony administered from London. Such arrangements involving the Government of India reflected conditions in the 19th century, and were rapidly becoming anachronistic, particularly in view of the looming possibility of Indian independence. Nor were the lines of official responsibility for these mandates, protectorates and occupied territories organized into a rational structure, handled as they were by a cumbersome collaboration between the Colonial Office, the Government of India, the India Office in London, the Foreign Office, the War Office and the Admiralty.[38] Farsighted officials such as Rendel were firmly of the view that they were ripe for reorganization. In 1930, a body was set up specifically to co-ordinate the policy-making of these departments, unmemorably named the Middle East (Official) Sub-Committee of the Committee of Imperial Defence, and George Rendel, by now a key figure, was appointed to serve on it as the Foreign Office representative.

Saudi Arabia in the 1920s and '30s

The Arab region that we now know as Saudi Arabia was an anomaly, in that it had never quite been drawn into Britain's web of control. The division of British

authority in the Middle East, between London on the one hand and India on the other, reflected the pattern by which its power and influence had been projected from either direction over the previous century and a half. The division actually made a kind of geographical sense, embodied as it was by a formidable natural barrier: the vast landmass of inland Arabia bordered to the north by the Syrian desert – the land that was now in the process of evolving into the Kingdom of Saudi Arabia. This arid and sparsely peopled tract was the sole region of the Arab world that historically had eluded domination by European powers.[39] Najd had suffered invasion and colonization only once, between 1811 and 1840, and that had been at the hands of Ottoman Egypt. Muhammad 'Ali Pasha's forces had managed to destroy the capital of the First Saudi State, al-Dir'iyyah, in 1818–19, but the cost had been crippling and the Egyptians eventually gave up their attempt at occupation. Vague subsequent Ottoman claims of suzerainty over its feuding amirs fell far short of any kind of political control, and Najd had long been regarded by other outsiders as an ungovernable void, of no economic or political interest.

But now, during the First World War and the 1920s, a new force had arisen out of this very space. Its charismatic Amir and now Sultan, 'Abd al-'Aziz Ibn Sa'ud, had united the regions that today form the Kingdom by a series of arduous military campaigns between 1902 and 1926. Most recently, he had progressively subdued his northern rival, Ibn Rashid of Ha'il, in 1920, taken over much of mountainous 'Asir in the south-west and, in 1925–26, put an end to the centuries-old governance of Makkah and the Hijaz by the Hashimite dynasty. During the War, Britain had given much support to the Hashimite Sharif of Makkah in fomenting the Arab Revolt against Ottoman rule – an episode glamourized by the publicity surrounding the exploits of T.E. Lawrence. It is less well known that the British had, at the same time, been giving financial and material support to Ibn Sa'ud, mainly to prevent him from attacking the Hijaz and undermining their war effort. This support was delivered from the Indian side through the agency of Sir Percy Cox, Capt. W.H.I. Shakespear and Harry St John Philby. All three men had dealt at first hand with the new potentate in Riyadh and had had ample opportunity to fall under his fabled spell.

After the War, Britain became disenchanted with the increasingly difficult Sharif and, in 1924, terminated its subsidies to both the Hijaz and Najd. This had the effect of leaving Ibn Sa'ud a free hand. As a result, the real balance of power in the Peninsula was allowed to assert itself, and rapidly did so. By the mid-1920s, Ibn Sa'ud controlled an enormous area, very nearly coterminous with Saudi Arabia's borders today, embracing the Hijaz as well as Najd, al-Hasa and 'Asir. By that time Britain, alive to the process of a new state forming in the region, was already conducting negotiations with the Najdi ruler to establish frontiers with Iraq, Transjordan and Kuwait.[40] Ibn Sa'ud was the first Arab ruler to have his sovereign independence recognized when, in May 1927, Britain concluded the Treaty of Jiddah with the Kingdom of the Hijaz and Najd and Its Dependencies.[41] From this moment on, the Saudi kingdom was to be the sole truly independent Arab state in a region otherwise under British control.

It was not all plain sailing for Ibn Sa'ud, however. In the late 1920s, his

unification project was almost fatally undermined by the Ikhwan Revolt in northern Najd. These extremist Wahhabis, so-called 'warriors of Islam', were suppressed with difficulty, and with help from British forces on the frontiers with Iraq, Kuwait and Transjordan.[42] Nonetheless by 1930 the new country was ready to look outwards, and to take its place on the international stage as a recognized state with a defined territory. In September 1932, its constituent parts were jointly proclaimed The Kingdom of Saudi Arabia – a name suggested by George Rendel himself and agreed in his office in London.[43]

Formal recognition entailed the appointment of diplomatic representatives by both sides. The British consulate at Jiddah was upgraded to a legation, and Sir Andrew Ryan appointed as first minister, taking up his post in 1930.[44] One of Rendel's first tasks was to obtain approval for the appointment of Ibn Sa'ud's choice as his man in London, Shaykh Hafiz Wahba.[45] Shaykh Hafiz would remain in post for the next twenty-six years, making many warm friendships among the British and eventually becoming doyen of the Diplomatic Corps in London. It was through him that the Rendels' 1937 visit to Saudi Arabia was arranged, and he himself accompanied them all the way from al-'Uqayr to Jiddah. He gave ready support to many Britons engaging with Saudi Arabia, notably to Lady Evelyn Cobbold when she made her pilgrimage to Makkah in 1933, and to Princess Alice and the Earl of Athlone in 1938.[46] He and George Rendel became friends and political allies, and the Rendels would maintain friendly contact with his family at least until the 1980s.[47]

Ibn Sa'ud's military and political successes were not matched by economic gain. Oil had not yet been discovered. However hard it may be to imagine now, in the 1930s Saudi Arabia was among the poorest countries on earth. In the early part of the decade the world economy was mired in the Great Depression, and the infant kingdom was still reeling from the Ikhwan Revolt. It had no source of income apart from pilgrimage receipts, and hard times meant that pilgrims from abroad were few: in 1933 numbers slumped to a mere 20,000, an all-time low.[48] In these desperate straits, Philby records the King declaring wearily: "I tell you, Philby, that if anyone were to offer me a million pounds now, he would be welcome to all the concessions he wants in my country."[49]

That was in 1931, and in the spring of 1932 the King despatched his second son, the Amir Faysal, to London again, this time to ask for a loan of half a million pounds, in exchange for which "he would welcome the assistance of British firms in exploiting the mineral resources of his country". The King was offering an open door; but Sir Lancelot Oliphant, Rendel's cautious boss in the Foreign Office, warily refused to go through it, citing economic difficulties and lack of business confidence as reasons – thus earning his sobriquet as "the diplomat who said 'No' to Saudi oil".[50] Curiously, Rendel makes no mention at all in his published memoir of this visit by Faysal to the UK, though he must have been involved in it, and indeed confirms in his 1937 report that he had last met him in London in the summer of 1932. Faysal was accompanied by Sir Andrew Ryan throughout his tour.[51]

Economic salvation arrived in the nick of time from another direction, in the form of the pro-Arab American philanthropist, Charles R. Crane, who was

invited to Jiddah at Philby's suggestion. This led to negotiations with Standard Oil of California (SOCAL) for the Eastern Province oil concession. In late February 1933, SOCAL's negotiators Lloyd Hamilton and Karl Twitchell arrived in Jiddah to compete for the concession with the Anglo-Persian Oil Company's Stephen Longrigg. The stage was set for the historic deal that would eventually transform Saudi Arabia into one of the world's richest countries.

The emergence of a new political unity, combined with the prospect of oil and the development of motor transport and radio communications, spelled the end of central Arabia's long isolation. Najd was opening up. Diplomats such as Andrew Ryan, Gerald de Gaury and Reader Bullard, as well as travellers such as Philby and Harold Dickson, would soon be beating a bumpy path by car to its growing capital, Riyadh, which hitherto had been accessible to only a handful of foreigners.[52] American oil men and other prospectors added to the medical missionaries who had preceded them.[53] From a British foreign relations perspective, the new kingdom straddled the old divide between London and India. To continue to formulate policy towards Arabia from two different directions was to invite confusion. George Rendel was characteristically clear-sighted about the need for rationalization, and played an important role in bringing relations with Arabia as a whole under London's purview at the expense of the Government of India, and imposing some coherence on the system.[54]

During the two interwar decades, Saudi Arabia was coalescing from an unstable assortment of feuding tribes and principalities into a unified state. Its creator – progressively Amir, then Sultan and finally King – had transformed himself from a tribal and sectarian chieftain of uncertain prospects into the ruler of a country on the international stage and, as the new custodian of Makkah and Madinah, a central figure in international Islam. As such, its monarch required more tactful and deferential handling than other Arab leaders, something to which not all officials were quick to adapt, though Rendel recognized it clearly enough. From a British geopolitical perspective, Ibn Sa'ud's unification project had created a state that was able to threaten the frontiers of Iraq and Transjordan and the security of Britain's protectorates along the Gulf coast.[55] More seriously still, he was regarded by Britain's 100 million Muslim subjects in India as protector of Islam's holy places and the pilgrimage. British officials had to get used to treating this potentate, whom they had previously regarded as a remote desert chieftain easily manipulated by small quantities of money and guns, as a serious political force in the region to whom they would have to make concessions when necessary. Britons on the ground who already knew Ibn Sa'ud (such as Gilbert Clayton, Gerald de Gaury, Andrew Ryan, Reader Bullard and Harold Dickson) were not at all taken by surprise at his ability to expand into his new roles and status. In London, George Rendel was foremost among those recognizing this evolving state of affairs and, as a man of forthright views, was influential in bending his superiors in the Foreign Office to his way of thinking.[56] So far from being symptomatic of the general failure of British imperial nerve in the 1930s, this particular recognition was a natural and inevitable adjustment to a new reality – one which would acquire even greater solidity with the discovery of oil in commercial quantities in Saudi Arabia in 1938.[57]

First Middle Eastern journey, 1932

It was in connection with Iraq in 1932 that George and Geraldine Rendel made the first of their two Middle Eastern journeys.[58] The Foreign Office did not encourage its London-based staff to undertake foreign visits, and it took tact and persistence to persuade officialdom not only to allow George to go, but to take Geraldine along with him too. All four children would by now have been at school, and so she was free once more to indulge her taste for travel. Her charm and sociability were a great asset: "Her coming proved fully justified (as in the case of my later journey through Arabia) and enabled us to establish social relations with a much wider circle and much more informally than if I had been simply an official travelling alone."[59]

The couple went overland, first by Simplon-Orient Express to Istanbul, and thence by train to Ankara, Konya, Aleppo and Nisibin. They were taken on by car to Mosul and Kirkuk, and from there on narrow-gauge railway to Baghdad. All are described in vivid colours in Rendel's published memoir, and the journey contributed greatly to his grasp of Turkish, Arab and minority affairs in all their complexity in the wake of the collapse of the Ottoman Empire.

In Baghdad, Rendel entered into discussions with the High Commissioner, Sir Francis Humphrys, on the new independence arrangements stemming from the 1930 Anglo-Iraqi treaty. In his first meeting with an Arabian monarch, he formed a favourable impression of the ex-Sharif of Makkah's third son and leader of the Arab Revolt, King Faysal I. He made a flying visit by air to Basra to acquaint himself with the issues over the disputed Shatt al-'Arab frontier with Persia, and to the Anglo-Persian Oil Company refinery at Abadan. Another short trip by air followed to Leonard Woolley's sensational Sumerian excavations at Ur. Women were not then permitted to fly in RAF aircraft, and Geraldine would have been highly frustrated by having to stay in Baghdad.

Air communications, oil and frontiers: these would emerge as the dominant British policy themes in Arabia and the Gulf during the 1930s, and, together with the security of the Red Sea route to India, became Rendel's prime focus during his tenure at the Eastern Department.[60] In the Gulf, oil production had already begun on Bahrain in 1932, and the prospect of imminent oil discoveries in the other Gulf Shaykhdoms and, though it seemed unlikely at the time, within Ibn Sa'ud's domain, added extra urgency to the business of agreeing frontiers between them.

The Rendels made their return journey overland via Damascus and Beirut, where George's task was to try to smooth relations with the French. A visit to Palestine followed, where George noted that Jewish immigration, just before the beginning of Nazi persecution, "was slow and cautious".[61] As a devout Christian, he found much to be moved by in Jerusalem, which he felt "seemed to have preserved a kind of sanctity", and as a diplomat he could appreciate how other faiths might feel the same about it: "No doubt the Temple Area with its lovely and ancient mosques gives the same impression to the Moslems, while at that time the Wailing Wall was equally sacred to the Jews."[62]

Palestine, however, was administered by the Colonial Office and thus not a direct concern of the FO. Rendel's main business was to discuss frontier matters with the Amir Abdullah of Transjordan, younger brother of King Faysal of Iraq. The

Amir was refusing to recognize King 'Abd al-'Aziz, on the grounds "as he explained to me, that Saudi Arabia was in a state of anarchy (which we knew to be untrue) and that Ibn Sa'ud's rule was crumbling (which was obvious nonsense)". Perhaps the Amir was too ready to be influenced by the near-disaster of the Ikhwan Revolt, still a recent memory. Possibly he had hopes of another revolt which was being stirred up by a group of Hijazi exiles under Ibn Rifada, who was about to attempt a futile invasion of the Hijaz a few weeks later. Rendel's second Arabian ruler, whom he judged to be lacking in realism and breadth of view, had failed to make as favourable an impression as his brother. Progress was made on the Syria–Transjordan border, but outstanding issues on the Saudi–Transjordan frontier continued to elude resolution.[63] Once Ibn Rifada's revolt had been quickly quashed by a Saudi army, the Amir Abdullah recognized King 'Abd al-'Aziz and a treaty between them was signed in 1933 that settled their differences.

The Rendels returned to England via Egypt, boarding an Imperial Airways flying boat from Alexandria to Athens, where they "saw many old friends and suffered some pangs of nostalgia for the Greece we had loved so well sixteen years earlier". They reached London on 23 March 1932, their journey having taken about seven weeks.[64]

Britain and Saudi Arabia, 1932–36

Back in London, Rendel had to deal with the crisis caused by the Shah of Persia's demand that the Anglo-Persian Oil Company's concession be cancelled and replaced with one more favourable to his country. The case was taken before the League of Nations, which found in favour of APOC, but the seeds were sown for future disputes over the national share of oil company profits. Always uneasy about relations with Persia, Rendel next saw to it that the proposed Imperial Airways route to India should be moved from the Persian to the Arabian side of the Gulf. Relations with Persia nonetheless gradually improved during his time at the Eastern Department, as they did with Turkey.[65]

In 1933, King 'Abd al-'Aziz appointed his eldest son Sa'ud as Crown Prince, and the Amir Faysal as foreign minister. In 1934, the King reacted to Yemeni incursions into the Najran area of the Asir highlands and claims to Jizan on the Tihamah coast, by sending a two-pronged campaign into Yemen. The Amir Sa'ud led one column into the rugged highlands and the Amir Faysal led the other down the coast to al-Hudaydah. This short war resulted in the decisive incorporation of Najran and Jizan into Saudi Arabia. The frontier would be drawn on the ground by Philby during 1936–37.[66]

The matter of Saudi borders elsewhere was becoming increasingly pressing in the light of the oil concession agreement that Ibn Sa'ud had signed with SOCAL in 1933, which referred to the "eastern portion of our Saudi Arabian Kingdom, within its frontiers". Ryan had already achieved much in clarifying Saudi Arabia's borders with Iraq and Transjordan, but was having less success with those between Saudi Arabia and the Trucial Shaykhdoms of the Gulf coast.[67] The problem was that these frontiers, which would have to pass through vast, unmapped desert tracts, had not been specified other than by the vaguest sweeps of coloured crayon and ruler. The

first inconclusive negotiations, led on the Saudi side by the acting foreign minister, Fuad Hamza, took place in London in 1934 and 1935, with the British side, led by Rendel, resisting Saudi claims to territories deep inside the Gulf Shaykhdoms and Oman under British protection.[68] The talks foundered not because of competing claims to undiscovered oil, but because of King 'Abd al-'Aziz's wish for an outlet to the sea in territory belonging to Abu Dhabi, whose rights Britain was obliged to uphold.[69] This south-eastern frontier would be a chief matter of discussion with King 'Abd al-'Aziz in 1937. Rendel faced foot-dragging not only from the India Office, still blinkered by its traditional reluctance to get involved in the hinterland of Arabia, but also from other departments of government. He was surely right to prioritize the effort, however. If he had been able to persuade his colleagues to take the issue more seriously and to obtain agreements on the ground, the serious Anglo-Saudi quarrel over Buraymi and the frontier with Abu Dhabi that erupted in the 1950s, and in which oil prospects had by that time become the central issue, might have been averted.[70]

Despite the difficulties over this frontier, Rendel was able to report steadily improving relations with Saudi Arabia.[71] After the Yemen war, King 'Abd al-'Aziz decided to send Crown Prince Sa'ud abroad on diplomatic missions. Because of the ongoing frontier talks, London was an obvious priority, and the British side invited Sa'ud and some of his brothers to attend part of the Jubilee celebrations of King George V and Queen Mary in June 1935. Ryan and Rendel were both heavily involved in arrangements, and cordial relations were quickly established. "Although I was in fact merely carrying out a policy approved by the British Government," writes Rendel, "the Arabs, who are intense individualists and like to think in terms of personalities, regarded me as a particular and personal friend."[72] He goes on:

> During this period our relations with Ibn Saud steadily improved and we arranged for him to send some of his sons to England to establish personal contact with the West. These visits proved successful and useful – though one nearly ended in disaster, when, while I was taking two of the Amirs on the Cherwell as part of a personally conducted tour of Oxford, the elder begged me to allow him to punt. He was immensely tall and dressed in full Arab robes. Had he fallen in, the result to our relations with Arabia might have been fatal. But I eventually persuaded him to be content with a paddle. The lovely setting of the Cherwell on one of our rare fine summer days made a great impression on him, and he went on exclaiming: "Jamil, jamil" (beautiful, beautiful) until we finally returned to Magdalen Bridge.[73]

The Saudis were anxious to repay the hospitality shown them, and in the autumn of that year King 'Abd al-'Aziz issued an invitation, through Hafiz Wahba, for Rendel and his wife to visit Saudi Arabia as his guests on a semi-official basis.[74] For departmental reasons Rendel was unable to take up the invitation in 1936, and his trip was delayed until early 1937.[75] Ryan, however, had established equally friendly relations with the Amir Sa'ud, and it was arranged that he should return to his post in Jiddah via Riyadh. He was to confer upon King 'Abd al-'Aziz the honour and robes of Knight Grand Cross (GCB), symbolizing Saudi Arabia's new status

The Amir Sa'ud (left) with Shaykh Hafiz Wahba outside the Hyde Park Hotel in London, on 17 June 1935.

as an independent state in direct relations with London. There was some debate about whether to invest the King with the robes of the order and, when it was decided to do so, Ryan was instructed in the art of putting them on in Rendel's office, using an exceptionally tall member of staff as mannequin. The route chosen for Ryan's journey across Saudi Arabia was exactly that which the Rendels would follow in 1937, from al-'Uqayr on the east coast. As with Rendel, the Saudis encouraged Ryan to bring his wife. Luckily for Geraldine, Ryan decided against it:

> It was contrary to Ibn Saud's custom up to that time to receive European ladies, or at any rate such as shared official positions. I did not wish to try him too high, nor did I wish to expose my wife to the possibility of being disregarded. She has never quite forgiven me, especially as it was not long before at least two important British ladies [viz. Geraldine Rendel and HRH Princess Alice] accompanied their husbands into the interior and were treated with all suitable distinction.[76]

Ryan's lack of Arabic was compensated for by the colleague assigned to him for the journey, Capt. Gerald de Gaury, an experienced and fluent Arabist who had already crossed Arabia from Jiddah to Kuwait earlier in 1935. De Gaury was also a gifted writer and photographer, and wrote highly evocative accounts of his Najdi travels in his books *Arabia Phoenix* and *Arabian Journey*. The pair flew from Cairo via Baghdad and Kuwait to Bahrain, where Ryan had meetings with the Gulf Political Resident, Trenchard Fowle, and the Political Agent on Bahrain, Col. Gordon Loch, just as Rendel would two years later.[77] Like the Rendels, they went by dhow to al-'Uqayr, where they donned Arab robes for the overland journey. Their official guide for the whole of their journey was Tawfiq Hamza, brother of Fuad Hamza. Ryan spent six days in Riyadh, meeting with the King every day, and investing him with the GCB on 25 November 1935. Discussions centred on frontier issues and the ongoing Saudi economic blockade of Kuwait. The onward four-night journey to Jiddah went by the same route as the Rendels' as far as 'Ashayrah, via Marat, Duwadmi, al-Qa'iyyah, Afif, Dafinah and Muwayh. From there they went via Sayl, Wadi Yamaniyyah, Zayma and al-Sharayi (al-Sharā'i') to Jiddah. It had been "the most eventful journey of my life", wrote Ryan.[78] His final act as minister before leaving Jiddah in June 1936 was to agree modifications to the Anglo-Saudi Treaty. He was replaced by Sir Reader Bullard.

The Rendels' 1937 Middle Eastern journey

As she states in her Foreword (see p. 46), Geraldine Rendel intended her travelogue for publication. Her claim, that it is no more than an amplification of the daily diary of the trip that she co-wrote with her husband, is borne out by a comparison of the two documents: her narrative does indeed adhere very closely to the handwritten diary, with only occasional omissions and, in places, slight reordering of the presentation.[79] The main improvement she has made is to the literary style. Her wit and turn of phrase enable the reader to hear her voice and form an impression of her character and sense of humour.

It is important to be aware of what she leaves out of her story. She clearly intended it as an account of a purely Arabian journey, and so what we have here is only a partial record of the Rendels' 1937 Middle Eastern journey as a whole. For a detailed account of the whole itinerary we have to consult not only the handwritten diary, but also another unpublished document: George Rendel's businesslike 71-page official typescript entitled 'Report by Mr Rendel on his Tour in the Persian Gulf and Saudi Arabia, Feb.–Mar. 1937'.[80]

The Rendels started by travelling overland to Brindisi, and from there by sea via Cyprus to Haifa, where a Nairn Car collected them for the journey by road through Galilee via Lake Tiberias towards Damascus. Things had changed since they were last here:

> The new Jewish colonies had greatly multiplied since our previous visit in 1932, and the countryside was beginning to take on a rather brash modern look; while Jewish hiking-parties with stout young women from Central Europe, in exiguous tight shorts, made an

odd contrast to the then still more numerous native Arabs, glaring suspiciously at these strange invaders.[81]

Political meetings began in Damascus, where discussions focused on the prospects for Syrian oil negotiations and closer co-operation with the French throughout the Middle East. On reaching Baghdad overland, Rendel was able to form his own impression of the strengths and weaknesses of various Iraqi officials and the prospects for Iraqi political stability; he was not especially impressed by either. Issues discussed included Iraq–Persia frontier issues and smuggling over the Iraq–Kuwait border. There followed two days in Basra as guests of Col. John Ward, Director of the Port of Basra and responsible for keeping the Shatt al-'Arab navigable. Ward's new Basra airport was admired: the creation of a viable air route to India was becoming a pressing British concern in the Gulf by the late 1930s. Rapid visits were made by launch to Muhammarah and the Anglo-Iranian oil refinery of Abadan, where the question of the Persian boundary along the Shatt was the focus of discussion.

The Rendels left Basra on 21 February 1937 to go by road to Kuwait via al-Zubayr, a desert town that was very Najdi in character and traditionally regarded as the gateway to Arabia for trade caravans. And it is at this thoroughly appropriate point that Geraldine chooses to begin her own Arabian narrative. She starts as she means to go on, concentrating on local colour and the social aspects of her experience. She airily refers to the trip as her 'Arabian holiday', and omits all mention of its political purposes, even to the extent of withholding the names of the British officials who received them, with the exception of Sir Reader Bullard and Harry Eyres in the Hijaz. Naturally, she was not privy to the discussions her husband held with King 'Abd al-'Aziz, the Amir Sa'ud and the Gulf Resident and Political Agents, and so she would have had no first-hand details to impart.

She is a romantic traveller, always on the look-out for the exotic and not always in tune with the Arabs' perfectly understandble aspirations for material progress. Like many other travellers in the East, she is more likely to be seduced by what she takes to be unchanging oriental tradition, the more redolent of the *Arabian Nights* the better, than by aspects of modernization and change too familiar from home. One may cavil at this quest for the picturesque, so typical of modern tourism, but it certainly piqued her sense of adventure. Though determinedly regarding the trip as a mere holiday, there are aspects of real travel about her account of it. She differed from modern tourists in being prepared to take off into unknown territory and endure the hardships, thrills, spills and frustrations of desert travel with patience and good humour. A pampered grandee on tour she may have been, but there were none of the pre-packaged, sanitized touristic 'experiences' that mass tourism thrives on today. Here she is stepping aboard the dhow for the first time:

> I stepped off the quay into the boat feeling that adventure had begun. I was walking right out of my life into another of which I had no real conception, and the present alone had reality. I had passed through a magic door and it had shut behind me setting my fancy free. My everyday world grew dim; it was like slipping into another dimension …[82]

"I stepped off the quay into the boat": the Rendels photographed on the morning of departure from Manamah, Bahrain, possibly by Charles Belgrave or Col. Loch.

From the moment she stepped onto Saudi soil she was required to be veiled, an experience she found by turns a nuisance, a natural acknowledgement of local custom, and a welcome screen against unwanted curiosity. In a society totally unaccustomed to women mixing with men in public, her presence elicited wildly contrasting responses: she was treated either as a great lady, or as a nobody. The King, the Amir Saʿud and the Qusaybis received her with exemplary good manners, no doubt incurring the disapproval of many of their conservative countrymen, while other male hosts could only respond by pretending that she did not exist. Geraldine was flexible enough to be understanding, concluding that this was not so much a case of bad manners as an inability to adapt to the unprecedented arrival of a woman in their midst:

> My position all through this journey was a mixture of that of a lady of the harem and of a European woman. When with the Amir [Saʿud] I was always given place to, and put first in everything. But on some other occasions, I was treated differently. I stood without being presented to anyone, and no man would speak to me, or even offer me a chair, because no Nejdi looks at any woman outside his own family circle.[83]

On the positive side, Geraldine's gender gave her a certain advantage. While George is able to describe in detail the hospitality he received in male company, such things as his maladroit efforts to eat with his right hand are the conventional stuff of European narratives of Arabian travel, as is the somewhat romantic aura that pervades his published account.[84] Geraldine on the other hand had access to something much more unusual and interesting: the private quarters of the Saudi elite and the women's side of society. Her descriptions of meeting the women and children of the al-Qusaybi and, later, the Al Sa'ud *harim*s in Riyadh and Jiddah, give us a rare and vivid insight into the side of Saudi Arabian life hidden from public view, and are as graphic as Lady Evelyn Cobbold's accounts of the private quarters of Makkan and Madinan households in 1933.[85]

George's official report, by contrast, continues its businesslike focus on politics and personalities. He paints a vivid and insightful portrait of the genial Kuwaiti ruler, Shaykh Ahmad Al-Sabah, with whom the British enjoyed excellent personal relations but "whose good qualities unfortunately seem likely to prove hardly less embarrassing to us than his failings". He is concerned with Britain's relations with Kuwait, and the ruler's worrying game of playing Britain, Saudi Arabia and Iraq off against each other in his attempts to thwart Iraqi and Saudi designs on his vulnerable shaykhdom. But despite the Shaykh's determination to "run a rather dangerous policy of his own, in thinly concealed opposition to our wishes", personal relations were excellent and the Rendels' arrival, attended by unusually heavy rain, was regarded as particularly auspicious:

> The Sheikh was radiant at what he called our "green coming". I had crossed swords with him on the subject of smuggling at a conference at the India Office during his last visit to London, but he was good enough to assure me that, in view of the rain I had brought him, our differences would be forgiven (which I was glad of), and forgotten (which was more than I desired).[86]

The Rendels were visiting during the build-up to Kuwait's constitutional crisis of 1939, when Shaykh Ahmad would turn a deaf ear to British advice and effectively stifle efforts by leading merchants to acquire a greater political role in their country's affairs. Rendel was also preoccupied with what he regarded as the outdated system of protectorate treaties governing Britain's relations with all the Gulf Shaykhdoms, which was "based on that applied to the Indian States, but [which] seemed to me to be becoming more and more out of key with modern conditions". But he was facing resistance to change in London.[87]

There were meetings with the Political Agent, Capt. Gerald de Gaury, whom Rendel admired, and with Col. Harold Dickson, "a strong but not a silent man", who had been Political Agent until 1936 and was now chief local representative of the Kuwait Oil Company. Rendel had already urged APOC to apply for the Kuwaiti oil concession, but had been met with a lack of enthusiasm. Only later did APOC wake up to the opportunity and manage to secure a fifty-percent share in the concession awarded to the Americans.[88] Uppermost now were the issues of the air route and smuggling: duty-free imports had been a pillar, even the *raison d'être*, of the Kuwaiti economy since its foundation, but these were now causing an intractable problem

not only with Iraq but also with Saudi Arabia, which was putting pressure on the Kuwaiti ruler to levy import taxes on the Saudi treasury's behalf on merchandise destined for Najd.

On leaving Kuwait, Geraldine's narrative would lead the reader to believe that the couple then went by sea direct to Bahrain. In fact they went to Bushire, on the Persian side of the Gulf, arriving on 24 February. From there they made a short tour of the hinterland as far as Shiraz and Persepolis, so that George could form an impression of southern Persia. Such a rugged excursion appealed greatly to Geraldine's sense of adventure, and her lively account of it is preserved in the handwritten day-by-day diary.[89]

The British Residency was a spacious establishment seven and a half miles inland from Bushire, set among lush gardens. While George called on the governor of Bushire, Geraldine passed the time playing tennis and taking photographs: there are many excellent images of the Persian trip preserved in the archives of the Royal Geographical Society. On 26 February, they left at dawn for the breath-taking and often precipitous drive across the successive mountain ridges and river valleys to Shiraz. The Rendels, as always connoisseurs of architecture, spent the following day admiring its beautiful mosques, visiting the tombs of the poets Saadi and Hafiz, and being entertained by the British Consul and various Persian officials. The Shah had banned the chador by decree in 1936 and the people all looked as if they had dressed out of European jumble sales, which the Rendels found dispiriting, as they did the "indescribably sordid and squalid" bazaars. On the 28th they motored out to Persepolis, to be duly amazed by the spectacular remains of the ancient Achaemenid capital. Next day, on the way back to Bushire, Geraldine made notes on the flora and fauna. Rain had caused mudslides, switchbacks were negotiated by hair-raising skid turns, and at one point the car spun round on the edge of a precipice, instilling a genuine terror at the prospect of her children being orphaned.

George Rendel's main purpose in visiting Bushire was to meet the British Resident in the Persian Gulf, Trenchard Fowle, who was responsible for the Political Agents in all the Shaykhdoms on the Arabian side. Despite his role as controller and protector of these Arab principalities across the water, the Resident simultaneously held the lowly post of consul-general in Persia, and was treated with disdain by Persian officialdom.[90] This paradoxical arrangement was a relic of the early 19th century. Rendel rightly regarded it as an anachronism and an obstacle to satisfactory Anglo-Persian relations. He was firmly of the view that that the Residency should be moved to Bahrain without delay, and was somewhat irritated by Fowle's apparent lack of urgency. Any such reorganization was really still a matter for the Government of India but, as Rendel remarks, "it does also affect Foreign Office interests, by slowing down the conduct of our relations with the Arab rulers of the Gulf and thereby further complicating their relations with their foreign neighbours, e.g. Saudi Arabia and Iraq".[91] Discussions with Fowle also covered the Kuwait smuggling issue, and the matter of frontiers in south-east Arabia.

As a result of this all-too-brief excursion across the Gulf, George Rendel formed an unfavourable view of the Persians when compared with the Arabs. He wisely says elsewhere that he never trusts his first impressions, yet he cannot help concluding with this judgement:

Above The British Political Residency at Bushire.

Below The Rendels were connoisseurs of architecture and can be seen here enjoying their visit to the historic mosques of Shiraz.

Through a Magic Door 25

Like all other visitors, the Rendels were awestruck by the remains of the ancient Achaemenid capital at Persepolis, which date from the 6th century BC. Their photography forms an important record of the site.

> It would be impertinent for me on so short an acquaintance to generalise about the Persian character. But I cannot refrain from recording the extent to which I was impressed by the contrast between the manner and appearance of the Persians and of the Arabs. The curious, slightly effete effeminacy of the Persian, and his lack of humour about himself, his queer gentleness and his all-pervading vanity, are particularly noticeable when contrasted with the rugged virility, comparative simplicity and bluff sense of humour of the Arabs of Arabia.[92]

However biased one might think this assessment, it augured well for the Rendels' return to Arabia. They left Bushire for Bahrain on 2 March on a British naval vessel, the *Deptford*: according to George, a "delightful trip, ... very pleasant experience [which] greatly increased our respect and affection for the Navy". Once at Bahrain, Geraldine's typed narrative resumes with no mention of the Persian trip, as if she and her husband had arrived by sea direct from Kuwait.

They had been accompanied from Bushire by Fowle and by Peter Loxley, from the Tehran embassy. Fowle had come along because Rendel wanted him on the spot to confer with de Gaury from Kuwait and Loch, the Political Agent on Bahrain, on frontier matters concerning Qatar, Saudi Arabia and Abu Dhabi. To refine their knowledge, Rendel wanted to carry out some investigations by air. After a warm welcome by the ruler, Shaykh Hamad bin 'Isa Al-Khalifah, the group were taken by RAF flying boat on a tour of disputed frontier areas: Hawar Island, disputed by Bahrain and Qatar; down the west coast of Qatar to Jabal Nakhsh adjoining Saudi Arabia; across the base of the Qatar peninsula to Khawr al-'Udayd; to the Sabkhat Matti between Qatar and Abu Dhabi; and back up the east coast of Qatar to Bahrain. The reconnaissance gave Rendel a good grasp of the topographical realities underlying any future resolution of these disputed areas, and a much firmer basis on which to discuss frontier concerns with Ibn Sa'ud in Jiddah three weeks later. Nevertheless, despite the newfound clarity, the frontier would continue to evade precise definition.[93]

The Rendels were entertained by the Lochs and by the Shaykh's resident British adviser, Charles Belgrave, and his wife.[94] A visit to the productive Bahrain oilfield and installations prompted George to reflect on the comparative fortunes of Bahrain and Saudi Arabia:

> Providence has been kind to Sheikh Hamad. Just as the pearl trade fell on evil days, plentiful and excellent oil was discovered in Bahrein – though, owing mainly to lack of foresight on the part of British oil interests, who would take no interest in the concession when they could have had it, the exploitation of this oil has fallen in to American hands. ... It seems hard on Ibn Saud, whose needs are so much greater, that his infinitely large neighbouring territory should so far have produced no natural resources in paying quantities.[95]

Dramatic irony indeed. He could not know, on 5 March 1937, that almost to the day a year later, on 3 March 1938, oil would be struck in very commercial

quantities on Saudi territory at Dammam Well No. 7, so promising a speedy end to Ibn Saʿud's financial woes.

Early the following day, the Rendels boarded a dhow supplied by Ibn Saʿud's agent in Bahrain and al-Hasa, ʿAbd al-Rahman al-Qusaybi. After a few hours of navigating the reefs, they reached Saudi soil at the little port of al-ʿUqayr, where they were met by the ever-attentive Shaykh Hafiz Wahba, "our admirable host, guide, philosopher and friend", and a line of local personalities. Shaykh Hafiz produced his own camera and took photographs.[96] From this point on they were required to wear Arab dress, and Geraldine to be veiled in public. Hasa Oasis surprised them with the vastness of its palm gardens and fields and numerous villages. On reaching al-Hofuf, they were accommodated in comfort in the guest house of the Amir's palace. The Amir himself, Saʿud Ibn Jiluwi, was famously uncommunicative and George got the impression that he "was a colourless creature with little authority or energy and unlikely to prove much of a successor to his ruthless and successful father. ... But I may be doing him an injustice Silence is not necessarily uncivil in Arabia."[97] The Rendels were most impressed by the al-Qusaybi brothers, ʿAbd al-Rahman and Saʿd, whose hospitality they enjoyed, but George could not avoid a certain suspicion:

> The Qusaibi family play an important commercial, and indeed political, role in this part of Arabia, and we have had reason in the past to suspect them of creating difficulties in regard to the reopening of trade between Saudi Arabia and Kuwait, in view of their special interest in trade passing through Bahrein. I would not put it past them to grind their own axes when it suits them.[98]

On leaving al-Hofuf for Riyadh in a convoy of cars and trucks, George could reflect on the tenor of travel in Saudi Arabia and the instinctive Arab preference for those of other faiths over those with no faith at all:

> The traveller in Arabia feels a strange liberation from the servitudes of European life, a readjustment of his sense of values – perhaps a keener perception of essential truths. The only fixed points of time are sunrise and sunset and the hours of prayer. These regular, unostentatious but obviously sincere halts for prayer won our increasing respect. The Arabs at that time were still true to their principles, and, incidentally, ready to respect others who were true to theirs. Indeed I found many small indications, both on this journey, and, in fact, all my dealings with the Arabs of those days, that we ourselves, as believing and practising Christians, enjoyed greater respect and authority among good Moslems than the orthodox European agnostics or unbelievers with whom most of their relations were normally conducted.[99]

In Riyadh, the Rendels were warmly received by the Amir Saʿud, whom they knew well from his 1935 visit to London, and who had been invited to visit London again for the Coronation later in 1937. The King himself was in Jiddah, as the pilgrimage season was in full swing. George was critical of "some of the notorious faults of the Arab character [being] much in evidence. Improvidence and lack of

practical efficiency were conspicuous." But his account is also notable once again for his eye for architecture, and he found much else to appreciate in his surroundings:

> The atmosphere of the palace at Riyadh struck me as purely mediaeval. I received the impression of a civilization and an outlook based on standards and a sense of values remote from those of the modern world, and in many ways more admirable – or at least more consistent and less materialistic. Incidentally I was much struck by the natural dignity and fine bearing of the Amir's retainers, of whom there were always some 20 or 30 at hand. They were for the most part good-looking, virile men with clear-cut, intelligent faces. The scene was reminiscent of the best drawings of Eric Kennington.[100]

Meetings with the Amir Sa'ud were both formal and informal; at a private dinner on the last evening Geraldine was even able dispense with her veil. Political discussion was confined to generalities:

> [Sa'ud] explained that … the keystone of Saudi policy was friendship with Great Britain. He hoped that this guiding principle would always be maintained. I made a suitable reply adding that the wisdom and sound judgement of King Ibn Saud had made the task of drawing our relations closer much easier for us. … Since then there have been many sources of friction, and the discovery and development of oil in Saudi Arabia has completely transformed the economic and social background. I still [1957] believe, however, that the Arabs of Saudi Arabia, while maintaining a somewhat detached attitude towards all infidels, probably regarded us at that time as the least dangerous of the foreigners with whom they had to deal, and that they meant what they said when they asserted that they wanted to be friends.[101]

Though even this fairly downbeat view of the Anglo-Saudi relationship has been judged too rosy, at least it was informed by a realistic insight into the underlying Saudi attitude towards foreigners, and the correct perception that what Ibn Sa'ud favoured above all was the highest bidder.[102] Nor was it infected by romantic notions of a special affinity between Britons and Arabs that mar many travel accounts. De Gaury, more perceptive than most British observers of the Saudis in the 1930s, was similarly free from illusion. Even though he was apt to rhapsodize about the noble simplicity of the Saudi way of life and their virtues of hospitality, he was never seduced into thinking that their friendship towards foreigners ran deep. He summed this up in a record of a conversation with King 'Abd al-'Aziz in Riyadh in 1939:

> I recall Ibn Saud's words to me in Riyadh. "In reality I abhor all foreigners. I would have none of them. The best of them are the British, and they – I would they were on the far shore of a sea of flame and fire –" and as he said it, without rancour or ill-humour, he smiled. The man often speaks out what is in his heart. *Atkallum bisuraha* (I speak frankly) is ever on his lips.[103]

The Rendels left Riyadh on 12 March for what was essentially a sight-seeing trip across the rest of Arabia, its highlight being a southward detour from 'Ashayrah to visit the scenic highland town of Taif and the 7,000-ft Shifa escarpment in its vicinity. Their route as far as 'Ashayrah was the usual trans-Arabian one, as followed by Ryan and de Gaury in 1935, via al-Dir'iyyah and al-'Uyaynah, 'Uwaynid, Barrah, Marat, Duwadmi, al-Qa'iyyah, Afif, Dafinah and Muwayh. At Taif, they visited a village close to the escarpment and the fertile Liyyah valley, and were entertained by the Amir who, though charmingly courteous, was "almost as silent as the Amir of Hasa".[104] Heavy rains meant that they could not go by the usual route from Taif to Jiddah that skirted Makkah via Wadi Fatimah. Instead, they left Taif on 17 March to return to 'Ashayrah, and thence to the Saudi Arabian Mining Syndicate's new metalled road, the only one in inland Saudi Arabia, running between Jiddah and the gold mines of Mahd al-Dhahab. This took them north to al-Birkah and then south-west across the drear and featureless black basalt *harrah* to the little oasis of Madrakah, where they picnicked. By the time they reached Jiddah that afternoon, they had travelled some 1,350 miles from al-'Uqayr.

On their arrival at Jiddah, political matters supervened once more. The newly installed British Minister, Sir Reader Bullard, was about to hand in his credentials, and Rendel was presented to the King immediately after the ceremony. The meeting took place in a large, open-fronted reception room on a spacious terrace of the palace – most probably the same as that photographed by those with Princess Alice in 1938. Geraldine of course was unable to attend. Like everyone meeting Ibn Sa'ud for the first time, George was much struck by his charm and commanding personality.[105] He spent a week in Jiddah in intensive meetings with the King on political matters, always accompanied by Bullard and Hafiz Wahba, with Yusuf Yasin representing the Saudi Ministry of Foreign Affairs. Both Wahba and Bullard, a good Arabist and as perceptive an observer as de Gaury, acted as interpreters. It proved impossible to resolve the issues of the frontiers in south-east Arabia[106] and with Transjordan, or the matter of Kuwaiti smuggling and the Saudi blockade. The problem of Palestine, by now of deep concern to Rendel because he rightly saw Britain's handling of it as crucial to its relations with the Arabs at large, was deflected on the grounds that a Royal Commission (under Lord Peel) was currently looking into the whole question of Jewish settlement.[107] But progress was made on other matters, such as non-interference by European powers, notably Italy, in Arabia. Since Italy's invasion of Abyssinia in 1935, the issue of whether to curb or appease Mussolini's ambitions in the Red Sea had moved right up the agenda. Britain's

Presented to GEORGE WILLIAM RENDEL, ON THE OCCASION OF HIS JOURNEY ACROSS ARABIA, BY H.M. KING ABDUL AZIZ ABDURRAHMAN AL FEISAL AL SAUD ("IBN SAUD") OF SAUDI ARABIA. Jedda, March 22, 1937.

King 'Abd al-'Aziz gave George Rendel a gold-hilted sword (see plaque opposite) and this photograph of himself as a memento of the visit, as well a valuable string of pearls for Geraldine. (See p. 212 note 156 below.)

Through a Magic Door 31

priority was to ensure the security of maritime communications with India. To this end, in January 1937 Britain had been keen to agree with Italy a joint declaration that both countries would seek to minimize friction in the eastern Mediterranean and the Red Sea. But it was unable to take a harder line because Italian co-operation was needed over other issues in Europe. Italy was at the same time spouting anti-British, anti-imperialist and pro-Islamic propaganda into the Arab world through Radio Bari, and courting the Palestinians as well as Ibn Sa'ud, though the latter was wary of the suitor. Rendel was able to reassure Ibn Sa'ud that his best security lay in the knowledge that any Italian interference in Saudi Arabia would be equally a threat to British interests, and that this convergence of interests provided a better insurance than the defensive treaty he was seeking.[108] Bullard, whose despatches recorded these discussions in detail, found the visit immensely useful:

> I venture to believe that Mr Rendel's visit and the conversations to which it gave rise have been of the greatest value, and will have helped to launch my personal relations with His Majesty under the happiest auspices.[109]

There were various lunches and dinners to attend, including one given by the Amir Faysal. Rendel judged the Amir to be listless, and found it "hard to believe that he will ever prove a ruler"! Geraldine, more acutely, records that "some say he is the brains of the family".[110] Philby, recently returned from his *jeux sans frontières* in the Yemen and Hadhramaut, flits across the scene from time to time, and gave a dinner at his house:

> Mr Philby is an old acquaintance of mine, and, though I am under no illusions about his failings, I have always appreciated his good qualities. He was friendly and interesting, but I was by that time too tired to make as much of the evening as I should have liked. My wife, however, had a good deal of useful and interesting conversation with him.[111]

The Rendels enjoyed a packed social schedule, and managed to meet practically the whole of the British and American colony at Jiddah and some of the foreign representatives too, "mostly at tea or sherry parties given by Sir R. Bullard, who is a very popular host". The American oilmen Thornburg, Davies and Hamilton of SOCAL were there, having followed the Rendels across Arabia from Bahrain in two light Ford cars. They were exceptionally genial. Rendel, however, pours cold water on the prospect of oil being found in al-Hasa. "It is doubtful," he writes, "whether oil will be found in Hasa in commercial quantities, and the future of the company [SOCAL subsidiary CASOC] is therefore uncertain."[112] Words that, less than a year later, he would have to eat.

A high point came when the finance minister, Shaykh Abdullah Sulayman, arranged a tea party with the aim of introducing Geraldine to the King. She was placed next to him – the first occasion on which the King had received any European lady in public.[113] Geraldine, as she recounts below, also spent time with the King's favourite wife, Umm Mansur, in the royal *harim*, an encounter that drew from George another over-confident prognostication:

> None of the women whom my wife met during this journey seemed to suffer from any sense of confinement or frustration. But there is still no doubt that the position of women was – and perhaps still is – one of the greatest blots on Arabian civilization. With the opening up of the country as a result of the discovery of oil, and with the new rule of sovereigns who have had personal experience of the West, it seems unlikely that the old regime will be able to continue unchanged for very long.[114]

The Rendels left Jiddah on 22 March on a ship of the Italian Red Sea service. In Egypt, George met Sir Miles Lampson, the British Ambassador, on the road between Suez and Cairo, and was able to brief him on his conversations with Ibn Sa'ud.[115] The Rendels reached London on 1 April 1937. Overwhelmed though he had been by the lavish hospitality and friendly help meted out at every step of the way, whether by the Saudis or British officials, George singled out Hafiz Wahba above all for special praise:

> [He] was our constant companion and personally supervised all the arrangements for our visit. We found him unfailingly friendly and helpful; and, although I knew him well before I went to Arabia, I can sincerely say that in the course of our journey I grew to like him steadily better – a somewhat unusual experience with travelling companions.[116]

The friendship between the Rendels and the Wahba family was one that would survive George's death in 1975.[117]

In his 1957 memoirs, George was understandably anxious to present his tenure at the Eastern Department as a time of steadily improving Anglo-Arab relations, before they were clouded by King 'Abd al-'Aziz's objections to developments in Palestine, and before "oil revenues had begun to undermine the better side of Arab life":

> Courage, fidelity in friendship, hospitality and a sense of humour are qualities which do not easily fade away. The Arabs moreover are intense individualists and have less natural tendency to Communism and materialism than many other Eastern peoples. Is it too much to hope that these qualities may yet survive the impact of modern life and the corruption of riches, and that the people of Arabia may yet live to make a real contribution to the peace and prosperity of the world?[118]

Anglo-Saudi tensions, 1937–39

George Rendel's return to the Eastern Department was followed very shortly by the celebrations attending the Coronation of King George VI in May 1937, to which the Amir Sa'ud had been invited. At the same time, the issue of Palestine was rising rapidly up the political agenda. Rendel was able to appreciate both sides of the argument. While sympathetic to Jewish claims and especially to the

plight of Jewish refugees from Europe, he was far from taken in by arguments that Palestine was an empty country waiting to be filled by Jewish immigrants, or that it represented just a tiny fraction of the vast Arab lands adjacent to it. His preferred policy was to set a fixed ratio between the Jewish and non-Jewish population.[119] As a Catholic, he was also sensitive to the preservation of Christian rights to their holy places and property. The conundrum of how to reconcile Jewish immigration with the rights of the existing Arab inhabitants became urgent in the summer of 1937, when the report of the Peel Commission, which had been set up in 1936 to investigate the whole Palestine question, was published. Great hopes had been placed on it but, thorough though it was, it could propose nothing more constructive than an unworkable scheme of partition, much to the disgust of King ʻAbd al-ʻAziz. Another commission followed, recommending Rendel's fixed ratio between Jews and Arabs as a target. By the time this had been embodied in a policy proposal in 1939, Rendel had left the Eastern Department, probably to his relief. This policy too proved unworkable and had to be abandoned after the Second World War. Rendel was certainly right to attribute much of the subsequent odium incurred by Britain in its relations with the Arabs to its failure to identify and follow through with a just solution to Palestinian grievances.[120] To be fair to Britain, no other mediator since has been able to come up with a workable solution, but at the time its failure was seen as a culpable one, inflicting lasting damage on its standing in Saudi Arabia and the Arab world in general.

In early 1938, having left the Eastern Department, Rendel was put in charge of negotiating an agreement with Italy over conflicting Anglo-Italian claims in the Red Sea.[121] The two sides agreed to respect each other's spheres of influence in the area, which carried the implicit recognition that Italy's rights and interests were equivalent to Britain's. It also committed both sides to refrain from trying to obtain a paramount position in Saudi Arabia. The agreement was condemned by many in Britain as a further appeasement of Italy. Nor did it please Ibn Saʻud. For a start, it seemed from his viewpoint a feebly even-handed response to Italian designs on the Yemen. But he also interpreted its terms as an infringement of his sovereignty, because it seemed to limit his freedom to negotiate as he pleased with either side. The agreement was concluded, but Mussolini's decision in 1939 to enter into a pact with Nazi Germany, coupled with the outbreak of the Second World War, extinguished any further need for Britain to take Italy's interests into account.

Despite his repeated expressions of friendship when face to face with British diplomats, the issues of Palestine and Italian scheming in Arabia had afforded Ibn Saʻud good reason to be annoyed with what he perceived as Britain's less than wholehearted espousal of his country's interests. So far from feeling bound by any special relationship, he was feeling free, in the manner of Britain itself, to negotiate with whom he pleased. By 1938, relations with Britain had deteriorated markedly. Britain's impasse over Palestine had even given him occasion to start making overtures to Germany. It was, however, only a brief flirtation. The discovery of oil in 1938 transformed Saudi Arabia's economic prospects. At the end of 1939, he would wisely opt for the neutrality which kept Saudi Arabia out of the Second World War.[122]

George Rendel rides through the streets of Sofia with King Boris, having presented his credentials as HBM Ambassador to Bulgaria.

The Rendels: the Second World War and after

George Rendel was about to leave Middle Eastern affairs behind. In the summer of 1938, he rejoined the Diplomatic Service by accepting his appointment as Minister to Bulgaria. He and Geraldine travelled by train to Sofia in June. As the political clouds gathered, they were unable to see as much of the country as they would have liked. The climate was dominated by the new German Drive to the East (*Drang nach Osten*), and Rendel's job was to do what he could to check German political influence and economic penetration. Much use was made of the Orient Express, as the family commuted to and from England for the school holidays. In 1939, it was decided that Geraldine should stay in England, while their elder daughter Anne, now nineteen, joined George in Sofia to act as his hostess and work in his press office. At home, Geraldine devoted herself to war work, organizing a network of Catholic clubs, hotels and canteens for servicemen in various theatres of war, for which she was later awarded an OBE.

In Bulgaria, the German–Soviet Non-Aggression Pact of August 1939 occasioned a sharp upswell of pro-German feeling among the largely pro-Russian

Sir George Rendel at the height of his diplomatic career in the late 1940s.

population, and a German invasion would be only a matter of time. On 1 March 1941 Nazi forces entered Sofia, Britain broke off diplomatic relations with Bulgaria, and Rendel had to hurriedly organize the evacuation of his staff. It was a narrow squeak. A special train was laid on for the tense journey to Istanbul. All seemed well as they reached the city, but as soon as they reached the Pera Palace hotel their relief was shattered by a massive explosion. Two members of Rendel's staff died, and many more were badly burnt and injured. As it turned out, in the mêlée of departure in Sofia, some Bulgarians had infiltrated two bomb-laden suitcases into the British luggage. George and the other embassy staff eventually made their way homewards by train through Turkey, Syria, Palestine and Egypt. Meanwhile,

press reports of the bomb incident had made Anne a celebrity of sorts. She stayed in Egypt for the remainder of the war, working in the cyphering department at military headquarters.[123]

On his return to England, George's diplomatic career continued its ascent. From 1941 to 1943 he was ambassador to the Yugoslav Government in exile in London. At the same time, he was assigned the task of working out a detailed scheme to reform the Foreign Service – a very suitable channel for his organizational zeal. As he puts it:

> I have always suffered from a kind of restless urge towards reform. It is an inconvenient impulse, and seldom a popular one. … I found there were more toes to tread on than I had suspected, and that my wife had been wise when she had counselled me – in vain – to refrain from such a prickly enterprise.[124]

Whatever toes he had proceeded to mangle, a knighthood followed in 1943. Next came four years in charge of the new United Nations Relief and Rehabilitation Administration, formed to bring some order to the chaotic economic and demographic aftermath of the Second World War, and he took part in the creation of the International Refugee Organization in 1947. This involved visits to the USA and Canada, during which Geraldine gave a series of lectures in New York, Washington and Philadelphia on women's war work.[125]

George then spent a year in Vienna as UK delegate to the Austrian Treaty Commission. He is still remembered with gratitude by the Austrians, who credit him with having saved Austria from absorption into the Eastern Bloc. Appointment followed as Ambassador to Belgium and UK delegate at the negotiations leading to the 1948 Treaty of Brussels. In 1948 Geraldine accompanied him on a tour of the Belgian Congo.[126] Following his official retirement in 1950, George became UK chairman of the German Debts Commission (1951–53), and chairman of the Singapore Constitutional Commission (1953–54).

Geraldine remained an active member of various Catholic organizations, and played the major part in running the Rendel household. The Rendels' grandson, Jonathan (b. 1946, son of David), remembers the huge and, to him, luxurious apartment at 48 Lowndes Square, Belgravia, which was by then the Rendel family home. By all accounts Geraldine was a sympathetic grandmother who ruled the family with a firm but loving hand. As a small boy growing up in the age of post-war austerity and who hated the cold, he recalls being amazed that the vast bathroom, as big as most people's living room, was centrally heated. Geraldine would wrap him up affectionately in big white towels to dry – and then tell him to sit up straight at table. He was enthralled when his grandfather donned his ambassadorial regalia of fancy uniform, medals, dress sword, and helmet adorned with peacock feathers, but grandmother would remain firmly unimpressed by such displays of pomp.

Geraldine remained active until her health began to fail in the late 1950s, and in her latter years she had to be cared for at home by a nurse. She died at the age of eighty-one, and was buried on 16 September 1965 at Putney Vale cemetery in south-west London.[127]

Left Sir George Rendel revisiting the palaces at al-Badi'ah outside Riyadh, where he and Geraldine had stayed in 1937. From left: the interpreter, Sir George, the chef de protocol, and their driver.

Below By road from Riyadh to Dhahran: Sir George in the centre of the picture, with Shaykh Hafiz Wahba to his right.

38 *Introduction*

George and Rosemary Rendel visit the Kingdom, January 1964

From 1959 to 1964, George was re-employed by the Foreign Office to chair negotiations over the Anglo-Egyptian Financial Agreement, intended to resolve economic and commercial disputes stemming from the Suez crisis of 1956. During this time he was also drawn back into Arabian affairs. Diplomatic relations between Britain and Saudi Arabia had been severed after Suez, and in 1959 he was engaged in unofficial negotiations to restore them.[128] These appear to have borne no fruit, perhaps because the Buraymi Dispute was continuing to poison relations.[129] But by 1962 things had changed. Saudi Arabia and Britain shared an interest in opposing President Nasser's support for the republican revolution in Yemen that had just erupted. The Kingdom needed friends, and specifically British military aid in building up the National Guard. Hafiz Wahba in particular had been urging a rapprochement.[130] In January 1963 agreement was finally reached, and George Rendel's friend, Sir Colin Crowe, was sent to Jiddah as British ambassador to the Kingdom.[131] As part of the effort to cement friendly relations, George was asked by the Foreign Office whether he would be willing to pay a good-will visit to Saudi Arabia in an unofficial capacity. Though by now in his mid-seventies, he accepted the assignment and, since Geraldine was far too frail to travel, decided to take his daughter Rosemary with him.

The trip was made during January 1964. It was unpublicized, and took place at a far from auspicious juncture at which to visit the Kingdom. Tensions were building rapidly as the five-year struggle for power between King Sa'ud and the Amir Faysal boiled to its climax.[132] It was widely accepted that Sa'ud's reign had been a pageant of extravagance and incompetence, and that the astute and frugal Faysal was a cool-headed leader able to restore economic stability, a measure of reform and sufficient firm governance to stifle discontent within the country.[133] As we have seen, George had enjoyed warm relations with both brothers in their youth and could draw on deep reserves of good will from either, but now that they were at enmity he must have felt distinctly uncomfortable in Riyadh. In January, however, Sa'ud was still King, even if only in name, and it must have been he whom they visited in Riyadh.

Sadly, so hush-hush was the visit that it has so far defied all attempts to discover any surviving official report of it, and so George's precise intentions remain unclear, as do any official instructions, if such existed. The surviving papers of Sir Colin Crowe make no mention of it, nor did either of the Rendels keep a diary of the journey.[134]

One might even begin to doubt whether the trip took place at all, were it not for three pieces of evidence. The first is a casual handwritten reference to it in the margin of a Foreign Office document, which places it in January 1964.[135] The second is a series of forty-one colour slides of the journey, and the third is the family memory of Rosemary describing it.[136] As she recalled, the trip was made "at the request of the Foreign Office to re-establish relations with Saudi Arabia, but on an unofficial basis to avoid ruffling any feathers".

The slides suggest that the journey began in Jiddah. From there they went to Riyadh, possibly by air, as there are no pictures of places en route. Hafiz Wahba was certainly with them from Riyadh onwards, though he may have joined them at Jiddah. The rest of the journey was made by road, during Ramadan, from Riyadh to

Dhahran via Hasa Oasis. Two large American cars contained the chauffeur, Hafiz Wahba, a chef de protocol, an interpreter, and the Rendels themselves. George is pictured visiting old haunts: the Badi'ah Palace outside Riyadh, and the spring pools of Hasa Oasis.

Rosemary's reminiscences highlighted her visit to the royal *harim* in Riyadh. As she told it, she was asked to visit after dark and was left at the gates of the *harim* garden in the pitch black. When the gate was opened, she had to walk towards a distant light on the building – painful for her, as she was wearing 'cocktail shoes' instead of the built-up ones she normally wore because of her polio-damaged leg. At the *harim* door she was met by an enormous man (a eunuch, she assumed) and was led into a large and noisy room full of women and children, apparently the King's wives and offspring. They were very talkative and friendly, examining her shoes and clothes, and commenting and asking questions in Arabic – some were able to translate for her. At the far end of the room was a large, raised platform with chairs arranged facing the room. A closed door led on to the platform and, when it opened, all fell silent. The King entered first, followed by half a dozen or so sons (all over fourteen), and they all sat in the chairs provided. To her embarrassment, Rosemary was led to an open space in front of the platform and given a chair to sit on. She was asked questions by the King about the trip across the desert. Then he made each of his sons in turn ask Rosemary a question in English – the younger ones spoke haltingly, she said, "But the older ones must have been to school in the UK and were more confident".

*　*　*

The 1964 visit seems to have been the last of George Rendel's diplomatic acts. He would have returned to London to find Geraldine in further decline, with only eighteen months to live. In 1957, he had been appointed chairman of the merchant bank Singer & Friedlander Ltd, a post he continued to fill until 1968. His pastimes were listed in *Who's Who* as travelling, sketching and music, and his club as the Travellers' in Pall Mall. He continued to live in the large apartment at 48 Lowndes Square until 1972, when he moved to a more modest flat at 24 Lennox Gardens, SW1.

George Rendel died on 6 May 1975, and was buried with Geraldine in Putney Vale. It is by lucky chance that the reappearance of Geraldine's manuscript, some eighty years after she wrote it, has enabled the notable contribution made by the couple to Anglo-Saudi relations, and to the record of a formative time in Saudi Arabia's history, to be memorialized posthumously in this publication.

Map

KUWAIT **IRAN**

Arabian Gulf

AL-'HASA

ad-Dammam
Dhahran
BAHRAIN
al-Manamah

Dahna Sands

Tuwayq Escarpment

'Armah Escarpment

al-'Uray'irah

Rumah
al-Rumhiyyah
al-Thumamah

al-'Uqayr

al-Hofuf

Doha

NAFUD AL-SIRR

Marat
al-'Uwaynid
al-'Uyaynah
al-Dir'iyyah Riyadh

QATAR

al-Duwadmi

• al-Hair

• al-Kharj

Haradh •

• al-Hillah

A R A B I A

Tuwayq Escarpment

Legend:
- ← The Rendels' route from Bahrain to Jiddah, 1937
- Sand desert
- Lava flow or volcanic debris

0 20 40 60 80 100 miles
0 40 80 120 160 kilometres

43

Arabian Journey
Three Weeks Crossing Saudi Arabia

Geraldine Rendel

Foreword

This book lays no claim to be anything more than the story of an Arabian holiday. It is simply an amplification of the diary which I kept from day to day. It was written at night by the light of one lantern sitting on the floor of our tent. Or, if by the end of the day I was too drugged by sleep to write it, then in the car, in spite of the jolting, when we first set out in the morning. Then I had the advantage of the presence of Sheikh Hafiz Wahba, the Saudi Arabian Minister in London, who accompanied us across Arabia, to answer questions, and translate and spell Arabic words and names. I am venturing to publish it because, in so far as it is the first record of a European woman's impressions of Riyadh and of this particular crossing of the Central Provinces of Arabia, it may have an interest of its own. For, as a woman, I was privileged to see and do things forbidden to the men who have explored the heart of Arabia.

1

From Basra to Kuwait

THE CIVILISATION OF SAUDI ARABIA in many ways approximates to that of the thirteenth century of the Christian era, and one must think to some extent in terms of that date to understand the Saudi Arabians of to-day. In an age when values tend more and more to be judged by purely material standards, they bear witness to such forgotten things as the sanctity of the spirit, the servitude of time, and that man cannot live by bread alone.

Within this mediaeval atmosphere Saudi Arabia is nevertheless a new state. It owes its comparatively recently won unity and political importance to the genius of one man: King Abdul Aziz bin Abdurrahman al Feisal Al Saud, better known to Europe as King Ibn Saud, the outstanding personality among the independent Rulers of Islam.

In 1901, Ibn Saud, a boy of twenty and an exile in Kuwait under the protection of Sheikh Mubarak, surprised Riyadh with a handful of followers and captured the city from its then rulers, the Rashids.[1] Thenceforward the fortunes of the Sauds have never looked back. Gradually Ibn Saud extended his conquests through all Nejd, Hasa, the Hedjaz and Asir, until his dominions extended from the borders of Iraq and Transjordan on the north to the Yemen and the Aden Protectorate on the south, and from the Persian Gulf to the Red Sea.

Although almost as large as India this area has no perennial rivers running from source to mouth, and one of the smallest rainfalls in the world. River beds known as *wadi*s, full only after rain, provide a subsoil abounding in moisture in which wells can be sunk, making irrigation possible; on these *wadi*s and in some places on springs the fertility of the oases depends.

The holy cities of Mecca and Medina, to which all Moslem eyes are turned, lie within the Kingdom of Ibn Saud. This and its position astride the sea and

air routes to the East give Saudi Arabia an importance out of all proportion to its population and economic development. For it is a country with few internal resources, with a population roughly estimated at three millions, and depending for much of its revenue on the pilgrims who come year by year to Mecca. Since my visit the oil prospector's drill has brought some increase of prosperity. An American Company is boring in Hasa, and Saudi Arabia may end by becoming a rich country.[2]

When King Ibn Saud invited my husband (hereafter in this book referred to as G.) and myself to visit his country, I could hardly believe in my good fortune. Permission to visit Nejd is rarely given to foreigners. When we went very few men and but two women, both of them British, had crossed Arabia, visiting Riyadh, from sea to sea. Mrs Philby was the first and I the second.[3]

We had planned to go in February, 1936, but force of circumstances obliged us to abandon our project. A plan postponed is often an opportunity missed and a lasting regret. Happily with us this did not prove to be the case. The invitation was renewed in the following year and accepted. Even then the pleasures of anticipation were dimmed by a haunting fear that something would arise at the last moment to thwart us. During the last few weeks before we were due to start, while I was endeavouring to learn a few words of Arabic through the good offices of a friend, I was haunted by the fear of my adventure being snatched from me at the eleventh hour. And it was not indeed until we crossed from Iraq into Arabian territory, beyond Zubair[4] on our way to

A sailing *bellam* near Basra, typical of the watercraft of the Shatt al-'Arab (20 February 1937).

48 *Arabian Journey*

Kuwait, that I felt sure of the Arabian holiday to which I had looked forward for so long.

We left Basra soon after nine a.m. on February 21st, 1937, to drive across the desert to Kuwait. It was a typical start: great uncertainty as to what car was coming, or indeed whether one was coming at all. But after much sending of messengers and discussion a Ford car arrived and we and our luggage were packed into it. There wasn't a great deal of room, so two of our suitcases were wrapped up in quilts and tied on to the running boards of the car with string in the approved desert manner. Later on in our trip, when we had passed one or two cars stuck fast up to the mudguards in desert quagmire, and indeed foundered more than once ourselves, I realised the risk we ran; but at the time as everyone else seemed to think it a usual arrangement, I lay low and hoped for the best.

Our chauffeur, who might have been a brigand of romance, wore a bright yellow *kafiyah* and had an uncontrollable passion for speed. He drove us out through the date gardens, by the side of green canals reminiscent of Lombardy or Venice, on to the salt mud flats and stony desert beyond, which form a natural boundary between Iraq and the Arabian Peninsula. On these mud flats we first experienced what a car can be made to do when it is not confined to roads; when its track is no longer circumscribed by sidewalks or hedgerows; when it can just take its own wilful way among a choice of deeply rutted tracks, or through low-growing scrub. It was reminiscent of trick-cycle

The Shaykh of Muhammarah's palace on the east bank of the Shatt al-'Arab (20 February 1937).

From Basra to Kuwait 49

riding at a circus and I waited breathlessly for the moment when the car would rise on its back wheels and attempt a reverse waltz.

Zubair, the Iraqi frontier post, was our first introduction to Arabia. We found the population celebrating the 'Id; the feast which ends the pilgrimage to Mecca.[5] A fair was being held, with sweetstalls and swingboats of their kind, and everybody was in their best clothes. This was my first experience of the heavy veiling of the Arabian women, which I was later to have to adopt myself; veiling so thick that one could barely distinguish where the veil ended and the heavy black cloth *'aba* worn over the head began.[6]

'Id al-Adha festivities at al-Zubayr, 21 February 1937. The swing boats can be seen on the left hand side of the top picture.

Gay splashes of colour showed in the children's clothes. The little girls had long *thaub*s to their feet and trailing behind them, in pink and violet and red, embroidered in gold and silver. The swingboats were much more adventurous than our variety. They were square boxes hung by ropes to rudimentary scaffolds, holding two adults or four children. They swung so high that they looked as if they were going to loop the loop and appeared very popular. There was great competition to get a seat in them. Added to all this a sheep market was being held in the large open square. Kids and lambs were caught by a leg and bargained over interminably; little flocks were shepherded from seller to buyer; donkeys threaded their way imperturbably through the maze. At a large tea house at one corner, rows of men squatted on long benches covered with matting and discussed prices.

We could only stay a brief half hour and had then to return to the car and continue our journey. Our lack of Arabic threatened at one moment to lead to complications at the Customs Post; G. having unluckily packed our necessary documents in an inaccessible part of his luggage. But the tactful production of a camera, and the taking of a photograph of the complete personnel of the Post, put relations on the pleasantest footing and all difficulties were smoothed out.

Beyond Zubair the desert became green, with low thorny scrub not unlike gorse. It also became treacherously waterlogged in places and on one stretch of apparently solid ground we overtook a car full of Arabs that had stuck fast in mud. We dared not approach to help them for fear of finding ourselves in a similar plight and finally were obliged to turn back on our tracks and make a considerable detour to avoid the swampy area.

About an hour and a half beyond Zubair we reached the Kuwaiti frontier post, Safwan.[7] Here a relief car in case of need was waiting for us, sent out from Kuwait by the British Political Agent.[8] An armed retainer of the Sheikh of Kuwait, who spoke some English, was with the car and told us he had been waiting two and a half hours for us. I could not help wondering, supposing we had broken down, how much longer he would have waited before setting out to look for us.

We now went on with two cars; the pace increased with competition. I was thankful to stop for a picnic lunch and rest my aching anatomy, for speed on desert tracks spells violent jolting.

After lunch we found several wild flowers; including a small yellow Star of Bethlehem, a miniature marigold and a yellow vetch, entirely new to me, with long serrated leaves. Later on, as we got nearer to Kuwait, the desert broke into fuller flower with slender blue iris, stretching for miles along the track.[9] We passed Beduin tents of black camel's hair,[10] and isolated Beduin guarding their flocks with guns slung over their shoulders.

Long before we reached Kuwait we saw its mud walls and towers coral-coloured in the afternoon sunlight against a strip of sapphire sea. It lies between

From Basra to Kuwait 51

The town walls and gates of Kuwait were thrown up hastily in 1920. This was the Rendels' first view of them as they arrived on 23 February 1937.

the desert and the Persian Gulf; a brave little town, hardly to be called an oasis, since it is almost completely waterless and treeless. But it has one of the best anchorages on the Persian Gulf, possessing an almost landlocked harbour of some twenty square miles which, though full of dangerous reefs, is the nearest silt-free harbour on the Arab side of the Shatt-el-Arab.[11] It is a centre of dhow building, both for the pearl fishing and for the sea-going trade, and Kuwaiti seamen have a great reputation on the Gulf. Yet most of its water has to be brought in tanks from Basra by sea.[12] Its wells are brackish and for its meagre harvest it depends on the rain, which only falls at the most three or four times a year. When it rains, the British Political Agent calls upon the Sheikh to congratulate him. But when it rains it pours; and this ungentle rain, when it drops too continuously, has been known to sweep away considerable portions of the mud-built walls and houses. We were told the story of a highly placed British official who was on his way through Kuwait when this happened and found himself constrained to contribute fifty pounds to the damage caused by his "green coming".[13] Strangers who bring rain are doubly welcome; but if the gift they bring outstays its welcome, then they are looked to for help to repair the damage caused.

The walls and gates that defend Kuwait on its landward sides are modern. In the days of the great Sheikh Mubarrak, the grandfather of the present Sheikh Ahmed, they did not exist.[14] A story is told of an American Mission which had settled on the outskirts of the then undefended town and was nervous for its safety.[15] Sheikh Mubarrak is reported to have told them that no further defence was necessary, as he "would be their wall". Whether he justified this boast or not, I never heard. The present walls and gates give the town much of its character; as

Kuwait was famous for its commercial bustle, as seen in the large open area known as Safat (above) and other markets in the town.

do also the carved wooden house doors with their grilles in the blind mud walls of the streets of the town.[16]

The Political Agent met us just outside the town and took us in through the principal gate. Very small beginnings of tamarisks were planted on either side of the road, their shrivelled stems so shrouded by rush matting from the covetous eyes of goats or camels as to be hardly visible. We continued along narrow winding streets, through a covered bazaar,[17] to the end of the quays where rows of dhows were lying up on the shore waiting for the pearling season, to the British Agency, which stands close to the seashore. It is an imposing, if ugly, building, with a garden in which a few unhappy-looking plants are coaxed into existence by the hopeful persistence of the Political Agent, and a tennis court.[18]

The new British Political Agency in Kuwait was designed by the Lutyens office in New Delhi and completed in 1935. Its first occupants were Harold and Violet Dickson, followed in 1936 by Gerald de Gaury.

Kuwait was also celebrating the 'Id and after we had been given some tea, we went down to watch the ceremonial dancing in the great market square. Every dhow was beflagged, the streets were thronged, and the whole town was on holiday.

Sheikh Ahmed, the benevolent despot who rules Kuwait, was watching the dancing from a raised dais.[19] When he saw us in the crowd he signalled to us to come and sit beside him. Sitting next to him I obtained an excellent view of his determined profile and humorous smile; also of his white spotted muslin *kafiyah* bound with gold head-ropes and of a fine solitaire diamond ring which he wore

on one hand. He is said to possess a pearl as large as the top of a soda water bottle, and to keep it wrapped in red velvet in his pocket, but we did not see it.

In this central position, I realised that I might take quite kindly to Arab clothes, when it became necessary to wear them later on. In all that vast circle of onlookers mine were the only legs exposed to view. All others were concealed by 'abas, except a few wearing trousers like those belonging to G. and the Political Agent. Furthermore the settee we sat on was high, and our feet did not reach the ground, which somehow seemed to make them more conspicuous.[20]

The dance we watched is, I believe, known as the Dance of the Naked Swords.[21] Two rows of men stood opposite to each other with drawn swords in their hands, swaying with a curtseying movement backwards and forwards. They sang a kind of battle cry, repeating the same words over and over again. Meanwhile a procession went round the circle in graceful rhythmic steps, breaking into more elaborate movements of the body from time to time. Some danced with guns in their hands, discharged from time to time into the ground or in the air; others beat drums. After a time a fire was lit in the centre of the dancers and the drummers crouched by it warming the skins of their drums to tighten them.

On our way back to the Agency we were taken to what is locally known as the Slaves Club, where the negroes celebrate the 'Id with dances of their own. Strangers are not often admitted to the Club; but our host, the Political Agent, obtained permission for us and we were even privileged to retain our shoes, the removal of which is usually exacted.

A small porch led through to a little open court, where the dancing was in progress. Those near the entrance made room for us and we stood with them and watched the proceedings. Music was provided by drums and a large lute-like instrument with six strings, hung with small triangular wooden objects and played upon by a closely cropped negro. A row of heavily veiled women crouched on one side of the court and moved their bodies in time to the music, while their menfolk did more active steps of the negroid type, with much body wobbling and rolling of the eyes. Both men and women chanted as they swayed; a curiously African interlude in a wholly Arab setting.

We returned to the Agency at dusk. That night it began to rain and the next morning was pitilessly wet. Had we come all the way from Chelsea to Kuwait for this, I reflected? But that evening when we dined with Sheikh Ahmed and found him radiant over the coming of the long-hoped-for rain, I realised that what to me spelt only grey skies and splashing through mud, the loss of a promised Arab feast with a neighbouring desert Sheikh, and no further opportunity to take photographs of the remaining celebrations of the 'Id, meant a year of prosperity to Kuwait.

Sheikh Ahmed gave us an entirely European meal, including French coffee,

From Basra to Kuwait 55

Like all other visitors, the Rendels were impressed by Kuwait's maritime heritage and nautical activity.

in a room reminiscent of furnished apartments at Brighton. A cuckoo clock struck every quarter of an hour while we dined, and all the china and silver which we were not actually using was exhibited in two glass-fronted cupboards against the walls of the dining room.

Sheikh Ahmed prides himself on being modern. He wears dress trousers under his black *thaub* and patent leather shoes. He rallied us on our antiquarian interest in the lifeless past and told us that to him interest centred only in the new and up-to-date. He was most anxious to possess a television set. He spoke with disparagement of the Beduin and said it was lucky for the camels that the Bedu had been created to care for them. But Sheikh Ahmed is a ruler of character and determination, proud of his little State, its pearling fleet, its magnificent sea-going dhows – beside which, according to him, the inferior argosies of Bahrein were the merest cockle shells manned by second-rate amateurs. To Kuwait – and to Kuwait alone – belonged the true glory of Middle Eastern seamanship.

What romantic craft these dhows are, with their broad bows and high balustraded poops, looking like Elizabethan galleys. The timber and fibre which compose them come from India; the dhows are built in Kuwait. The pearling fleet then consisted of some seven hundred dhows. The pearl fishing starts in June, when they set out with considerable ceremony. The oarsmen sing as they row and a choir master is always taken on board to train and direct the music.

One of the main markets in Kuwait was devoted solely to maritime supplies and equipment.

There is much competition to secure an able choir master, as it is an inducement to good crews to sign on if they are sure of a good leader for their singing. There are a dozen oarsmen as a rule and eight divers. The divers take it in turns to go down and to hold the rope which, with a heavy stone attached to it, takes them to the bottom of the sea. They wear no diver's suit or helmet, remaining only a few seconds under the water. The chief peril is the shark, which infests these waters and takes an annual toll.

The return of the pearl-fishing fleet in September is celebrated by a species of regatta, which the Sheikh of Kuwait attends. He goes out in his launch to meet the home-coming dhows and at the end of the ceremony fires a gun, upon which they race for port. There are festivities in the town after their safe arrival and much activity among the pearl merchants, who drive hard bargains with the fishers for their wares. A dhow is considered to have done well if it brings back forty pearls from a season's fishing. Many get far less. The pearls vary much in value according to size, shape and colour. They are white, golden, or steel colour, and the owners keep them wrapped in scraps of scarlet velvet, or other material, which is supposed to preserve their colour and lustre. But the advent of the cultured pearl from Japan – though its import into the Gulf is forbidden – and the consequent slump in the price of true pearls has ruined the pearl trade and the Gulf pearl merchants have fallen on evil days.

At the low tide a ship cannot approach nearer than a mile and a half from the shores of Kuwait. Even a small boat has to stand outside the inner harbour. Passengers and cargo for the steamers which ply up and down the Gulf have to be borne aloft in carrying chairs, on the shoulders of Kuwaiti seamen who walk out to the boats often up to their waists in the sea.

It was in this exalted fashion that we and our luggage left Kuwait on the following day, to join the ship which was to take us down the Persian Gulf to Bahrein.[22]

On leaving Kuwait, Geraldine had her first experience of the old-fashioned Gulf method of embarkation.

2

Bahrein

WHEN I WENT UP on deck at dawn next morning and saw the Islands of Bahrein rising from a pearly sea in roseate haze ahead of us, my heart missed a beat.[23] For these islands were to be the starting point of our journey across Arabia. What would the next ten days reveal? What strange vicissitudes, what changed horizons, what transformed scales of values might they not have in store? What intimate understanding of a once great and now all too little-known people and country should I have learned in three weeks from that hour?

The Sheikhdom of Bahrein, under British protection since 1820, is a richer and more sophisticated principality than Kuwait. It is ruled under a benevolent personal despotism by Sheikh Hamad, with the help of a British Financial Adviser in internal administrative affairs, and the guidance in political matters of a British Political Agent representing His Majesty's Government.[24]

Manama, the capital, lies at the northern end of the larger island. Less than a mile to the north is the separate island of Muharrak,[25] crescent-shaped and ending on the south-east in a string of almost Venetian-looking fishing villages rising straight out of the sea and built on the coral reefs of these shallow waters. Between the islands large areas are enclosed by fish-traps of plaited reeds. These supply local needs, and a certain amount of fish is exported to Saudi Arabia for camel fodder, as we discovered later when we reached Uqair.

An attempt was made some years ago to join Manama to Muharrak by a causeway across the reefs. But it was found that the interference with local shipping was too great and there is still an unbridged gap of a hundred yards or so across which one has to ferry.

I was taken in a launch across these waters on the morning after our arrival. There was a freshening breeze and many dhows scudded past us through a lively sea looking, with their great curved sails, like lovely sea birds skimming the waves. Large vessels still have to harbour in the outer anchorage, some way from the land; but now that Bahrein has become a station both for the British Navy and the Air Force, sloops and flying boats can lie close in shore. For Bahrein now has many amenities and its growing European and American community offers a warm welcome to the sailors and airmen who land there.

We called at a tiny islet in the outer anchorage to see one of the sights of Bahrein: Arabs diving to fill waterskins with sweet water from submarine freshwater springs bubbling up from the bottom of the sea. This excellent water, which used to be the sole supply of the islands, is still largely used by Bahreinis in preference to the slightly sulphurous spring water obtainable on the islands. Being sceptical by nature, I asked to be allowed to taste the water which was brought up by the divers and found that it was quite sweet.

The pearl trade of Bahrein centres in Manama, and the Bahreinis hold that their pearl banks are richer and produce finer pearls than those of Kuwait, whatever Sheikh Ahmed of Kuwait may think about it. But Providence has been kind to Sheikh Hamad. Just as the pearl trade was falling on evil days, oil was discovered in considerable quantities on the principal Island. Now he is assured of a steady and growing revenue for his little State from oil, which, when we were there, was gushing out from numerous wells at the rate of many hundreds of tons a week, and the lure of oil is casting a spell on all the neighbouring parts of Arabia. We were taken to the oil fields during our visit. The Standard Oil Company of California holds the concession and their very capable manager showed us round. We were much impressed by the model village which they have created for their employees. Air-conditioned bungalows imported in sections from California with electric lighting, heating and refrigeration, modern bathrooms with constant hot water, and verandahs with mosquito-proof netting, put the primitive accommodation provided by the Government of India for the British Political Agent in the Island to shame. Not to speak of a library, a dance hall with a good stage in it, and an excellent general store, with cold chambers for the preservation of meat, and gardens laid out between the houses. Tennis and squash courts were in process of construction.

That afternoon we were taken to call on Sheikh Hamad at his country house, which lies about ten miles outside Manama towards the western shore of the Island. We drove southwards through rich and extensive date groves, with occasional glimpses of clear sulphurous water, showing blue between the palm trunks. An excellent dust-free road – oil surfacing being one of the compensations of proximity to an oil field – has been built from Manama to the southern part of the Island. From time to time a notice saying in English and Arabic that the

Bapco Buses stop here (to convey the employees of the Bahrein Petroleum Company to and from their work) lends an incongruous note. But the scurry of a mongoose across the road, or the slow creaking of a donkey-worked well, bring back the atmosphere of the East. South of the palm groves there is a region of barren salty plain covered with innumerable tumuli. Their ancient tombs have never, I believe, been officially excavated, but they have been well described and their origin discussed in Sir Arnold Wilson's book on the Persian Gulf.[26]

Not far from where the oil field was subsequently discovered and in a little hollow on the west side of the Island, lies the Sheikh's country palace. It is a large, white structure of no pretensions, in good taste, standing in a courtyard enclosed in high railings. A mosque is attached to it, with a typical Bahrein minaret like an eighteenth-century candle, with graceful tracery and a light gallery near the top.

Sheikh Hamad was standing at his gate to receive us, with his sons and a bodyguard of the smart uniformed Bahrein police in their red winged turbans and khaki shorts. He is a grand old man, considerably older than Sheikh Ahmed of Kuwait, and with great dignity and a fine presence. In his white and gold *thaub* and brown *'aba* with a hand resting on his golden-sheathed sword he made an impressive figure. He took us across the court and up a flight of steps that led directly into a long carpeted *diwan* running the full length of the front of the house. He held us each in turn by the hand as we stepped over his threshold and led us in, which is the Arab custom in welcoming a guest.

The Sheikh seated himself on the carpet against the wall on the further side of the room, where three cushions were spread, and invited us to sit down on either side of him. His sons sat facing us against the opposite wall. They were fine-looking men; one in particular, whose matrimonial complications, I was told, were a great source of anxiety to his father. They took no part in the conversation. Tactful and well-phrased questions were put by Sheikh Hamad to each one of us in turn; the men coming first. When my turn came, it was of course the inevitable enquiries about the number and ages of my children, of the male sex being understood. Often during this journey was I tempted to wander from the path of truth and boast of more sons than I possess, for the sake of bringing variety into the conversation. Only the presence of my husband on one occasion prevented me from inventing twins.

Coffee was brought and highly sweetened tea. Rosewater was sprinkled over us and the incense burner was held before each of us in order that we might wave its fragrant fumes towards head and breast with our hands. Sitting cross-legged in a European skirt is difficult to manage. You either show too much, or suffer agonies of cramp. Choosing the more modest course, I became so stiff that when the moment of departure arrived I could hardly rise from the floor.

On leaving, the Sheikh escorted us to his gate and stood watching our departure with his sons around him. I felt that our black Chevrolet was quite

unworthy of so romantic a setting. We should have been going forth in a richly caparisoned caravan on camels decked with gay trappings, or fine Arab steeds, and I in a palanquin with silken curtains closely drawn. Thus we should have been in harmony with the picture, instead of striking a discordant note.

On my last afternoon I visited the Sheikha, chief wife of Sheikh Hamad, in her house just outside the town. When we arrived she was standing at the head of the staircase which leads up from the court to the verandah of the first floor; and, as we mounted the steps, I heard her voice reciting Arab greetings some moments before we reached her. She was a charming personality. Her expression was keen and kindly and her brown eyes beamed intelligence and humour. She wore an orange chiffon *thaub* with a short puce damask jacket, and over all a black gold-embroidered *'aba* very similar in shape to the men's *'aba*, but worn over the crown of the head. A string of large gold beads gleamed at her neck and wide gold bangles clasped each wrist over the sleeves of the *thaub*; while a gold wrist watch lent an oddly incongruous touch of modernity to her appearance.[27]

She led us by the hand into her room, which opened off the verandah, with many windows on both sides, some looking to the sea. Here sweetmeats and biscuits were spread out on a little table and we sat beside her on the settee with small towels spread over our knees and tasted the delicacies provided, while her waiting women waved away the numerous flies that buzzed round us.

Conversation never flagged. My English companion[28] spoke excellent Arabic, and translated for me as we went along. She had known the Sheikha for many years and they had much to talk about, and I was privileged to hear a good deal about the local life of Bahrein. Tea was brought in large European cups and, after we had eaten and drunk, the rose water sprinkler. Finally, on the point of departure, the incense burner, after which we took our leave.

The Sheikha accompanied us to the head of the staircase and there said goodbye. As we crossed the court on our way out, we looked back and saw her standing leaning over the balustrade of the verandah, calling down Arabic blessings upon us until we were out of sight.

3

From Bahrein to Hasa

A KEEN YACHTSMAN of my acquaintance told me that the part of our journey he envied us most was the crossing of a small stretch of unsurveyed water between Bahrein Island and the Arabian mainland.

I remembered this saying on the quay at Bahrein when I had my first sight of the craft which had been provided to take us to Uqair, the port on the coast of Hasa whence our desert crossing was to begin.[29] She was a smallish dhow of perhaps forty tons into which an engine had been introduced, thus giving her the right to call herself a launch. Her high poop, carpeted with Persian rugs, was surrounded by a slender wooden balustrade and had a wide awning over all. Cushions were spread across the stern, where the awning was rolled up giving an agreeable outlook to the sea. For our special comfort a settee upholstered in that dreary material known as rep,[30] three cane-seated chairs of the kind hired out by the less expensive caterers, and a round table had been thoughtfully provided. Three wooden steps led down from the poop on to the deck, and more steps again into a good-sized cabin under the poop, which would have provided sleeping accommodation on its benches for three or four people.

On the deck amidships was a small hut about the size of a telephone box, with a binnacle, and a three-legged stool in front of a wheel, from which navigation was carried on. A big single sail was furled on a spar by the slanting mast. Below in the galley a fire gleamed out of the darkness and a rich smell of hot fat floated upwards from the roasting sheep which was to provide our midday meal.

The dhow put me in mind of pirate ships seen on the stage in *Treasure Island* or *Peter Pan*, and like plays of adventure on the high seas. She breathed romance

Geraldine stands between Col. Percy Gordon Loch (left) and Charles Belgrave on the quayside at Manamah, before embarking for al-ʿUqayr (6 March 1937).

from stem to stern; but she did not suggest any special seaworthiness for a seven-hours voyage through reefs and shoals in partly uncharted waters.

The Captain, a handsome seaman from Hasa in a mustard-coloured *kafiyah*, and his crew of three, came ashore to be presented to us. They all shook hands, with the dignity and air of quiet confidence and poise which appear to be the birthright of the Arab.

I stepped off the quay into the boat feeling that adventure had begun. I was walking right out of my life into another of which I had no real conception, and the present alone had reality. I had passed through a magic door and it had shut behind me setting my fancy free. My everyday world grew dim; it was like slipping into another dimension and finding surprisingly that one fitted in. That, as nearly as I can find words to describe it, is what happened to me.

The Captain took his place on the three-legged stool in front of the binnacle, the engine started chugging. We waved to our friends on the quayside. The distance between us and them rapidly widened. We were away.

G. and I disposed ourselves on the cushions at the back of the poop and watched Bahrein Island slipping away from us in a golden mist. The breeze

freshened, and the men sang a pleasant little song as they hoisted the sail. The boat swung and swayed, the tables and chairs slid about and collided with each other and ultimately had to be lashed with a rope and stacked together on one side of the poop. The settee alone stood firm as a rock, resisting the turbulence of the waves with its Victorian solidity. The mist melted in the sunshine and we made good speed.

Coffee was brought to us immediately after we started, prepared with cardamom in the Arabian manner. This bitter-flavoured drug takes getting used to; but we ended up quite liking it and it is pleasantly stimulating. A bowl of oranges and bananas followed almost at once and, a little later, tea. Finally, at midday, a meal of hot mutton in the centre of a dish of rice. Although we neither of us suffer from the sea, we did not feel much inclined for a rich stew, and I am afraid a good deal of it went overboard. I hope the porpoises who were sporting around the dhow appreciated it as a change of diet.

As we drew nearer to the Arabian coast the sea grew calmer and marvellously blue. The water was so clear that one could see the silver sand between the rocks on the bottom. We passed between tiny islets, with sometimes so little room to spare that I held my breath until the narrow straits were safely navigated. But our Captain never faltered; never indeed left his post at the wheel until we reached Ras Sayia about three o'clock in the afternoon and turned northwards up the bay to Uqair.[31] His instruments may have been out-of-date and his knowledge of modern naval scientific methods less than nothing; but I give him full marks as a navigator in his own difficult waters.

From here onwards we began to take soundings for the depth of the channel along the bay. I shall not easily forget the picturesque figure of our Arab leadsman, standing on a small platform at the side of the dhow swinging out his lead and calling the soundings every few yards in a melancholy, cadenced voice. As we went along the coast we got our first glimpse of the great sands, a northern spur of the dunes of southern Arabia, which we were to cross an hour or two later on our way to Hasa.

Uqair, the principal port of the Hasa Province, is a mere speck of civilisation, lying between the sea and the sands of the desert, which sweep right up to its walls. It has a Custom House, a fort dating from Turkish times, a few mud-built houses and a quay, at which, when we arrived, six dhows were unloading a cargo of ill-smelling fish.[32] This we were told was destined for camels' food; though the aroma was so powerful that I should have thought even the strong stomach of a camel might have rebelled against it.

Waiting for us on the quay we found Sheikh Hafiz Wahba and the Amir of Uqair, with several other local officials. They took us to an upper room in the Custom House and tea was brought.[33]

King Ibn Saud decrees that Europeans who travel in central Arabia must

From Bahrein to Hasa 65

A fair wind for al-'Uqayr: Geraldine sails for the Saudi coast on board
the dhow provided by the al-Qusaybis.

wear the dress of the country. So while we were sipping our tea, two bundles tied up in gaily printed cotton material were brought in. Sheikh Hafiz opened them. One contained the necessary garments for G. and the other female attire for me. G. wore from now on a brown camel-hair *'aba*, embroidered in gold thread, a *kafiyah*, or head kerchief, and the *'igal*, or head-rope, which holds the *kafiyah* in

66 *Arabian Journey*

Shaykh Hafiz Wahba leads the welcoming party as the Rendels land at al-ʿUqayr.

its place. I arranged myself in the black gold-embroidered *ʿaba*, worn over the crown of the head, which, with a scarf bound low on the forehead to conceal the hair and an opaque black veil, forms the street or travelling dress of a Saudi Arabian lady. I will say it was not comfortable clothing for one unaccustomed to it. The weight of the *ʿaba* on the head was considerable and I felt rather as I used to when, as a child, I dressed up in somebody else's clothes that were too big and heavy for me. But later I was grateful for my *ʿaba* and veil on many occasions. My presence naturally excited a good deal of curiosity, for, so far as I know, no European women, with the exception of the woman doctor attached to the King's harem and, on one or two occasions, a trained nurse, had entered Nejd at this date, besides Mrs Philby and myself.[34]

We left Uqair with three Ford cars and a Ford brake for our luggage. Few except the Beduin travel by camel nowadays. The Arab has experienced the lure of speed and cars are the universally adopted method of travel among the better-to-do classes.

It was a thrilling experience, that first race over desert, with the steep rises and falls of the dunes, and the cars swerving here and there to avoid a boulder or dodge some scrub, with our speedometer registering between fifty and sixty miles an hour. There is no particular track, but cars can cross the sand without

From Bahrein to Hasa

great difficulty if a high speed is maintained and the steeper edges of the dunes are avoided. Pressure in the tyres is reduced to give a better grip, and whenever we reached a strip of firmer ground we stopped to cool the engines, which heated rapidly on the heavy sand.

The infinite variety and subtlety of colour in great stretches of sand have a special fascination. These sands ranged in hue from a rich honey colour to a silvery mauve, which deepened to purple in the shadows and to black as the sun got lower. The wind had swept the sand in some places into great curved ridges like miniature cliffs, and in others had ribbed its surface like the sands of the seashore. The vegetation in sand also has the appeal of something exotic and out of the normal. The fleshy stems and grey-greens of such flowers as the horned poppy, or the sea holly with its exquisite blending of blue and mauve and green, suggest a life more potent and mysterious than that of ordinary wayside plants; one associates them in one's mind with stories of plants in South American forests which prey on human life. There was a certain amount of coarse grass in patches and groups of stunted palm trees twisted by the wind, crouching under the lee of the dunes. Some twenty miles out we crossed our first salt plain, the Sabkhat of Shatar, with the salt lying like a white frost on the ground, and no vegetation.[35]

Between Uqair and Hasa there is fifty miles of sand. As we approached the inland limit, belts of palm began to appear in the distance and we reached the two outlying villages of the oasis, Jisha and Jafar.[36] Like all villages and indeed all buildings of any importance in Saudi Arabia, Jisha and Jafar are walled and fortified. This dates from the days when

En route between al-'Uqayr and Hasa Oasis: Geraldine's first encounter with the Saudi Arabian desert.

Camels rest outside the walls of al-Hofuf.

raiding tribes were a constant menace; and it is only since the rule of the present King that this form of internecine warfare has ceased.

The Hasa oasis which we now entered is one of the largest in Saudi Arabia.[37] It is one of the biggest fruit-producing areas, and its vast date gardens are irrigated by the sulphur springs for which Hasa is famous.

The town of Hofuf, which lies in the centre of the oasis, is surrounded by bastioned mud-built walls with massive round towers at intervals of a few hundred yards, and an inner walled Kut or citadel dominating it. Darkness had fallen when we passed through the outer wall by a narrow and unimpressive gate. After perhaps a quarter of a mile we came to the formidable gateway of the Kut, which was opened for us by the Arab guard. A few hundred yards up a narrow street, lighted only by the lanterns carried by pedestrians, brought us to our destination, the Palace and Guest House of the Amir of Hasa. Here we lodged during our stay in the town.

The palace is of two storeys, built round an arcaded court open to the sky in the traditional Moslem style. The arches are semi-circular, supported by short round columns, and the arcade only surrounds three sides of the court. Our suite, which opened off the first-floor gallery, was that used by King Ibn Saud on his rare visits to Hasa. The rooms were long and narrow and high, with a great number of windows, unglazed, and light shutters of perforated wood. The shutters had to be kept closed in order that one should not be overlooked from neighbouring houses; and such light as there was came from lunettes of coloured glass, yellow and blue and red, above the shutters. Above the lunettes ran a frieze of plaster grilles in fine geometric designs, based on elaborate variants of interlocking

From Bahrein to Hasa

circles, no two alike. There was also very effective incised plaster work on the walls of the gallery and the rooms. This form of decoration, both inside and outside the houses, is peculiar to Hasa and we saw and admired much of it in the town.[38]

Our *diwan* had cushioned settees all round it, so high from the floor that it was more comfortable to sit on them in the manner for which they were intended – cross-legged, or, as I noticed the less flexible among my Arab acquaintance did, with one's legs drawn up sideways underneath one.

Our bedroom had six windows in one wall, and corresponding niches with a single shelf in them on the other walls. It was entirely unfurnished, except for a large and fine carpet and quantities of cushions in blue- and red-striped material disposed along the walls, some upright and others lying on the floor. Our two camp beds had been put up in the centre of the room, with a small table between them. On the table stood a long-spouted ewer and a basin of very small circumference, with a wide flat rim to it, both in elaborately chased white metal. Two cane-seated chairs completed the equipment, which was to be our camp furniture throughout our journey.

The town of al-Hofuf was imposingly fortified with thick walls and circular bastions.
Above Inside the southern wall.
Below Outside the eastern wall of the town.

70 *Arabian Journey*

The three Berberine servants who were to accompany us across Arabia were brought in and introduced to us shortly after our arrival.[39] Muktar, Abdurraman, and Muhammad were fine-looking fellows from Upper Egypt, and made an impressive trio in their snowy turbans and wide green sashes. Muktar was the butler and had been employed in the Sporting Club at Cairo. His immaculate service, based on the best club traditions, was sometimes extremely incongruous in the great spaces of the desert. This narrative, as it unfolds the story of each day, will show what Muktar, always smiling, always willing, never punctual, but always anticipating and ministering to our needs, came to mean in our daily lives. Abdurraman was the cook, and a good one. His meals, though one never quite knew when they were coming, when they did materialise were plentiful and excellent. When he was with us we fared like princes. When he got lost, which happened more than once, we fared ill. His personal outlook on the trip was jaundiced by the advice of a friend in Egypt, who had told him that it was excessively hot in Nejd and the Hedjaz.

The Rendels' three Egyptian servants pose for the camera in the courtyard of the Guest Palace in the Kut quarter of al-Hofuf: from left, Muhammad, Abd al-Rahman and Mukhtar.

From Bahrein to Hasa

In this simple faith he had selected his wardrobe, leaving his overcoat behind. He endured the bitterness of an irretrievable mistake, walking about perpetually wrapped in a mustard-coloured blanket and suffering considerably on the colder nights in the desert.

Muhammad I can only describe as a male tweeny, who did everything that nobody else felt inclined to.[40] He and Muktar spoke a few words of English. I had still fewer words of Arabic. Nevertheless, with this limited linguistic equipment, we managed to understand one another and be on excellent terms.

After the evening meal G. was taken to call on our host, the Amir of Hasa, by Sheikh Hafiz. An armed servant with a sword and a lantern called for them and led them through a heavy door studded with brass nails from our own gallery on to a kind of rampart with a low parapet. This led past two courts and through another door straight into the upper end of the Amir's *diwan*: a large room some twenty-five feet across and perhaps sixty in length, divided into four sections by three pointed arches with incised plaster decoration. One end of the room was furnished with long settees and in one corner the Amir sat cross-legged. At the other end two rows of retainers in black and brown *'aba*s sat on the floor with their swords across their knees.

The present Amir of Hasa, Saud, is the son of the famous Ibn Jiluwi, one of King Ibn Saud's most trusted lieutenants, who ruled all Hasa until his death in 1934, and whose energy and ruthlessness were known and feared throughout north-eastern Arabia.[41] It was Ibn Jiluwi who instituted the historic blockade of Kuwait, which put an end for so many years to the smuggling for which Kuwait has always been notorious; and also unfortunately to all legitimate trade – to the great profit of Uqair, Hasa and Bahrein. He is also reputed to have played a leading part in 1929 in helping to crush the ill-fated revolt of the Mutair tribe, who rebelled against King Ibn Saud's efforts to interfere with their ancestral pastime of raiding southern Iraq up to the Euphrates.[42]

Saud, the ruling Amir, is in the early thirties and has the physical disability of an extreme inward squint, which makes it very difficult to know whether one has his attention or not and complicates conversation. He made a speech of welcome to G. and Sheikh Hafiz; but had an air of embarrassed distraction and said little more during their visit.[43] The only flicker of animation he showed was when G. asked him about gazelle hunting and hawking. Then he spoke of his horses and invited us to visit his stables before leaving Hasa.

We slept well on our camp beds that night in our spacious room. So ended our first day in Saudi Arabia.

4

Hasa Oasis

I WOKE EARLY next morning to find that G's camp-bed had just collapsed under him. His complaint was drowned by that of a camel, who was expressing his 'malaise' immediately under our windows. The grumbling of a camel is not unlike the guttural rage of an angry old gentleman at a Club, whose toast has not been done to his liking. The camel does not get red in the face, or on the top of his head; but the sounds of acute exasperation are much the same.

To this accompaniment we rose and dressed. We breakfasted alone. Sheikh Hafiz never shared this meal with us. A little milk, preferably from the camel, fulfilled his needs till midday. After breakfast we went up on to the roof of the Palace, from which there is a wonderful view of the whole oasis. With the help of Muhammad and a chair and in spite of the folds of my *'aba* I mounted on to the high narrow parapet, and looked out over a city of flat-roofed houses and little open courts, set in the heart of an oasis. A mosque with domes and a single minaret lay below me.[44] Beside it rose the massive walls and round tapering towers of the citadel. A brilliant sun beat down upon it and the light and shade were dazzling in their contrast. In the distance, the gardens of the oasis formed a green girdle round the town, and beyond them, north, south, east and west, stretched the desert.

So absorbed was I by the panorama spread out before me, that a murmur like the buzzing of innumerable bees on a hot summer's day did not at first penetrate to my senses. It was only as it took on a shriller note, as if the crickets were joining in the chorus, that I became aware of it, and looking down saw that all the little open courts to one side of the Palace were filled with the veiled forms of women and children. Chattering and gesticulating, they looked and pointed

Above The view north-westwards over the roofs of the Kut quarter of al-Hofuf from the Guest Palace.

Opposite top The adjacent view north-eastwards, overlapping with the image above, giving a panorama of al-Hofuf.

Below Looking over the roof of the Guest Palace towards the historic Mosque of Ibrahim Pasha, built by the Ottomans in the 16th century.

Left A view of the courtyard of the Guest Palace.

Below A view of the rooftops of al-Hofuf looking southwards

Hasa Oasis 75

upwards towards me, and I realised to my confusion that word had gone round that the foreign lady at the Amir's Guest House was to be seen on the roof of the Palace. I need hardly say that I dropped down from my conspicuous position as rapidly as my still very unfamiliar garments, and the absence of Muhammad or a chair, permitted.

On our return to our rooms we found Sheikh Hafiz in our reception room with the brothers Abdurraman and Saad Qusaibi, two well-known merchants of Hasa and Bahrein and owners of large fruit gardens and pearl-fishing dhows.[45] They were discussing a programme for our morning, which was to include a visit to the town and bazaars, and afterwards to the hot springs, for which Hasa is famous.

There was some discussion before we started out about my clothes, one of the brothers being of the opinion that I was not sufficiently covered up by them. A longer and heavier *'aba* was produced, which completely concealed my ankles and feet. Wrists and ankles should not be shown. But it was so cumbrous that I felt I could not face walking any distance in it; and as opinion was not unanimously in favour of it, I begged off and stuck to the one I already had. My veil then came in for criticism and was condemned as too transparent. I doubled it meekly, but even that did not give satisfaction. The woman's veil must be a complete blackout and there is no nonsense about it. Finally a beautiful veil of heavy black net embroidered with silver stars was produced and I put it on. I was relieved to find that, while it proved an extremely effective screen from outside, when adjusted so that my eyes came in between the stars I could see through it quite well.

The finishing touches were then given to G.'s clothes. The right folds for the *kafiyah* and the correct angle for the head-rope make the whole difference to the general effect. I must say G. took kindly to them and looked very convincing, though he never quite learned to keep his *'aba* under control; and on windy days and nights it was apt to catch on thorn bushes and get involved with lighted lanterns and other obstructions. But at a distance, back view, I found him quite hard to recognise.

Thus equipped we sallied forth. I confess to having felt not a little nervous over that first walk in the streets as an Arab woman. But I soon grew accustomed to my clothes and learnt how to deal with them. One of the minor difficulties was that I could only see straight in front of me and felt like a horse in blinkers.

The main bazaar of Hasa is a wide street, with an arcade along one side of it and the walls of the citadel on the other. The arcade is built of round arches, with lunettes above each and has an edging of shark's-tooth design.[46] After every third arch is a higher one, leading either to an inner bazaar, or to a *khan*. All the Eastern bazaars I had visited hitherto had been watered down by Western influence. A great deal of what one saw was only there because Westerners came expecting

to find it. In the bazaar of Hasa this atmosphere was entirely absent. There was not a European in the place besides ourselves. The people were carrying on their daily lives entirely unaware of foreigners. There was nothing for sale except the commodities they needed for themselves: dates, rice, spices, fruit, meat, vegetables and the like. Camels strolled down the centre of the roadway. The large white asses of Hasa, known all over Arabia and Egypt, with their legs and bellies painted with henna, scurried along through the crowds pursued by small boy drivers calling "Balak!" ("Thy attention!") as they ran after them.[47]

We drifted into the crowd and I soon lost all self-consciousness in the picturesque strangeness of my surroundings. Little open booths, with their merchandise spread out on the ground, had knots of buyers in front of them driving bargains with grave-faced sellers. One had golden citrus as large as small melons, with rough knobbly skins, piled up in front of it.[48] Another had endless baskets and trays filled with spices of different colours, saffron and tamarind and camomile and many others. There was endless variety of type amongst the crowds, from the fervent-faced Puritanical Nejdi, to the merry smile and twinkling eyes of the simple Arab good looker.

Many women were shopping and others selling in the women's bazaar. They pressed close to me in the crowd and I could just distinguish light and movement in their eyes behind their veils. I noticed that many of them were wearing *'aba*s of a thinnish black gauze, more suitable to the climate than mine. I asked Sheikh Hafiz afterwards whether I could not have one, but was given to understand that no female of distinction could be seen wearing anything so flimsy. A great many of the men also were wearing summer *'aba*s in cream, black or brown gauze, edged and tasselled in gold. Hasa is famous for its *'aba*s embroidered in gold or silver thread; all the most beautiful *'aba*s are made there. Mine, I believe, was a fine example of Hasa work. I was also given a Hasa *deraya* of flowered silk.[49] It had a design of leaves and flowers in soft shades of mauve and pink and green on a white ground, with the most exquisite embroidery in gold thread of a close shell pattern, more beautiful than any other that I saw in Arabia.

Geraldine Rendel poses in the full Arab dress that she was required to wear in public during her trans-Arabian journey

Hasa Oasis 77

Above and below The main marketplace of al-Hofuf was the Suq al-Khamis, or Thursday market, located outside the eastern wall and towers of the Kut Quarter

Above Part of the Suq al-Khamis was the covered market known as the Qaysariyyah.
Below Women leave the wood-selling section of the Suq al-Khamis.

Hasa Oasis 79

Above A view along one of the street markets in al-Hofuf.
Opposite Hafiz Wahba (left) and 'Abd al-Rahman al-Qusaybi outside the main door of the Qusaybi House, al-Hofuf. Built in the early 1920s next to the Qaysariyyah market, its elaborate plaster decoration was typical of Gulf architecture.

At the far end of the bazaar beneath one of the towers of the Citadel we found Beduin with their camels loaded, preparing to set out into the desert. There were several women amongst them sitting on the camels surrounded by sacks of rice. The Bedu women are less heavily veiled than their town sisters. They wear a black mask, leaving the eyes free, which is more practical for the exacting life of the desert; and when strangers approach they draw their *'abas* across their faces to veil completely.

We entered a street where nothing but wooden pack saddles for camels and donkeys were being sold. Here I was considerably taken aback by a camel sitting at the side of the road being fitted for his saddle. Blinkered as I was, I did not see him till he made a deafening remark in my ear and I found his jowl within a few inches of my head.

Our walk ended at the fine mansion shared by the two Qusaibi brothers and their families. Entering under a high, arched porch leading to a heavy wooden door, we passed through the outer vestibule into a large and lofty *diwan*, which

80 *Arabian Journey*

Children, naturally inquisitive the world over, arrive after school and crowd around the doorway of the al-Qusaybi House during the Rendels' visit.

had a gallery running round the top of it. I noticed one or two small boys taking a peep at us from this gallery, but they withdrew as soon as they saw they were observed. Manners are good in Arabia. Perhaps it is more exact to say that there is great respect and consideration for the feelings of others, which, I suppose, is really the same thing.

Immediately below the gallery was a plaster frieze with occasional medallions in low relief – a further attractive example of Hasa work. The room, like all rooms for formal occasions, was unfurnished except for carpet and cushions; but two settees were brought in for our special comfort, and I was grateful for them. Though ultimately I got reasonably good at sitting cross-legged on the ground, in the early days I found it a considerable strain on the knees. Rising from that position also needs training and has a technique of its own. The simple way, of course, is to do what a baby does in the same circumstances – fall forward on to all fours and hoist oneself up on one's hands. I need hardly say that this is not a course to adopt. The right method is to get straight on to your feet in one uplifting movement without using your hands. This is no mean feat and I felt quite proud when I had acquired it. It is also bad manners to show the soles of

'Abd al-Rahman al-Qusaybi poses for the camera with one of his children by 'Ayn al-Khudud, one of the great natural artesian spring pools of Hasa Oasis.

your shoes. When sitting, the folds of the *'aba* should be draped to conceal them. This adds another complication for the novice, as unless she remembers to make sure that her feet are free of her *'aba* before rising, she may easily find herself standing on the edge of it and completely stymied.

Tea was served to us and, while we drank it, Abdurraman Al Qusaibi's youngest son was brought in, an attractive little boy of five and a half years,

Hasa Oasis 83

obviously adored by his father. He told us that he had recently shot a goat with his own gun, in emulation of his father's shooting of gazelle. Boys in this country start their shooting, as well as their riding, at a very tender age.

Abdurraman asked me whether I would like to visit some of the ladies. On my accepting the invitation, he took me to another house across the street. Here he left me sitting in the court while he went upstairs to announce my visit. His little son, who had accompanied us, remained with me and we were joined by a small black-eyed girl of about the same age in a long red *thaub*. She stood with her hands clasped behind her back and stared at me with that gravely simple and wondering look of children that somehow makes one feel humble; but could not be persuaded to talk. She may, of course, have entirely failed to understand my attempt in Arabic to ask her name and age, but I prefer to think that she was too shy to speak.

After a few minutes, Abdurraman returned, a little embarrassed I felt, and said in his halting English: "The ladies in this house are not ready for you. But we will return to the other house and my wife will be very glad to receive you."

I suspected that it was a surprise visit and they were not prepared to receive a foreign stranger at such short notice. I certainly should have been very annoyed if my husband had brought a strange foreign woman to my house before eleven in the morning and expected me to show her hospitality.

We returned to the principal house, where they proved to be more enterprising. Through a door at the back of the vestibule I was taken up a winding stone stairway, leading to a roof terrace with a charming little arcaded gallery round it. Several small girls were playing there and negresses standing about. As we passed the children, my host murmured: "Very large family."

Crossing another court on to a smaller roof terrace, we passed through a bead curtain, and entered a charming little room decorated in white and blue. There were cushioned settees on the floor all round the room except at the further end. A piece of furniture of white wood, which can be most nearly described by the word chiffonier, had many little shelves and brackets on which stood coffee pots and other small ornaments and utensils of brass; the whole covered by what looked like a fine butter muslin, no doubt a precaution against the flies in summer.

I was left alone in this room for a few minutes and then two ladies came in through the bead curtain, followed by Abdurraman. They removed their slippers on the threshold and entered barefoot. He presented them to me as his wife and his sister-in-law, the wife of Saad Qusaibi. His wife unveiled at once; but his sister-in-law had to remain veiled in his presence, as she afterwards explained to me. Both ladies were slim, about 5 feet 3 inches in height, and extremely good-looking, with large dark eyes and clear olive skins. Each had a gold ring with a large single pearl set in it fastened through one nostril. This form of ornament is

called *khusam* in Arabia, and can be detached and taken off like an earring. Their clothes were lovely: long, straight pink silk *thaub*s, high to the neck and fitting tightly to the wrist covered by transparent black chiffon *deraya*s, embroidered in gold and sequins, which trailed on the floor behind them. The wide sleeves of the *deraya* were wound over the head and used to veil the face. They looked like figures out of some fine Persian miniature come to life.

As soon as Abdurraman left us, they removed my *'aba* and veil and were much astonished at the tailor-made costume which I was wearing underneath, and which cut a poor figure in the company of their fairy-tale garments. For some minutes we struggled with an attempt at conversation, interspersed with much laughter on both sides at our efforts to understand each other. An older woman came in, whose position in the household I could not determine, and asked me many questions; only a few of which I was able to understand and answer. They took me into one of the children's bedrooms, which had a little white European bed in it with net curtains and blue ribbons, of which they were obviously very proud. They also took me into their dining room which had a large European dinner table in the centre.

Abdurraman fetched me after about twenty minutes and we said goodbye. As we came down the stairs, from every chink and corner I was conscious of peeping forms, excited whispers and giggles from persons unseen. On reaching the vestibule we were met by a crowd of small boys coming in from the street.

"The children coming home from school," Abdurraman explained. At first I thought they were all his and his brother's sons; I learned later that the two brothers were responsible for a school, at which their own and a number of other Hasa boys were educated.

Soon after eleven o'clock we left the Qusaibis' house in a car to visit the Springs. Abdurraman and his little son and Sheikh Hafiz accompanied us. Some three miles east of the city, by winding lanes through the date gardens, we came to a pool of crystal-clear green water flowing over silver sand. From a deep-mouthed hole in the centre a spring bubbled up and the water was carried by irrigation channels far through the gardens and rice fields. This is Khodud.[50] We got out of the car and stood looking down at the slim trunks and graceful fronds of the palms mirrored in the transparent depths, and watched a kingfisher flash across the pool like a brilliant meteor and vanish. Set like a jewel in the midst of the date gardens, Khodud remains in my memory as the loveliest of many lovely places which we saw in the oasis of Hasa.

On the south side of the city is Ain Naim, a warm sulphur spring used for indoor bathing.[51] It lies outside the date gardens and is approached across a gravel plain. The spring, which is enclosed in a bath-house surrounded by a high wall, rises from a deep rocky basin, into which the bathers descend by steps cut in the side of the rock. Ain Al Harra is another spring, which forms a good-sized lake

Above 'Ayn al-Khudud, one of the four principal springs of Hasa Oasis, with a water-lifting device. Hafiz Wahba, Geraldine Rendel and 'Abd al-Rahman al-Qusaybi can just be seen leaning over the wall on the far side.

Below The men's section of the warm sulphur bathing pool, 'Ayn al-Harrah, Hasa Oasis.

86 *Arabian Journey*

of warm sulphurous water.[52] I learned to my surprise that it is used for outdoor bathing for both sexes; the women's bath being walled off at one end. Abdurraman Qusaibi suggested that I should go and visit the women's portion, while he took the male members of the party to see the men's bath. Not unwillingly, I slipped through the curtain gate which protected the opening to the women's pool and flattened myself as inconspicuously as I could against the inside of the wall. It was a pleasant place, with a tiny islet at one end of the pool and reeds and rushes growing at the edge. A small bath-house was built further along the wall against which I was standing and several women were sitting outside it drying their hair after bathing. Others stood in the water up to their shoulders, some with young children in their arms. No-one appeared to be able to swim. All were clothed in long black garments completely concealing their limbs.

For a few minutes I remained unnoticed. Then one of the women caught sight of me and drew nearer to where I stood. Closer inspection confirmed her suspicion that there was something queer about me and she ran back to tell her friends. In a few seconds I was surrounded. Those who were already dressed hurried over to look at me; others hastily completed their toilets and came along also. At least a dozen ladies pressed round me talking volubly, while I backed away towards our car. I was only saved from an embarrassing situation by the return of the menfolk from the men's bathing pool. At their approach the black draped forms fluttered away like birds disturbed by gunfire.

The last and in some ways most interesting spring we saw that morning was Umm Saba ('Mother of Seven'). Abdurraman had said it was on our way home; but neither he nor our driver were sure of the way. We made a big detour to the north of the city, lost ourselves and had to cut across country. We explored a ploughed field, went over some small sand dunes, and eventually got out of the car to facilitate its leaping over several ditches before we finally arrived. Lying on the edge of the date gardens, more open and sunlit and larger than Khodud, Umm Saba is an enchanting spot. The spring, rising from a hole some ten feet across into the middle of a harp-shaped pool, feeds seven streams, which flow out of the central pool at different levels. This distribution of the water is a considerable feat of engineering.

By now it was long past what seemed to us to be a reasonable hour for lunch, when one had breakfasted at seven-thirty. But in Saudi Arabia one eats when it is convenient and not at any fixed hour. There always is a midday meal, but it may be taken at any time between noon and four o'clock, according to your engagements. To fast for eight hours at a stretch without apparent discomfort or loss of poise is quite normal. On this occasion we lunched excellently in the Amir's Guest House about half past two.

Later in the afternoon, Abdurraman Qusaibi fetched us again in his car to take us to see his own gardens in the oasis. Along little winding lanes beside the

Above 'Ayn Umm Saba ('Mother of Seven'), one of the four largest spring pools, had seven channels running off it to irrigate the palm gardens.

Below Geraldine (by the car) makes her escape from the women's section of the bathing pool at 'Ayn al-Harrah.

88 *Arabian Journey*

Hafiz Wahba, Geraldine Rendel and 'Abd al-Rahman al-Qusaybi in the latter's garden.

irrigation channels fed by the spring, we passed through the extensive gardens owned by the Amir of Hasa to a very lovely garden belonging to Abdurraman. A small pavilion with an open loggia stood in the centre and all around was a mass of peach and citrus blossom, divinely scented, under towering palms. Abdurraman gathered me sprays of the citrus bloom, which is like lemon blossom, only twice the size, and gave us each a citrus as large as an ostrich's egg. A small boy was sent up one of the palms to show us how simply they could be climbed. He ran up easily, pressing his bare feet against the trunk and holding on to the fibrous bark with his hands. The fertilisation of the palms is done in this manner, the pollen being scattered over the fronds by hand in the spring. The dates, for which these palm groves are famous, are harvested in August. The palm wood is used for roofing and ceilings, and for cooking utensils; the fibre for making mats and ropes and baskets.

This garden was not our final destination. Abdurraman possessed another about two miles further on, reached by winding paths so narrow in places that more than once a wheel of the car went over the edge and had to be lifted back on to the track to avoid a greater disaster. They led to a little summer pavilion, with a swimming pool in front, which had a high dive from a mud platform to one side of it. Abdurraman apologised for the water being somewhat cloudy, saying that

Hasa Oasis 89

The garden pavilion belonging to 'Abd al-Rahman al-Qusaybi.

his family had been bathing there that morning. He took us through the pavilion on to a terrace bounded along its outer edge by a graceful stone balustrade. Below the terrace the garden stretched away in a forest of giant palms, with green patches of lucerne and tangled sprays of peach and pomegranate.

With some pride he showed us an indoor bath, down a flight of winding steps which opened off the terrace. It was sunk into the earthen floor and reminiscent of a Roman bath on a small scale. We walked in the gardens and I was allowed to unveil. By the time we returned to the terrace, a little table had been spread beside a cushioned bench against the balustrade. On it halva, loukoum and other sweetmeats, different kinds of biscuits and fruits preserved in syrup, were set in small dishes. Tiny green limes the size of walnuts and bunches of oleander and lemon blossom were laid on each plate.

We gathered round the table, tea was brought to us in small glasses, and we sat on sipping, and tasting and talking, to the strange accompaniment of jackals howling round us in the oasis, till sundown. As the sun set, Saad Qusaibi came from the pavilion on the terrace and gave the Call to Prayer. Sheikh Hafiz and Abdurraman rose from the table and asked to be excused. The household assembled on the terrace in two rows, a carpet was spread, and Sheikh Hafiz knelt upon it and led the Evening Prayer.

5

From Hasa to 'Uraira

OUR DEPARTURE from Al Hasa on the following day was in the nature of a spectacle.

We were woken at 6 a.m. by the chatter of the crowd which had assembled outside the Amir's palace to see our stuff being loaded on to the lorries; and while we dressed and packed our suitcases, the whole of our installation was removed bit by bit. As we relinquished a towel, or finished with a coffee cup, it was whisked away to be packed by Muktar, until our rooms were bare of everything but the carpets and cushions which belonged to them.

Our full convoy consisted of four cars (a Chevrolet and three Fords), a Ford shooting brake, hereafter known as 'El Box', and four lorries, spoken of individually as 'El Loury'. One lorry held the tents for our camp. A second carried the really remarkable collection of furniture which the charming thoughtfulness of our hosts had provided for our comfort: tables, chairs, carpets, lamps, canteen of cutlery, and quantities of crockery and glass. Never before can a desert crossing have been so luxuriously equipped. The third lorry was the kitchen. A huge black cauldron swung at the back of it, and bulging water skins were slung out at the sides in juxtaposition to cooking utensils of various kinds. Inside were large bundles of bedding, a primus stove and our stores. These included several dozen bottles of Evian Water, many tins of biscuits and usually a couple of sheep, one alive, tethered inside the lorry, the other in portions festooned over the wheels. A wicker coop of live chickens rode on the summit; and as this lorry was constantly sinking in the sand and not always with us at meal times, the majority of these luckless fowl ended by doing the whole journey from the Persian Gulf to the Red Sea on the top of the lorry, and eventually turned up at Taif thirty-six hours late

looking much the worse for their experiences. This lorry was driven by a large and cheerful negro known as Juju, and carried three or four other negroes as passengers.

The fourth lorry held the repairing outfit; but as it was nearly always waiting with whichever car was in trouble, and there was always one, if not more, in difficulties owing to the bad going, we rarely saw it after we had started. If a car broke down we abandoned it at once for one of the others, leaving it on the desert to wait for the arrival of the repairing lorry.

The Ford brake, 'El Box', took our suitcases, our three servants, and light refreshments to fall back upon when the kitchen lorry foundered. As times grew more difficult and breakdowns more frequent we came to depend on 'El Box' more and more. How many times we raked the desert with our field glasses in the hope of seeing 'El Box'; how spirits rose when, like Elijah on Mount Carmel, we saw a small cloud of dust the size of a man's hand in the distance, and knew that food and the faithful Muktar were not far away.

Our complete company numbered some twenty-five souls. Among us we had Abu Salam Ghali, the manager of the hotel at Mecca, who organised our commissariat most ably;[53] though how he managed to absent himself from Mecca so soon after the Pilgrimage I never discovered. Musfer, our guide, was a good-looking and exceedingly merry fellow, whose laughter was always to be heard during the day, or about the camp in the evening. Fakhri Sheikh-El-Ardh, a Syrian secretary in the Ministry of Foreign Affairs, who joined us in Hasa, was a cheerful and helpful member of the party. He was much in request as an interpreter speaking excellent French, learnt during a course in Agricultural Engineering at Montpelier University, U.S.A.[54]

Sheikh Hafiz Wahba, the Arabian Minister in London, our host and on all occasions guide, philosopher and friend, was the perfect travelling companion.

Before leaving Hasa, G. went to say goodbye to the Amir, and we afterwards paid a short visit to his stables. We found some two hundred horses, kept in open yards, tethered to their mangers. Mares with foals were in a separate yard. The horses of Hasa rival the purest breeds of Nejd, and though neither of us are qualified to judge horseflesh, there were clearly some very fine animals amongst them. The Amir has given up racing, we were told, and is allowing his stud to go downhill; the advent of the motor car in Arabia has definitely damaged the status of the horse.

At 9.30 a.m. we finally set off with our whole convoy for Riyadh, a distance of 350 miles.[55] From now on we kept Arab time; that is to say we counted the twelve hours of daylight (6 a.m. till 6 p.m. as they were in March) as one to twelve. In these pages, however, I shall describe our days by European time, which will be simpler both for my readers and for me.

The caravan route from Hasa to Riyadh runs westward. The route for cars,

Above and below The Rendels visited the Amir Sa'ud bin Jiluwi's stables on the morning of their departure from al-Hofuf. The stable manager is shown in the picture above. The fort is Qasr al-'Abid, on the northern wall of the Kut Quarter.

From Hasa to 'Uraira

The fort known as Qasr Sahud stood just outside al-Mubarraz, to the north of al-Hofuf.

which is only a track as roads do not exist, takes a more north-westerly direction, in order to avoid some specially difficult places. Even so the going is extremely bad at times, and the track constantly completely loses itself. Cars select any route that seems promising on the plain. In the occasional broken hilly areas tracks have to be kept, and deep wheel ruts will continue for many miles; too deep sometimes, making it difficult for a car with a low clearance to avoid striking its undercarriage. In sand areas there is usually no track, and the drivers choose their own way, with more or less unpleasant consequences according to the quality of the sand. When it is loose and soft, sticking can only be avoided by very skilful driving, and not always then.

In the desert one travels from well to well. Our first halt that day was to be at the wells of 'Uraira,[56] some eighty miles from Hasa. I should perhaps mention here that many of the places which are named on maps of Arabia would not appear at all on the maps of more populated countries. Some of the more important wells marked on the route charts consist of nothing but a stone-lined hole in the ground, often with no distinguishing mark and only to be found by those familiar with the country. Some of the places marked on our maps we never found at all. Frequently there is no sign of human habitation, except for a few scattered Beduin tents, for several hundred miles.

The Central Arabian desert, unlike the deserts of North Africa, is by no means all sand. Large tracts of it are green, with much scrub of different kinds, and in spring grass and flowers. When we crossed, the camelthorn (*arfaj*) was in bloom and this dry, withered-looking shrub, the dainty dish of camels, was covered with round button-like saffron-coloured flowers.[57] There were also quantities of a little hawkweed spread over the plain, in great golden strips, forming an exquisite contrast to the pearly grey of the camelthorn.[58]

Early motor transport in Saudi Arabia frequently proved the superiority of the camel.

After about an hour's going over barren plain with sandstone hills eroded into fantastic shapes to the north of the track, we had our first puncture, and a twenty-minutes delay while it was mended. This was a good excuse for refreshment, and Muktar served orange drinks on a brass tray while we waited. Not long after, another car lost some vital bolt, which the chauffeur insisted held the body to the chassis, and it had to be left behind to await the repairing lorry which was following us.

We had now reached an open sandy area called N'ala, a long stretch of soft sand, which was difficult for the cars.[59] One of the lorries stuck almost immediately. A few minutes later our car foundered likewise. An animated scene followed. Everyone got out and ropes were attached to the rear buffer of the car, to which a dozen or more of our convoy harnessed themselves and pulled and pulled until they succeeded in getting it on to firmer sand where it could be restarted. Another party was extricating the lorry and there was some competition as to which should salvage their car first. To my great surprise 'El Loury' won; for it appeared to be in up to the top of its wheels and to be hanging on one side half way up a steepish sand dune. Nevertheless, they succeeded getting it to the top of the dune before we were free and it plunged recklessly down the other side, amid encouraging cries, and went on. After our car had been delivered from the sand, its clutch was discovered to be burnt out, and we went on in a relief car sent out after us from Hasa by the Amir as a final gesture of hospitality. Knowing his desert, he doubtless felt pretty confident that we should need it sooner or later.

We were warned that there was worse sand to come before we reached 'Uraira, and so it proved. The Umm As Sigyan, a very soft sandy valley, fully justified this prophecy.[60] Our car actually crossed it without sticking, which was a great tribute to the skill of the driver; but all the lorries foundered one after

From Hasa to 'Uraira

Geraldine and Shaykh Hafiz enjoy a picnic on the road to 'Uraira (al-'Uray'irah).

another, and we were delayed nearly two hours before they reappeared. It was happily within the time limit for a midday meal, and small chickens cooked flat, as if the cook had sat on them accidentally, which had been thoughtfully placed in our car by Abdurraman Qusaibi, provided a succulent meal. Our cutlery being still somewhere in the sand, we ate them with our fingers, but they were none the less good for that, though I found pulling them apart difficult. I would never have believed that a chicken had such a two-way stretch.

After we had eaten, we wandered off and collected wild flowers. We found a pure white scabious, the size of the blue meadow variety in England; a glaucous plant, not unlike woodspurge, with brilliant red leaves and flowers, which only grew in the shelter of scrub; a small brown hyacinth, like a tiny bluebell; and a tall lily in bud. Unluckily I never succeeded in finding this lily in flower and could not place it; but it was not unlike our wild garlic in shape. One of the most decorative flowers was a mauve nettle, which grew in clumps in large quantities. There were also many aromatic daisies. "The desert shall rejoice and blossom as the rose."[61] We indeed saw it. At long last the missing lorries turned up, and after another hour's running we crossed the Sabkhat al 'Uraira and saw the hills of the Jabal Juda range to the south of our track.[62] These *sabkhah*s give one an acute impression of desolation and waste. Their only merit lies in that being entirely flat and hard and without vegetation or obstruction of any kind, they can usually be crossed safely at high speed. Another half mile brought us to the wells of 'Uraira after eighty miles of exceedingly bad going, accomplished in three hours and three quarters of actual running.

Above By 1937 there was little left of the once-populous Ikhwan settlement of 'Uraira (al-'Uray'irah).

Below The Rendels' party drawing water from a well at al-'Uray'irah.

'Uraira was at one time an Ikhwan settlement belonging to Ibn Jimma of the Ajman tribe, but it is now abandoned.[63] There are seven houses, only one of which is in fair condition, and is said to have belonged to Ibn Jimma himself. Several fine tamarisk trees provide shade and there are three wells of sweet water. Strange rock formations rise up from the desert distance, one of which looked like a model of a lion couchant and as such was a most unsuitable neighbour for an Ikhwan village, all portrayal of the animal form being forbidden to the Wahhabi. The Ikhwan, or Brotherhood, are the Wahhabi fighting force inaugurated by King Ibn Said in 1912. They have settlements throughout Nejd and constitute the main body of the Saudi Arabian Army.[64]

Wahhabism is the state religion of Saudi Arabia and represents the teaching of Islam in its purest form. Its founder, Muhammad Ibn Abdul Wahhab of 'Awaina in Nejd, preached Islamic puritanism throughout Nejd two hundred years ago.[65] With the

From Hasa to 'Uraira 97

help of Muhammad Ibn Saud, the Amir of Daraya and an ancestor of King Ibn Saud, whom he converted to his views, Abdul Wahhab succeeded in imposing Wahhabism on the whole of Nejd. He preached the return to the exact teaching of the Koran stripped of all later accretions, or attempts to adapt it to the changing conditions of a modern world. The discipline includes a long list of forbidden things, such as alcohol, and tobacco, music, dancing, or gambling; the portrayal of human or animal forms; the wearing of silk or gold ornaments, or the use of precious metals. Even coffee is forbidden; but this prohibition is no longer enforced. We found coffee everywhere. Likewise silken garments, gold bracelets, anklets and *khusam* (nose-rings) were worn by the women of the richer families; but it may be that in this, as in so many other ways in Arabia, women do not count.

Domes and minarets, elaborate tombs or shrines of saints, are no longer tolerated in Nejd, though we found a few domes and minarets in Hasa and in the Hedjaz. Worldly honours are denied even to the Prophet, so greatly do they fear lest idolatry or fraud should creep into their practice of religion. Cemeteries have small and roughly hewn headstones, without inscriptions, to mark the place of burial, and usually look like some very stony piece of ground that someone has recently attempted to plough. We saw no pictures, or statues, or monuments while we were in Arabia. I do not even remember seeing any designs of animal or bird life in any of the many beautiful carpets we came across in the course of our journey.

We only paused at 'Uraira for such time as was needed for our men to fill their waterskins at the wells. This they did to the accompaniment of one of the strange little chants, which seem to be necessary and appropriate to all occasions of strain in unison, such as drawing water, hoisting a sail, loading a camel's pack, or pulling a car out of the sand. They are sung on a monotonous note, with perfect rhythm, the same words being repeated over and over again.

We had now only another thirty miles between us and the site which had been chosen for our first camp in the desert. Crossing a wide plain, with camels grazing scattered about, we came on to sand and rock. On one of the more sand-submerged rocks the petrol tank of our car struck a leak. While we were waiting for it to be patched, Muktar spread a little carpet on the desert and brought us tea in Japanese biscuit-coloured glazed cups with "Think of me" written round them in forget-me-not blue. These cups served us for all occasions until we got to Jidda.

On once again and in another half hour the sunset, and Sheikh Hafiz stopped the cars and got out to say the Evening Prayer. The whole party, with the exception of G. and myself, knelt on the desert. Taking a little sand in the palms of their hands and dusting it over the face as a symbolical ablution, they prayed aloud and prostrated themselves. When travelling, the noonday and evening prayer may be said together, and so it was with us; the prayer at dawn we usually only heard between dreams.

We pushed on through a wonderful clear violet twilight, with the last glories of the sunset trailing across the western sky. It was dark long before we reached the spot where we had planned to camp, and the rest of the party had not arrived. We could only suppose that in the darkness they had followed some other track, but for the time being they were lost. It was an intensely dark night without stars; darkness that seemed opaque and hemmed one in. I had the curious illusion of driving through a narrow gorge or thick wood; I felt that if I put my hand out by the side of our car I should touch something; and when the moon rose and lit the vast shimmering expanse of desert all round us I experienced a definite sense of relief. I had this same impression on other occasions when driving at night.

The barometer had been falling and now a strong south-easterly wind sprang up and drove the sand over us. Although owing to the blowing sand visibility was poorer than it normally is at night, the lorries were obviously some miles off the track, or in that country we should have seen their lights. I can imagine few things more apparently hopeless than looking for anything in the desert after dark. The prospects for our first night in camp were not bright.

Sheikh Hafiz, however, in all circumstances unperturbed, was confident that if we pressed on for another five or six miles we should reach a point where all tracks meet. "There," he said, "*inshallah*, all will eventually arrive. If we pass the night there, we shall all link up again before dawn."

His advice was taken and we went on. So long as one has water and fuel to build a fire, one place in the desert is as good to camp in as another, and at any rate by going on we were shortening the distance between us and Riyadh.

We reached the cross-roads, if they can be so called, about half past nine. Scrub was collected and a fire got going; and the men made themselves tea in a petrol can. We were tentless and bedless and foodless. Our car had only a canvas hood and was rapidly filling with sand and we were getting pretty cold, when lights were seen in the distance and presently 'El Box' drove up. A welcome sight indeed. The seats were taken out of it and we got inside and rolled ourselves up in our rugs and slept.

Two hours later, one of the lost lorries came lumbering into the circle of the dying firelight. It proved to be the one carrying the tents, and Muktar and Muhammad were in it. Immediately all was hubbub, and although they had been pulling lorries out of the sand for hours, in an incredibly short space of time they had erected a palatial tent, its walls draped with red and yellow material and its floor covered with Persian carpets, worthy of the Field of the Cloth of Gold. Into this we were transferred. The kitchen lorry, alas, was still to seek; but a camp bed and shelter from the bitter wind and driving sand was immeasurable relief. We turned in, hungry but cheerful; and incredibly, in spite of the roaring of the wind and the rocking of the tent, slept sound.

From Hasa to 'Uraira

Above and below The Rendels stopped at this encampment of the Al Murrah tribe to ask for camel's milk, which was willingly provided according to the laws of Beduin hospitality.

6

To Rumaya

THE WIND DROPPED at dawn and it was cloudy and cold; but by the time we had eaten and broken camp the sun was shining. We were on our way again by eight o'clock.

A few miles out we passed near a Beduin camp, and at Sheikh Hafiz's suggestion we stopped and walked over to it and asked for milk.[66] Arab hospitality is proverbial. The Bedu, in spite of his poverty and the bitter need of desert life, will break into his last loaf sooner than refuse hospitality to a stranger. Camel's milk in generous measure was brought in a pail and our party dipped bowls in it and drank their fill. A camel was milked for G. and me into one of our own bowls and we drank the milk of the camel for the first time. It had a froth like sea foam on the top and I found it quite delicious. I was also given *laban*, a hard, curded milk that looked rather like English cattle cake and tasted like strong cheese.

The Beduin camp near the wells from June till October, when the first rain usually falls. After the rains they drive their herds and flocks out in search of new grazing and often wander many hundred miles from their permanent camps to go where good grazing is to be had. News travels unexpectedly fast in the desert. A rumour reaches them that the grazing is good north, or south, or east, or west, and they drive their camels in that direction. When the seasonal wells dry up and the *wadi*s have no more water in them they return perforce to their own wells. But they will wander for two or three days' journey even from them in search of food for their beasts, and it is not uncommon to find tents with only the aged and the children left in them.

The Beduin are one of the hardiest races in the world. With the flat desert loaf and a cupful of water, the Bedu will walk under a burning sun for thirty or forty miles in a day without ill effects. It has to be remembered, of course, that

the endurance exacted by desert life does not allow of the survival of weaklings, and the absence of doctors and medical knowledge means that serious illness is usually fatal. They are not long-lived. On the other hand, they grow to maturity at an early age. A boy of thirteen is considered grown up. One of King Ibn Saud's sons, the Amir Muhammad, was in command of an attacking army when he entered Medina in 1925, at the age of fifteen.[67] They wear clothes of the same weight all the year round and are equally hardened to the great heat of summer, and the cruel north winds, *shamal*, which blow in the desert in winter. Their only source of livelihood is their camels and sheep, which provide them with milk, meat and clothes. The young camel is excellent eating and is usually sacrificed for occasions of feasting. Camel hair and sheep's wool clothe them, and are sold to provide other necessaries of life. Camels are also given as dowry for a daughter who marries.

I visited the women's tent in this camp and found a young mother sitting with a girl child on her lap, who looked about twelve months old according to our standards, but was probably more. She had a silver amulet suspended from a chain round her neck, which showed through her ragged shift, and her eyes looked weak. Another woman was stirring a pot of some whitish broth over the fire with a bunch of dry camelthorn sticks. They told me it was truffles cooking in milk. Truffles are fairly plentiful in eastern Arabia and are a favourite food with the Beduin.[68] Both women were wearing the black mask with the eyes showing which replaces the veil for the desert-dweller. The tents were of black camelhair, with patches of coloured carpet inserted here and there, and entirely devoid of comfort.

After we had parted from them, we went on across the Summan, hard barren table land broken by low distant hills, for many miles, until we dropped down a steep stony escarpment, on to the Dahana Sands.[69] Though marked as a sandy area on most of the route maps, these sands are one of the great grazing grounds of the Beduin. When we crossed them they were covered with camelthorn, *arfaj*, and *nussi*, a kind of coarse succulent grass, and much beflowered;[70] and large herds of camel were grazing on them with many calves. The sand seems to occur in veins, or strips, with stretches of firm ground between; and with a good guide it is possible to avoid the soft sand and cross in cars without much difficulty in three hours or so. Somewhere on these sands is the boundary between Hasa and Nejd; but no-one could tell us exactly where.

We halted at Arwaq al Nadhim for the midday meal.[71] The carpet was spread beside the car and Muktar brought the basin and ewer and piece of soap for the ceremonial washing which was the daily ritual before and after meals. Water was poured over our hands and a small bath towel presented. After the washing at the end of a meal, Sheikh Hafiz would produce a tiny phial of perfume, which he spread over our hands with a little glass rod.

Some of the people at the Amir Sa'ud's camp at Rumaya (Rumhiyyah).

An hour after leaving Al Nadhim we passed Talhat 'Imr, where stands a large solitary *salam* tree like a sentinel on the desert.[72] The only tree for fifty miles, this is a landmark in the Dahana, and its meagre shade must have afforded relief to many weary herdsman in the great heat of summer. The *salam* is a small fine-leaved acacia and there are several varieties. We found some with long spiny thorns, growing to the proportions of a small tree; others which were only bushes, with long pods like runner beans; and some in flower, with round yellow flowers like the mimosa.

In another hour we reached Ramah.[73] Here, on the top of a small rise, there are six important wells, from the largest of which a camel draws water continuously. Here a messenger from the Crown Prince of Saudi Arabia, the Amir Saud, met us with an invitation to visit his hunting camp at Rumaya,[74] a few miles further on. The Amir himself had gone on to Riyadh to be ready to welcome us there, but thought we might be interested to see the camp. We pressed on with all haste, for we were expecting to be in Riyadh that night and had still another three hours or so to go, and a pause at Rumaya would lengthen our journey. On arrival at the camp, however, we learned that the invitation was to spend the night and that all arrangements had been made to accommodate us.

The whole camp turned out to receive us. The personal retainers and men-at-arms stood at attention with their rifles and swords. In front of them were four young men with the Amir's hunting hawks upon their wrists, and their perches slung across their chests. The Head of the Camp came forward to meet us and led us in.

The Amir Saud's own pavilion was placed at our disposal. It was a large double pavilion, with an inner sleeping tent. The inner tent had a double wall and between the inner and outer wall was a passage about three feet wide,

To Rumaya 103

surrounding the sleeping tent. Thus Guards could safeguard the Crown Prince while he slept. There were four entrances to the inner tent. They were closed with padded flaps and light cane blinds, either of which could be rolled up, or used separately, so that more or less privacy could be secured as occasion required. Against the wall which had no door was spread a couch of carpets and silken cushions. The outer tent was very large and had nothing in it but a small brazier. Both tents were hung with a gold printed fabric and fine Persian carpets lay on the ground.

I confess that my spirits sank a little to find that in this romantic tent, which took one straight back to the Golden Age of Arabian history, I must keep all the flaps down in order not to be seen. From now on I experienced what it is really like to be a veiled woman. Crossing the desert, though my 'aba and veil were always over the back of my seat in the car, I had only worn them when we approached Beduin, or passed an occasional caravan. Our chauffeurs were from Bahrain and used to seeing European women, and it was not necessary to be veiled for them. In the camp at Rumaya, discipline became far more rigid. Only G., Sheikh Hafiz and our three Berber servants could see me unveiled. There was one other: a negro boy, the special slave attached to the Amir Saud's harem, who had been brought up from childhood with the Amir himself. He had been left behind to wait on me, and was allowed to come in and out of the tent freely because, as someone said: "He doesn't count. He's like a piece of furniture."

Presently, however, I was taken out, closely veiled, to see the hunting hawks. These lovely keen-eyed birds sat solemnly blinking on the keepers' wrists, each answering to its name, and allowed me to stroke their heads when their leather hoods were slipped back. Their plumage was of a speckled brown, and they were used for hunting bustard I was told.

G. and Sheikh Hafiz were invited to dine that night by the Head of the Camp. What follows is the account G. gave me of the proceedings. The meal was served on the floor of a long narrow tent. Four stools, some eighteen inches high, carried round trays about four feet in diameter. On these were piled large portions of roasted sheep; with the heads, three or four to a tray, stacked in the centre, and a deep fringe of rice all round. Under the trays were bowls of soup and sheep's milk yoghourt, placed alternately. The guests sat in circles round the trays. At G.'s place, at the top table, a fork and spoon and glass were provided, though these utensils were not much use to him in the event. G. was led up to his place by the Head of the Camp, and the usual washing ceremonies were carried out. He sat down as near to cross-legged as he could manage, with Sheikh Hafiz on his left, who told him to do whatever he did and to be very careful only to eat with the right hand. It is bad manners to eat with the left hand in Arabia. Still worse to eat with both; but then so it is in Europe.

Proceedings were opened by Sheikh Hafiz dipping a spoon into the bowl of

Amir Sa'ud's falconers at Rumaya (Rumhiyyah) proudly show off their birds to the Rendels.

soup opposite to him and then into the rice on the tray of sheep. This was easy to follow; but the next manoeuvre, penetrating the outer coating of fat of a roast leg of sheep, and excavating a portion of the meat with the fingers, was a skilled job. G. did not do very well at this; and one of his fellow guests took pity on him and pulled out pieces from the leg of mutton and put them on the rice fringe in front of him. G. made an effort with these, but found their size rather a problem and turned his attention to the rice. Eating rice also has a technique all of its own. The rice is taken in the hand (the right hand of course), rolled up in the palm by the fingers into a neat lump and pushed by the thumb in a forward motion towards the mouth. If not correctly timed the rice goes down the sleeve. G. was not altogether successful and, being observed wiping his face, was given a bath towel as a feeder. The uses of the bath towel in Arabia are very varied. In addition to its normal function, I have known it as a duster, dishcloth, tablecloth, table napkin, and on this occasion as a bib.

The helpful guest to whom G. was already indebted now branched into side lines and extracted succulent pieces of liver, and other inner portions of the sheep, for him; which embarrassed him, as he does not take kindly to this type of food. A final titbit was the tongue, wrenched bodily from one of the sheep's heads. This, G. said, was excellent. He then observed that he and Sheikh Hafiz

To Rumaya 105

had been provided with a small separate dish of hashed chicken for themselves, wedged in between the soup and the yoghourt under the edge of the tray of mutton. After consulting Sheikh Hafiz, G. decided to offer bits of his chicken in return for the pieces of mutton he was receiving. This worked admirably and was appreciated, the only drawback being that it encouraged his vis-à-vis to present him with more dainty morsels than he could deal with. Fortunately at this point Sheikh Hafiz started on the yoghourt, and a small dish of tinned pears, which were a pleasant dessert.

During the meal two negroes with lamps and two with bowls of yoghourt stood behind G.'s place. At the end of the meal, basin and ewer were brought and G. once again ceremonially washed his hands. Then all rose, and he and Sheikh Hafiz walked out together between standing lines of guests. The Head of the Camp, his second-in-command, a fine-looking man with black imperial moustaches,[75] and two or three others, came to Sheikh Hafiz's tent for coffee, and listened to Arabic broadcasts from Cairo and Jerusalem of no political interest on a rather elderly wireless set. Presently faintly and after many grunts the radio started to give light music from Cairo; upon which (though possibly not because of it), all the guests took their leave and Sheikh Hafiz and G. were left alone.

In the meantime, I had finished a conventional European meal of chicken and rice and tinned asparagus and fruit, served to me by the faithful Muktar in our outer tent. I returned to the inner tent and, seating myself on the couch, I imagined what the scene must be when it was inhabited by its rightful owner. I pictured the Amir Saud reclining on the silken cushions after a day's hunting, with the negroes in scarlet, who usually attend him, standing about his couch. I saw his retainers and personal friends coming in to speak with him; perhaps a huntsman bringing word of damage to a favourite hawk; and his two small sons, who we heard had been with him in camp, running in and out to tell him of their prowess with horse and gun. By the time G. joined me, after his supper, I was so far sunk in my dream that it seemed the most natural thing in the world to see the flap of the tent lifted by what appeared to be an Arab, and I was brought back to earth with a slight jerk by his cheery voice.

7

Arrival at Riyadh

By seven o'clock the next morning we were out in the camp photographing camels. The sun had just risen and the moon, a pale shadow of herself, was still visible in the western sky. Three herds of camels had been collected for our inspection, with some seventy or eighty calves. The young camel is a most entrancing creature and more like one's favourite uncle's Christmas present from Hamleys than I could have believed possible. They had woolly coats in shades of cream, or grey, or beige, or pure white; and deliciously irresponsible legs, which they flung about in all directions. One or two were so young that they could only just stagger along. They were rounded up and separated from their mothers in order that we might photograph them, and there were some exciting moments when some of the babies refused to come into line and had to be chased and thrown on the ground squealing amid much laughter, before they would submit. The older camels grunted ceaselessly with a roaring note, like an early sound film doing its best.

A large herd of black and white sheep and lambs were also driven past, led by a small donkey; and, last of all, the hawks were brought before the camera with their keepers.

The beauty of really fine camels was a revelation to me. In their natural surroundings they have a dignity and grace which one would never suspect from those drab and ragged-coated creatures who appear to suffer from perpetual mange in other countries. Here in the desert their coats are beautiful in quality and have infinite variety of colour. I saw white and cream and buff and grey and dark brown camels; but I think the pure white camel is the most beautiful of all. I found myself getting quite a good judge of camel form as I went on, seeing at

Above and below Beduin tribesmen parading their livestock and preparing to go off to pasture on the morning the Rendels left Rumaya (Rumhiyyah) for Riyadh.

once when they were well-shaped and graceful, and when their heads and necks were too heavy for their bodies. A camel, like a woman, to be beautiful should have a small head.

Most beautiful of all was the departure of the camels. Three herdsmen, each mounted on a superb camel, led their herds out across the desert to their grazing, calling to them as they went.

Shortly before noon we set out for Riyadh. We crossed the Thamama, a dry water course, where there are numerous unlined water holes of good water which run dry in summer.[76] After about an hour we rose over two sandstone ridges of between three and four hundred feet and reached Buwaib on the edge of the Arma plateau.[77] The descent from the shelf of this plateau is very steep and has been estimated at one in three for the first few yards. It winds down a very stony track and has the reputation of being dangerous. The surface is certainly about as bad as it can be; but apart from this the gradient did not appear to me more formidable than many Devonshire hills I know. Perhaps I was rendered callous by much rough going, but I confess it seemed to me far less dangerous than many places which our cars had been expected to negotiate in their stride and which no-one in Europe would dream of attempting without caterpillar wheels. Our whole convoy got down safely without incident, however, and we went on over flatter country, getting ever more barren, with a line of deep red hills in the distant foreground.[78]

The approach to Riyadh, the capital of Nejd and of all Saudi Arabia, is over miles and miles of high-lying ochre-coloured gravel plain, without a sign

The Rendels' convoy descends the 'Armah escarpment at al-Buwayb en route to Riyadh.

Arrival at Riyadh 109

Riyadh seen from the north-east across the cemetery on the Rendels' approach to the city.
The towers of Qasr al-Masmak can be seen just left of centre.

of vegetation. The city first rises out of the desert as a remote line of walls and towers, and a streak of emerald green across the prevailing aridity becomes, as one draws nearer, the gardens of the Riyadh oasis. A car came out to meet us and Muhammad Shalhoub, the Director of Finance in Nejd, got out and welcomed us with many elaborate greetings in the name of King Ibn Saud. He was a grand-looking old man, with a fine presence, and said to be very old. But this probably only meant at most sixty-five in this country.[79]

The King was not himself in Riyadh. He had just finished the pilgrimage in Mecca and was returning to Jidda, to receive us there. The Amir Saud, the Crown Prince, was to be our host.

Muhammad Shalhoub directed us to go straight on to the Badia Palaces, which lie six miles to the south-west of Riyadh, where we were to be lodged.[80] These two palaces, the old and the new, are in the attractive oasis of Wadi Hanifa, and stand side by side above the Wadi on its western bank. Across the Wadi facing them is a little Nejdi mosque, with a long line of simple arcades and no minarets.

The Old Palace was formerly the King's Summer Palace and Guest House, but it is now used by the Crown Prince. The New Palace, which has replaced it and is King Ibn Saud's Summer Palace, was built in 1935. They stand a few hundred yards apart, surrounded by gardens. The approach to them is down a steep and stony track on to the bed of the Wadi Hanifa, which is about fifty yards wide with a soft sandy bottom, and is dry except after rain. The impetus with which one descends from the steep track into the Wadi is supposed to carry one

110 *Arabian Journey*

Muhammad al-Shilhub and Shaykh Hafiz Wahba join a group to be photographed outside the Palace door in the centre of Riyadh.

across it; but five times out of ten this is not the case and then one has to be pushed across. Once over, a slight incline takes one up to the entrance to the New Palace. Here the Royal Guard turned out to salute us.

The New Palace is a good example of modern Arabian domestic architecture.[81] It is built round two open courts with arcaded galleries of simple columns and high balustrades with shark's-tooth edging. The decoration of the walls of the galleries and of the rooms opening off them was plaster-incised work such as we had seen in Hasa. But though very effective, it was of much rougher workmanship both in design and in execution than the Hasa work. This form of mural decoration appealed to me increasingly. It broke the coldness and austerity of plain walls without losing the charm of flat surfaces and simplicity, and was restful to the eye. Wooden doors painted in simple geometrical designs and red- and blue-striped matting on the gallery floor added a pleasant note of warmth to the prevailing whiteness.

Our rooms opened off the gallery on the first floor. Two staircases led down from this gallery to the vestibule; and at the head of each a sentry kept guard night and day. Our *diwan* was long and narrow, with six windows looking on to the palm gardens. Two central columns with simple flat capitals supported a ceiling of palm trunks. Settees and chairs lined the walls without a break. In the centre was a table covered in green satin holding a pot of ink and pens and a small vase of desert flowers.

Arrival at Riyadh 111

Above The approach to al-Badi'ah went past this typical Najdi mosque and crossed the bed of the Wadi Hanifah before reaching the palaces where the Rendels stayed.

Below The doorway of the older of the two palaces at al-Badi'ah.

Above The new palace at al-Badi'ah, built in 1935, was a good example of the Najdi architecture so much admired by the Rendels.

Below The first courtyard in the new palace at al-Badi'ah.

Opposite Geraldine Rendel photographed by George in the first floor colonnade of the new Badi'ah Palace, with Shaykh Hafiz Wahba in the background. The geometric designs carved into gypsum plaster are typical of the Najdi interior decoration of the time.

This page The photography session in the colonnade included George Rendel (above), a policeman and assistant (top right), and the Rendels' servants Muhammad and Mukhtar (right).

Arrival at Riyadh 115

We had single bedrooms, both alike. High upholstered settees ran round two sides of the room. On the third was a large, black iron-and-brass bed, with a mosquito canopy of thick muslin, two plush blankets, no sheets, a large bolster covered in cream satin stripe, and a small pillow in a flowered-silk frilled case. A plain wood table, covered in the same green satin as the one in the reception room, held a chased metal basin and long spouted jug, of the same shape as we had in our camp equipment. Above it was suspended a large and really fine mirror in a cut-glass frame. What a luxury this was after four days with only G.'s small shaving mirror and my own handglass in a dark tent.

A still greater luxury was the bathroom. This covered a very large space. It was approached by an anteroom of considerable size, which had no windows, or apparent purpose, except to ensure greater privacy. From this one entered the bathroom itself and beyond it again, curtained off, was a small closet. In the bathroom was a wood-heated stove and a large, round zinc tub, several small jugs and a bowl, and a small wooden footstall on which lay a pink cake of soap in a saucer. The zinc tub was filled with hot water and one stood on the stool, dipped one of the little jugs into the water and poured it over oneself, the water draining away through a hole in the floor. The only drawback from my point of view was the extreme heat. The stove was an excellent one and the water boiled rapidly. When it was boiling, the stove became red hot and roared and vibrated and gave all the signs of being on the point of bursting. On such occasions the temperature of the room rose to that of the hottest chamber in a Turkish bath and one had the sensation of being slowly boiled, with the possible alternative of being blown up. All the same it was a great luxury.

One hour and a half after our arrival at the Badia Palace, we were on our way back to Riyadh to pay our first visit to the Crown Prince. The track between Badia and Riyadh follows the poles of the telephone line over a stony and barren plain, past the wireless station at Shamsiya to the house of the Emira Nura, a

The Palace of Amirah Nurah, sister of King 'Abd al-'Aziz.

Thumayri Street was the main thoroughfare to the
Palace square in the centre of Riyadh.

Arrival at Riyadh 117

The main square, looking back towards Thumayri Street from the door of the Royal Palace.

sister of King Ibn Saud, and the wife of Saud al Arafa.[82] It is said of this lady, who has the reputation of being a remarkable personality, that her brother, the King, never refuses anything she asks of her. I was disappointed to learn that she had not returned from Mecca, as I had hoped to meet her. From Shamsiya, the road runs along by the Emira Nura's garden, and brings one by a narrow and uneven track to the walls of Riyadh. These are of mudbrick with shark's-tooth edging, broken at intervals by plain round towers.

We entered the city by the Dhumairi[83] Gate and up a wide street, with high houses of mud and limestone built straight on to the road, leading to the Palace Square. Police in yellow and guards in red uniforms were posted at intervals on both sides of the street.

The Palace Square is very fine. The wall of King Ibn Saud's Palace fills the western side of it, a Guest House for tribal sheikhs the eastern, and across the northern end runs a recently built arcade of double columns and arches. When the King is in residence, this square is constantly filled by Beduin who come in to discuss their affairs with their great ruler. They camp in the square and are fed at the King's expense for three days, the traditional period of desert hospitality.

The Palace with its main gate and colonnade connecting it with the Great Mosque.

The Palace itself is a high, strongly fortified building with two massive towers. Along its great wall it has a single row of windows with simple horizontal lines of decoration above and below the casements, and above again along the parapet. It is undoubtedly beautiful and was a revelation to me of how fine modern Arabian architecture can be.

At the door of the Palace a number of people were waiting to receive us; and there was a large crowd of curious onlookers in the Square. As soon as I got out of the car, I was taken charge of by a somewhat dour-faced gentleman, who appeared to be the Master of Ceremonies. He beckoned me to follow him in a summary fashion, and led the way through a vestibule crowded with men-at-arms and other retainers, to an inner court. I concluded that G. and Sheikh Hafiz were close behind me, but dared not look back to make sure. I found this walk from the entrance of the Palace to the *Diwan* for the Reception of Foreigners, where the Crown Prince received us, distinctly trying. At any time the uneven earthen floors, frequent unexpected single steps and ridges, long curved flights of stone stairs with extremely high treads, all in semi-darkness, would have been difficult enough. With a long *thaub* touching the ground, a heavy *'aba* and thick

Arrival at Riyadh

Curious onlookers gather beneath the colonnade by the main door into the Palace.

veil, it became extremely formidable. The more so as the narrow passages were lined on both sides with men-at-arms, negro slaves, and other members of the Royal entourage, leaving only just sufficient room for us to walk between them. However, I managed it with tolerable dignity, I hope. The leisurely, dignified gait of the Arabs was a great help on this and other occasions. It gave one time to manipulate one's unaccustomed draperies with a certain amount of grace and rhythm, and to negotiate unexpected obstacles. Still I was grateful for my camouflage. Few of those about the Palace were accustomed to see European women, and no other European woman had been publicly received in King Ibn Saud's Palace before. They were as curious to see me as I was to see them, and though perfect courtesy and respect were maintained on this, as on all other occasions, I think some of them, at any rate, did their best to get some idea of what I was like through my veil. Others averted their eyes with rather black looks and I felt that my presence at so public a function in the heart of Nejd was not universally approved.

120 *Arabian Journey*

We reached the door of the *Diwan* for the Reception of Foreigners and my guide stood to one side and indicated, by a wave of his hand, that I was to pass on to where the Amir Saud, the Crown Prince of Saudi Arabia, stood at the far end of the room waiting for us. The Amir Saud resembles his father in physique, standing head and shoulders taller than most of his countrymen and combining, in an unusual degree in so large a man, both dignity and grace. Under a gentle courtesy and perfect sympathy of manner lie qualities no less striking, if not so immediately obvious, as those of King Ibn Saud. At an early age he was appointed Viceroy of Nejd and rarely visited the Hedjaz until 1934, when he commanded the eastern front in the Saudi–Yemen War. On the other hand, unlike his father who has never left his country, the Amir Saud has paid long visits to Europe and England on two occasions, which cannot but have had considerable influence on his world outlook. Often when I have watched him at some of our more incongruous efforts at hospitality in this country, I have wondered what is really going on behind that subtle, thoughtful

Sentries and others in attendance at the main door of the Palace.

Arrival at Riyadh

face, with the veiled eyes that flash now and again into one of his singularly vivid smiles. And on the rare occasions when I have seen his face cloud, I have realised that just as he is a very good friend, so he might also be a very good enemy.

"*Assalamaleikum*" (Peace be on you).

And the reply: "*Alaikumassalam*" (On you be peace).

"*Keif halak?*" (How do you do?).

"*Alhamdu lillah*" (Praise be to God, well).

With these greetings we met, and the Amir led us both by the hand to chairs on either side of the throne on a low dais where he himself sat. While we talked of our journey, and spoke of memories of his visit to England two years earlier, coffee was brought in by two slaves.[84] One carried a brass coffee pot with a broad curved spout like the beak of a toucan; the other a pile of little cups without handles, fitted one into the other. Only about two teaspoonfuls of the highly spiced coffee are poured into the cup before it is given. When the cup is empty, the watching negro approaches to pour in more. If you do not wish for more you wave your cup with a little circular movement of the wrist, which is an indication that you have finished, and it is then taken from you. Highly sweetened tea was afterwards brought. Tea is always served a few minutes after coffee on formal occasions.

The Amir presently announced his intention of returning with us to the Badia Palace for an informal lunch as our guest. He rose and we went back to the entrance of the Palace once more, where the cars were waiting. The second walk, with his sustaining presence by my side, seemed much less long and intimidating. He took us in his motor, with two of his bodyguard standing one on each of the running boards of the car. I was sitting in front by the chauffeur, the usual place accorded to me, the female chassis being more susceptible to bumps, and got an excellent view of the gold-embroidered scarlet sleeves and tunic of the negro standing just beside me.

We progressed slowly thus to Badia, where the dignity of our arrival was a little dimmed by the car sticking in the soft sand of the Wadi Hanifa in front of the Palace. But those who were looking out for our arrival hastened to our aid and in a few minutes we were safely over and indoors. During the rainy season this Wadi becomes a rushing torrent and has been known to be so swollen that it is considered impracticable to bridge it; but I cannot help thinking that some kind of causeway could be constructed and much embarrassment and loss of time avoided.

One forgets, however, that time in Arabia has quite a different value from time in Europe. Time serves the Arab, not he time. In Europe we serve time and ruin our nerves and digestions in the process. In Arabia time, like Eternity, is God's. It is treated with complete fatalism as something over which one has not got ultimate control. If we were too late to carry out some project, Sheikh Hafiz

did not say we had stayed too long somewhere else, or started too late, or eaten too slowly, as we would have said to each other. He merely said: "The sun is too low, we cannot go to-day." The sun had stolen a march on us and that was that.

We had a pleasant and friendly meal in our dining room with the Amir Saud, waited on by Muktar and Muhammad, so that I was able to be unveiled without causing scandal. The Amir talked of shooting and hawking and told us that he had shot three hundred gazelles while in his camp at Rumaya. One wonders that the gazelle is not exterminated by such slaughter, although I believe there is a closed season for shooting them.[85] He also told us that his favourite hawk had accompanied him from camp to Riyadh as he did not trust her out of his sight. After lunch he left us, having first invited us to dine with him in Riyadh on the following evening.

Later that afternoon we walked in the garden of the palace. These gardens are irrigated by wells worked by six white Hasa asses. The water is raised in leather skins, and each donkey pulls up one skin as he reaches the end of his walk. This is emptied automatically by the action of a guide rope into a trough and distributed by means of small runnels through the gardens. The perfect precision with which the six donkeys go up the slope towards the well, and immediately turn round to descend again, is a remarkable contradiction of the traditional obstinacy and stupidity of the ass. They worked (I hope in relays) all through the night while we were in Riyadh, and the creaking of the pulleys over the wooden wheels was a great blot on the peace of this pleasant spot. It was known as the donkeys' orchestra.

Several camels came drifting through the garden as the sun was setting, on their way home after the labours of the day. But these were homely beasts, not to be compared with those we had seen that morning at Rumaya. When I commented on their different appearance, Sheikh Hafiz said: "They are for work and not for show or for milk."

As indeed they looked.

Arrival at Riyadh 123

124 *Arabian Journey*

8

With Amir Saud in the Palace at Riyadh

His two younger sons were sitting with the Crown Prince when we called on him the following morning. Fahad, the elder, who was eight years old, had a white *thaub* and *kafiyah*, no *'aba* or head-ropes, and the most perfect and dignified manners. He was a good-looking boy with a long slim nose, and eyes set wide apart. The younger, Muhammad, a boy of four, had round black eyes like pools of ink, with imps of mischief in them, and rosy cheeks under his tan. He looked adorable in a minute purple velvet *thaub* tied round him with a cord, and a white *kafiyah*. He shared the wide royal settee with his father, either kneeling or standing as the spirit moved him, but never still.

They were in a small and informal *diwan* opening on to a sunlit roof terrace. Some of the Amir's brothers and cousins were with them. I was impressed by the fine bearing of those who were about the Crown Prince. Handsome and virile types, they possessed a keen sense of humour and seemed always ready to take a joke against themselves.

As I was placed next to the Amir Saud, I found myself beside Muhammad; and while the others talked high politics, this engaging infant made friends with me. He played with my rings and talked to me in his baby Arabic, which, perhaps because it was nearer in construction to my own halting words, I found myself better able to understand. He only interrupted his flirtation with me to stand up on the settee and ring the bell immediately behind his father. This he did repeatedly, looking at me to see whether I admired his daring. As no-one attempted to answer it, I concluded that it was a game he often played, and the

Opposite Two views of market activity in Riyadh.

slaves were accustomed to it. When he got tired of ringing, he made great efforts to persuade me to lift my veil, but this I felt bound to resist.

Presently the Amir turned to me and said how much he regretted that the rules of his country had compelled him to ask me to be veiled during my journey. I assured him, quite truthfully, that I considered the veil a small price to pay for all the interest and pleasure which my visit to his country was giving me. I added the hope that I had in no way unwittingly offended against the customs of the country, and he at once reassured me. I had the impression that this speech of his was made chiefly for the benefit of the others present to put my visit on its proper footing. My position all through this journey was a mixture of that of a lady of the harem and of a European woman. When with the Amir I was always given place to, and put first in everything. But on some other occasions, I was treated differently. I stood without being presented to anyone, and no man would speak to me, or even offer me a chair, because no Nejdi looks at any woman outside his own family circle.

Coffee was brought to us and I was amused to observe that the tiny Muhammad drank his coffee like a man. Those who served it kissed the Amir's hand on approaching him. Sheikhs have the privilege of kissing his nose when they greet him; and his personal friends, and those whom he wishes to honour, kiss his cheek.

After about half an hour's talk, G. went out to visit the town and the bazaar accompanied by the Chief and Assistant Chief of Police. The Amir said that he was sorry he was unable to suggest that I should accompany them. He was afraid that in Riyadh, which is the heart of Nejd and Wahhabism, I might be caused embarrassment by the attention I should excite. But there were windows in the Palace, he added, looking over the bazaar and the town, from which I could obtain an excellent view, and he suggested that Sheikh Hafiz should take me to them.

I was accordingly taken through the Palace across several large and small *diwan*s, until we reached two long rather dark rooms opening into each other with five windows in each, all looking out on to the bazaars. The second room was fitted up as an office. It had five maps of the five Continents on the walls, made in Egypt in 1928, a mahogany grandfather clock, a leather-topped desk in the centre of the room, and a small iron stove against a column in the middle, with an ugly stovepipe in zinc which ran right across the room to the ceiling through which it disappeared. It was lit, like the rest of the Palace, by a rather weak brand of electricity which had usually to be helped out with lamps. I understand that since our visit, new plant has been installed by a British engineer and the light is now much improved. There were fine modern carpets on the floors.

From the windows of these two rooms I amused myself for nearly an hour, going from one to another and getting different angles of view down into the

Above, below and over page Market and street scenes in Riyadh.

With Amir Saud in the Palace at Riyadh 127

town. The women's bazaar lies directly under the windows of the Palace and is divided off from the main bazaar by a wall running all its length. I watched the Riyadhi women selling their eggs and vegetables and what looked like pumpkins; and the purchasers squatting in the dust to strike a bargain and carrying away their purchases balanced on a pad of cloth on the top of their *'aba*s.

On the further side of the wall was the general bazaar, of which I also got an excellent view by passing from window to window. It was not as large as the bazaar at Hasa, and seemed much emptier; but we were told that this was due to the large number of the Riyadhis who were not yet returned from Mecca. G. told me on his return that there were not a great many stalls, nor a great variety of goods. The usual groceries, coffee, tea, spices, sugar, rice, etc., were selling and there was a certain amount of local leatherwork for sale. Much of the cloth was Japanese, and Japanese canvas shoes were a conspicuous feature. The metal and china ware were Japanese, German, or Czecho-Slovakian. Some stalls were selling male palm flowers for fertilisation purposes.

G. was shown many smaller Royal residences in the town adjoining the Palace and connected with it by bridges and overhead passages, belonging to King Ibn Saud's sons. Quite a quarter of the city must be covered by the houses of the Royal family. The only other buildings of outstanding importance in Riyadh are the Fort, which is to the north of the main street as you come up it from the Dhumairi Gate, and the Great Mosque, which lies behind the bazaar.[86] The Mosque is a typical example of Nejdi religious architecture: very simple in structure, low and flat and without domes or minaret. The call to prayer is given from a stunted and inconspicuous tower on one side of the building. Only followers of Islam are allowed to enter mosques in Arabia, and we never saw the interior of this or any other.

When I had glutted my curiosity from the windows of the Palace, I was taken to see some of the other rooms. The *Diwan* where the King receives the Beduin Sheikhs when they come in from the desert to visit him was a very fine hall. A row of six columns down the middle supported a timbered ceiling. Each column had a narrow belt of plaster decoration round it about a third of the way up. There were velvet settees round the walls, with a more imposing one for the King at one end. These seats are a modern innovation. Two years earlier, Sheikh Hafiz told me, I should have seen nothing but cushions on the floor. The carpets were of great size and three of them, those lying nearest to the King's seat, were strikingly beautiful in design and colour.

I returned to the room with the maps, where G. joined me, and we went back to the Badia Palace together for lunch.

That afternoon we spent wandering over the ruins of Daraya, the ancient Wahhabi capital of Nejd before Riyadh was built.[87] It lies beyond Badia, higher up the Wadi Hanifa, some ten miles north-west of Riyadh, and the great height

Above Daraya (al-Dirʿiyyah) seen from the track from Riyadh.
Opposite Geraldine being shown round the ruins of Salwa Palace.
Below The new villlage of al-Dirʿiyyah seen from a ruined mosque.

With Amir Saud in the Palace at Riyadh 131

Views of the imposing ruins of Salwa Palace, al-Dir'iyyah.

and solid masonry of the walls and towers still standing give one a remarkable impression of the power and greatness of the Wahhabis. It was destroyed with fire and sword by an Egyptian expedition sent by Mahomet Ali in 1818, and Riyadh was built to replace it.[88] We explored the narrow hilly streets under the guidance of Sheikh Hafiz and walked through the fruit gardens, which are still being cultivated in the midst of the ruins.

Later the same afternoon we visited the northern court of Badia Palace. Intended for the great heat of summer, this court has a wide gallery with many windows opening from it on to the palm gardens. At one end the open balustrade is replaced by a wall of twice the height – an arrangement to enable the ladies to come and enjoy the breezes in seclusion in the hot weather. At the far end of this court was a small room with a remarkable ceiling covered with white canvas on which were stitched stars and crescent moons, tea and coffee pots and other symbols in gay coloured silks.[89] Beyond it was a little locked mosque.

We dined that evening at the Palace with the Crown Prince. Hitherto I had only worn the *'aba* with my own costume underneath; but on this formal occasion I wore a black chiffon *deraya* embroidered in silver over a purple *thaub*, and G. put on a cream gauze embroidered *'aba*.

The Amir Saud received us in the *Diwan* for the reception of Tribal Sheikhs. We found him sitting on a high cushioned settee in a black and gold *'aba*. It was a fine room with two columns in the centre. There was some humorous interchange between the Amir and Sheikh Hafiz as to whether our reception in this room entitled G. to the rank of a Sheikh. The point was still in doubt when we went to dinner.

A longish walk through dimly lit corridors full of armed men and slaves ended in the Amir's own private apartments.[90] Here we dined waited on by Muktar and Muhammad. As soon as we were seated at the table and the Amir's

132 *Arabian Journey*

followers had left the room, I was asked to unveil and remove my *'aba*. It was a very simple room with perfectly plain walls. The Western dining table was, I believe, the one we had brought with us in our camp equipment, lent for the occasion of an European-served meal. The only other furniture were two stools covered with silk cloths on which stood the usual long-spouted ewers and basins of chased metal.

There were six lightly shuttered windows, three on each side of the room. Three must have looked out on to a court or garden. The other three were open to a corridor, which was slightly below the level of the room itself. In this corridor the Amir's Suite sat during our meal, watching us eat. I had my back to the outer windows and faced many pairs of eyes glittering from the outer darkness. Doubtless there was gnashing of teeth also, as I suspect there were many who disapproved of their master dining in the company of an unveiled European woman.[91]

After dinner the Amir took us to his own private *diwan*, where we were alone with him; and I felt that now we really were being treated as friends. It was a much more intimate and homely room than any we had hitherto seen. Many mirrors hung round the walls. We counted thirty-three of them. There were several pieces of mahogany furniture of the late Victorian type, a nice tallboy in Damascus ivory inlay work, tables and velvet-upholstered chairs, and at least a dozen clocks, all going. Countless witchballs of various hues were suspended from walls and ceiling.[92] They were a distinctly successful experiment in colour decoration.

After coffee, the Amir Saud suggested that I should visit his daughter and two of his sisters. His wives, he said, were still in Mecca. Leaving G. and Sheikh Hafiz to entertain each other, I went with him to the ladies' part of the Palace. He took me down a winding stairway, which he ran down like a boy, but which I found a little difficult to take at his pace with my trailing *deraya*, although I was still unveiled. We crossed an open court, passed along a corridor which led to a second court, and, at the further end of this, we found the three little princesses standing in a row at an open door.

A singularly sweet-looking trio they made as they stood there, with their hands by their sides and their dark eyes raised to mine in shy curiosity. They all looked about the same age; but age is hard to tell, as old and young seem to dress alike; or perhaps the differences are too subtle to be perceptible to a foreigner. I was told later that the Amir's daughter was fourteen. The sisters did not look much older, though they were a little taller. They all had black *deraya*s over coloured *thaub*s and were unveiled. Their shyness was overwhelming. Not all the Amir's efforts, nor my attempts at a few words of Arabic, could induce more than smiles and laughter. When pressed to speak, they hid their faces on each other's shoulders and giggled. We went into their rooms, where negress slaves

were waiting to see them to bed. They had stayed up beyond their usual hour, I gathered, in order to see me. The sitting room was long and low and narrow, with a good deal of furniture and small objects dotted about, and more witchballs. The bedroom had three couches on the floor against different walls and a column in the centre covered in a scarlet material with small silver stars on it. A brazier stood at the foot of the column with the dying embers of charcoal in it. There were mirrors all round the walls. Clothes are kept outside the rooms in chests such as one sees in the bazaars, made of wood and studded with brass nails.

We said goodnight to them and left them to go to bed. As we crossed the court, their tongues were freed and a babel of chatter was unloosed behind us. Pursued by their tinkling laughter, we walked along the gallery round the court and, peeping through the balustrade, I saw an eager group, joined now by the negresses, all talking at once. I would have given a great deal to hear and understand what they were saying.

We walked on and their voices died away. We entered the second court, which lay in a bath of moonlight. The clean-cut sable shadows of the columns fell across it, and above it was the moon in a pattern of stars. The Amir Saud looked up at the breathless beauty of the night and said:

"The moon and the stars are the roof of my house."

9

Riyadh to Duwadmi

THE VITAL IMPORTANCE of a really early start next morning had been stressed by Musfer, our guide, overnight. The Nafud El Sirr, the most difficult sands on the whole route, had to be crossed before darkness fell, and we had several hundred miles of bad going in front of us.[93] In spite of this, at eight o'clock next morning our chauffeurs and several members of the party were not to be found. They had all had dates with their friends in Riyadh the previous night and there was great difficulty in collecting them. By 8.30 Sheikh Hafiz had succeeded in finding our own chauffeur, and we decided to go on to Riyadh to say goodbye to Amir Saud, leaving messages for our convoy to meet us at the Wireless Station at Shamsiya.

The Amir Saud received us again in the little *diwan* where we had found him the previous morning. He was alone with his two boys this time, both in full Sheikh's dress like their father, with brown *'aba*s and gold *'igal*s. Fahad held his father's immense curved sword in its gold scabbard and Muhammad had a small golden dagger in his belt. The Amir explained that Fahad had put on full dress for the photograph which we were to be allowed to take. Muhammad had insisted on putting on his also, when he saw his brother dressed. It was heavy and cumbrous for him, and the head-ropes kept slipping down over his forehead and having to be pushed up, but he bore it all with great stoicism and dignity, while we took photographs of all three on the roof terrace opening from the *diwan*. As soon as the photographs were finished Muhammad was carried off, looking like a very large doll, in the arms of a young negress.

We took our leave of the Amir with many expressions of friendship on both sides.[94] It was not to be for very long, as he was coming to England in two months' time to represent his father at the Coronation of King George VI.

So back to the Wireless Station at Shamsiya in the hope of finding our convoy there and ready to start. A barren hope. We were the first at the tryst and continued to be for some considerable time. I sat on a hard, wooden chair under a verandah inside the courtyard and sipped tea, while the lorries and cars drifted slowly in one by one. Let no man make the mistake of thinking he can hurry an Arab. So much for our early start. But no one worried. One of the more attractive aspects of desert travel is its complete casualness. Everything is "Inshallah" and no one attempts to give the Almighty a helping hand. A lorry sticks in the sand. We stop and wait for it to be pulled out. Muktar spreads the carpet on the desert and serves tea, or orange juice, and we all sit peacefully till the lorry has been salvaged. On once more till the next mishap: a hole in the petrol tank of our car, the third that day. We change into another car, and leave the damaged one behind on the desert to be repaired (if the repairing lorry turns up), or not repaired if it does not – "Inshallah". If ever we fretful Europeans showed any signs of restiveness with our lot, Sheikh Hafiz would say: "The desert is a hard life." Or: "If these things did not happen you would not have experienced what life in the desert is really like."

Yet we did ultimately start that day, in a northerly direction on a rising track, over stony and barren plain. About three miles out we suddenly saw the kitchen lorry, which was a few hundred yards ahead of us, go up in smoke and flames and we hurried on to their assistance. By the time we reached them the worst was over and the flames had been extinguished, though black smoke continued to pour from the bonnet. They spoke of a short circuit, but no one seemed to know what had actually happened. The fact that it had ceased to happen and that 'El Loury' did not appear any the worse for its baptism by fire, was all that mattered.

The solitary casualty was Juju, the Senegalese driver, who had cut his hand in two places while extinguishing the flames. He stood like a large sorrowful child, holding out his bleeding hand with a most pathetic expression. The cuts proved to be only surface scratches and I applied iodine and plaster and soon restored him to smiles.

Our first village that day was Jubaila, some fifteen miles north of Riyadh in the valley of the Wadi Hanifa. Its ruined houses are still watched over by a look-out tower on the outskirts of the village; we only saw two that were inhabited houses.

'Awaina, on the west bank of the Wadi, follows almost at once: a long straggling village, also largely in ruins, with a good deal of barley still being grown among the debris, and tamarisk trees. 'Awaina used to be the biggest town in Nejd before Daraya was built in the eighteenth century and was the birthplace of Abdul Wahhab, the founder of Wahhabism.[95]

Opposite The Amir Sa'ud and his two sons, Fahd (right) and Muhammad, had made careful preparations for this shot by the Rendels, who took two other similar images of the group.

Above Inside the wireless station at Shamsiyyah.

Opposite The Rendels' convoy passes alongside the Tuwayq escarpment on its way to 'Awaynid and Marat.

Left and below In the vicinity of 'Awaina (al-'Uyaynah), once the largest town in Najd before the rise of al-Dir'iyyah.

The going through these two villages was very bad and it was a relief when we got beyond them on to the Sabkhat Al 'Awaina, where the track improved.[96] Rising slowly through a long green valley with many *salam* bushes to a low pass, the track dropped steeply westward between the brilliant red bluffs of the Jebel Tuwaiq.[97] These cliffs, three hundred feet high, have a projecting shoulder known as Khashm Al Hisan.[98] Here were many *asharr* bushes, a bitter shrub, with small white flowers, which is useless for grazing purposes, and we were once again on stony arid plain.[99]

A few miles brought us to 'Awainid Wells,[100] and here we were stopped by a Bedu who was waiting on the track to intercept some pilgrim who would carry a letter for him to Mecca. The Sheikh accepted the letter and later passed it on to travellers going to the Holy City.

The flat gravel desert continued without interruption until we reached Marat.[101] On this plain we got our first glimpse of the Nafud Turaif Al Habl, a long ridge of rolling sand dunes, deep coral in colour, about three-quarters of a mile to the north of our track.[102] It first appeared entangled in a mirage, looking like coral islands in an azure lake; but as we went on the phantom water vanished and the colour deepened almost to flame. With a foreground of golden sand, grey camelthorn and strips of golden dandelion, it made an unforgettable pageant of

The walled oasis of Marat was one of the main settlements in the Washm district of lower Najd.

colour. One of the tragedies of human limitation is the rapid blurring of impressions. However vivid at the time, they fade in spite of all one's efforts to retain them, as fresh images overlay them. I can still visualise those flaming sands in my mind's eye; but I know that if I saw them again they would be ten times more beautiful than I can now remember them.

We passed no human habitation until we reached Marat, a walled village of some three thousand souls, built of dark red mud, reminiscent of Devonshire soil in colour. Big date gardens stretched beyond its walls and there was a large pool for the storage of rainwater. We only stopped long enough at the wells to fill our water-skins, as the hour was getting late and we had yet another fifty miles to cover before we reached the treacherous sands of the Nafud Al Sirr.

A few miles beyond Marat we crossed the Qunaifida Sands; benevolent sands these, with a binding of *arfaj* and *thamam* bushes, which made the going easy.[103]

The silence was very wonderful on all these days. At first I used to be conscious of missing something; find myself listening, straining to hear something, the whisper of leaves, the stirring of bird or beast in bushes, the murmur of insect life, the breeze in the grass; any of the sounds familiar to other great empty spaces. But there was nothing. This silence was always most impressive in the last hour before sundown. Then a lovely violet light used to steal over the desert and such breezes as there might have been during the day dropped to rest. Sometimes when we halted at sunset for prayers, I used to wander away from the cars and let myself be swallowed up in the immense stillness, broken only by the distant murmur of prayer, as the Moslems prostrated themselves before God on the desert.

We reached the edge of the Nafud Al Sirr just as the sun was setting in a blaze of glory and the great sands glowed like burnished copper.[104] These sands, which are accounted the most difficult on the whole route, rise and fall in great swelling dunes for the first few miles, growing more level as one proceeds. Their surface had not been improved by the recent passage of pilgrims to Mecca. The convoy of the Royal Family and their entourage alone, we were told, consisted of three hundred cars and lorries. The track had suffered badly and in many places we had to abandon it and make our own.

To cross great stretches of sand safely one must attain and keep as high a speed as possible. To slow down in soft sand is to stop; to stop is to sink and stick. The Arab driver, therefore, goes all out, hell for leather, zigzagging across the sand. The sensations of the passenger are much the same as those experienced on a very rough sea. The car leaps and bounds like a living thing, swinging violently from side to side. The driver avoids what he can and goes over what he cannot, and a small bush, or fair-sized mound, has to be taken in the stride. Rocks must be avoided and usually are by a hair's breadth. The car slackens on the upward slope, wheels spin and you think you are sunk. Perish the thought! The engine picks up again, the car frees itself from the clinging sand and goes to the top of the ridge. Down the other side you plunge faster than ever, to founder in a deep trough of sand at the bottom. Ten or twelve minutes are spent in pushing and dragging and at moments lifting the car until a firmer patch of sand is gained, and the engine can start once more. On again with darkness falling. The car rocks and seems to shudder at its own temerity. More than once I thought we should be thrown over sideways, or turn a somersault. We passed a car lying derelict upside down on the sand, and I realised what happened if your front wheels sank and your back ones did not, and murmured prayers, visualising a row of dreary orphans in England.

Fifty-five minutes of it and we were over. I give our driver full marks for bringing us safely over those sands. Then night, with the fires of the Beduin glowing out of the darkness on both sides of the track and stars without end; countless myriads of stars marshalled in their battalions, the whole blazing firmament as far as eye could see.

On the further side of the Nafud lies the fort and village of Duwadmi, where we arrived about 11.00 p.m. 'El Loury' with the tents was sunk in the Nafud; 'El Box' with our supper and Muktar and Abdurraman was also behind us somewhere in the sand; the kitchen lorry we had not seen for hours. Once more we were foodless and bedless. As usual the indomitable Sheikh rose to the occasion. The Amir of Duwadmi Fort, he felt sure, would be delighted to welcome us. We made our way there and so indeed it proved.[105]

The Amir received us most hospitably. He was very anxious to kill and dress a sheep for us; but we did not feel equal to so heavy a meal at that late hour.

Above, below and opposite The fort of Duwadmi was the chief security and refuelling station between Riyadh and the Hijaz. The group opposite includes the amir of the fort.

We were shown into a large upper room in the Fort, approached by a steep and dark stone stairway, to spend the night. It was kept for the use of the King and his family on their way to and fro between Mecca and Riyadh. Two solid central columns supported a ceiling timbered with palm trunks and rough wood; the central beams, painted in bright coloured designs, ran the whole length of the ceiling, connecting the two columns. Red and blue carpet covered the immense floor-space and up to the window sills on the walls; and small oblong cushions in red and blue stripe lay on the floor. There were five wooden shuttered windows on each side of the room; and primitive but spotlessly clean sanitary arrangements available by crossing a small roof terrace through a door at the far end.

They brought us tea and we made a light supper of biscuits, oranges and chocolate; and told each other that after all we had much to be thankful for. Quilts were laid on the floor, and rugs and air cushions that we had fortunately taken with us in our own car. Our only lighting was one kerosene lantern on the floor, which shed a small circle of light making the surrounding shadows blacker than ever, and our electric torches. For the first time we sought comfort in the flask of brandy which we had brought with us, carefully camouflaged amongst G.'s underclothing in his suitcase, to this prohibitionist land.

And so to bed. How thin a quilt feels on the floor, and how difficult not to roll off it when you try and tuck a rug under it. What an incredibly hard thing an

aircushion can be. It is almost impossible to get just the right quantity of air for comfort into it. If there is little, your head presses the centre down flat while the sides bulge up over your ears and bonnet you; if there is much, you feel as if you have a tree trunk under your head. G. maintained there was a happy mean but I never found it.

We passed the night in tolerable discomfort. Soon after midnight 'El Loury' with the tents arrived. Still later 'El Box' also, which assured our breakfast in the morning.

Duwadmi Fort is a solid building covering some hundred and twenty yards square with arched gateways and four towers. It was built in 1931 after the defeat at Duwadmi of the Ataibe Tribe, who rebelled against Ibn Saud in 1929, and lost 4,000 camels to the King.[106] Except for the Muwaih Fort, two hundred and fifty miles further on, this is the only fixed human habitation between Marat and Taif, a distance of nearly five hundred miles.

The Amir of Duwadmi Fort is the grandson of a freed slave who belonged to Feisal, King Ibn Saud's grandfather.[107] No bondman can rise to any position of authority in Saudi Arabia; but once freed he is as good as any man. There is no colour bar and he can hold the highest post in the land. On the other hand, the Arab will always remember that the freed slave has once been a bondman; and though he will not dare to say it before his face, he will do so behind his back.

An Arab friend[108] with whom I discussed the question of slavery was prepared to admit that it was wrong in principle; but maintained that, as practised in Saudi Arabia to-day, it did not cause suffering or hardship to any great degree. Slaves were very well treated, he said, often brought up with and loved as one of the children of the family. A slave owner, he told me, on his deathbed will often send for a judge and formally free a slave to prevent him from falling into bad hands – an admission, of course, that there are bad slave owners. It is certainly true that they are constantly better dressed than their masters and speak with them on equal, if not familiar, terms. Fresh slaves are no longer allowed to be imported into the country; and it is said to be only those already there and their descendants who form the slave class.

"The Saudi Arabians," my friend went on, "do not care themselves to be personal servants. All retainers, even those who serve the King himself, call themselves Companions of their masters. The Arab," he ended proudly, "is the servant of God, and not of any man." It did not seem to occur to him that this is the complete case against slavery for all men.

10

Qai'iya, Afif, Dafina, Muwaih and Ashaira

Large granite tors and blocks of black basalt were strewn over the vast plain we crossed after leaving Duwadmi the following morning. Our convoy now consisted of the one lorry, three cars and 'El Box'. On the lorry was a black and white sheep, whose mournful face looking over the side haunted me during the day; and I was quite relieved when I heard that evening that he had been sacrificed for the men's supper. Also two chickens, to replace those unfortunate birds in the wicker cage, whom we had not seen since we crossed the Nafud Al Sirr.

As we proceeded we got distant views of sharp-peaked blue- and rose-coloured mountains. There were many mirages, some of which looked so close that one longed to go and dip one's face in those will o' the wisp pools, for it was very hot. There was a burning breeze which caught the sand up into spiral columns and blew them along, and one saw how the idea of Genii appearing might have been suggested to the writers of Arabian fairytales.[109]

At noon we reached Qai'iya, having done our first hundred miles.[110] The wells here are shallow and quite hard to find. The water is of poor quality, and though our men found the wells they did not take any water from them. Nevertheless there were many Beduin tents round about and sheep grazing close to the track.

Three small shepherd boys, aged ten and eight and six they said, came over to the cars to make our acquaintance. Their keen, intelligent eyes sparkled like black onyx in their little brown faces, and one could see their lean, lithe bodies through their ragged *thaub*s. They looked like slim fauns. We tried them with plain chocolate which, after much persuasion, the eldest boy nibbled with great caution and then spat out with an expression of extreme disgust. The flat loaves of the desert, however, were gratefully accepted and eaten forthwith.

Above The route from al-Duwadmi passed this 'sphinx-like' group of mountains.

Below Shaykh Hafiz Wahba (centre) persuaded these three Beduin boys to be photographed by the Rendels.

146 *Arabian Journey*

Sheikh Hafiz asked the eldest shepherd boy if he would like to go with us to Mecca. He replied that he would rather stay in the desert with his mother. To tease him the Sheikh then said: "Do you not love the House of God?" To which the child answered: "I love the House of God, but my sheep are here." A conclusive reply.

We left them standing in a row munching their loaves and pushed on towards Afif, the next well, where we purposed to have our midday meal.[111] Presently 'El Box' punctured, and we were foolish enough to leave it behind to be repaired and follow us. About an hour short of Afif, as there was no sign of it and it was nearly two o'clock, we decided to stop and wait for it and our lunch. We got out of the car into a sun which seemed to sear you from the crown of your head to the soles of your feet. It had a curiously exhilarating effect on me, making me feel slightly drunken. For an hour or more we waited, sitting gloomily in the meagre shade of a *salam* tree and thinking of the stories we had read in our childhood about the sufferings from hunger and thirst of travellers in the desert. Our only distraction was a very beautiful beetle of great size with broad yellow stripes on his back and round his black belly. This roused G. temporarily from the lethargy of hunger, but he soon relapsed. At half past three one of us, I forget which, had a brainwave. We would send our car back along the track to find 'El Box', extract Muktar and the lunch from it and return again. Why we did not think of this obvious solution sooner I cannot imagine. I can only conclude that our brains had been atrophied by privation and exposure to the noonday sun. The plan was carried out forthwith and the car returned after another half an hour with Muktar and the food. It appeared that 'El Box' had gone on puncturing resolutely, one tyre after the other, and they were still mending the last puncture a few miles behind us. They drove up triumphantly while we were eating and we did not lose sight of them again that day.

Thence, keeping a range of blue mountains to the south of us, we went on to Afif, which has one well of good water, stone-lined, eighty feet deep. Here we fell in with a number of lorries loaded with pilgrims returning from Mecca. The lorries had masses of heterogeneous luggage on the roofs and crates of earthenware bottles containing water from Mecca slung out over their sides. There were camel caravans also, but not as many, as the usual caravan route runs farther south. Some of the camels had brightly coloured rope fringes with tassels hanging from their saddles. The women rode inside a kind of howdah with curtains round it and often had children on their laps. Some of the more devout pilgrims walk to Mecca, sometimes coming great distances. We heard of a case of a man and his wife who had taken three years to walk and had had two children born on the way. Nearly all travellers at this season are pilgrims, and we always allowed it to be assumed that we were also. I passed for a Turkish lady, unable to speak Arabic.

The inconspicuous well at 'Afif was marked by a prominent hillock topped by a pillar.

Beyond Afif the country opened out on to a wide plain, with hills of an almost unbelievably dark and brilliant shade of violet to the south. There were some stony and sandy patches and a good deal of thin reedy grass. As we went further, patches of black igneous rock, like coal, were scattered over the plain, and isolated rocky peaks rose like steeples in the distance. Our camping ground for that night was to be Dafina.[112] It was still eighty miles ahead of us, so we decided to sup where we were and send on the lorry, with the two small British Army tents which had been brought in reserve and we still had with us, to Dafina to pitch the camp before we arrived.

When we finally reached Dafina about half past nine, having done two hundred miles that day, we found everything ready for us. A large fire had been built and was burning merrily, and tea was being boiled in the petrol tin as usual for our party. A very picturesque group they made squatting in the circle of firelight, drinking tea from small glasses with handles and talking, talking, laughing, and again talking. What chatter-boxes they were and what a cheerful, good-humoured company. No one could wish for better travelling companions. Several Beduin dropped in from neighbouring tents. When they see a campfire burning they all come in, taking their welcome for granted, and, with an "Assalamoleikum", sit down with the rest. It has been truly said that who cooks in the desert is the host of the Beduin. But they themselves are equally hospitable. On more than one occasion we were given as much camel's milk as we could consume, without thought of payment or return of any kind.

Dafina was our first really early camp, on this journey. We turned in soon after ten o'clock and slept sound.

Dafina by daylight next morning proved a pleasant spot, with quite large *salam* trees, much scrub and camels grazing.[113] The general effect was green and genial. We packed rapidly and left our tents to look round a while before we started.

Packing in the early morning is the acid test of harmonious travelling, I think. We stood it pretty well, though it was apt to jaundice our outlook for the first few miles of the day. In spite of every effort to put just what you need for the next night on the top, there is always something indispensable to the modicum of comfort

Geraldine and Hafiz Wahba wait as the camp at Dafina is packed up for the onward journey.

The cars were able to put on a turn of speed over salt flats, such as this one known as Sabkhat al-Dafinah.

Qai'iya, Afif, Dafina, Muwaih and Ashaira 149

that you have resolved to maintain which manages to get to the bottom and has to be retrieved. Then in a tent which is anyhow dark, and where you cannot raise the flap for fear your wife may be seen unveiled, it is not easy to shave or do your hair with a mirror four inches by six, for which you have no facilities to either hang or stand. We used to try and hold it for each other, rather unsuccessfully – G. maintaining that when I held it he could see nothing but the crown of his head. It is also easy in such circumstances to mislay things. Constantly we would be looking for a shoehorn, or a pair of scissors, both elusive and essential; or the wherewithal to sew on buttons, which seemed to leap off our clothes on the slightest provocation. These were all trifling drawbacks however to the interest and pleasure of our days.

Camel's milk was brought to us by a Bedu woman before we started in a leather skin, tasting sour and strong of the hide. The Sheikh, when he saw my face after the first sip, told me to pretend to drink it, so that the feelings of the giver might not be hurt. I took his advice and later poured it into the ground. He asked her about her sons and then about her daughters. She spoke about her sons and then wanted to know why he had asked about her daughters. One does not usually speak of one's daughters to strangers. With a twinkle in his eye, Sheikh Hafiz said that he was wondering whether one of them might not do for his son to marry, and he looked at G. as he spoke. The woman appreciated the joke and laughed heartily with us.

We broke camp soon after eight a.m. Our first fifty miles were across *sabkhah*, the wide salt plain known as Khabra Khal.[114] Parts of this were so thickly covered with salt that it looked like freshly fallen snow. The Sheikh told us how on one occasion when he had been crossing this *sabkhah* by camel caravan and they had camped for the

The fort and petrol dump at al-Muwayh in the border zone between Najd and the Hijaz.

Not for the first time, the Ford brake 'El Box' got stuck in the mud, as here in Sahl Rakbah after a rainstorm.

night in the centre of it, they had had difficulty in the morning in knowing in which direction they were going, so monotonously white was the plain. We went on slowly rising over dry volcanic ground, and big stretches of desert strewn with basalt rock, until we reached Muwaih.[115] This fort, which was being used as a petrol dump, is 3,000 ft up and marks the boundary between Nejd and the Hedjaz. It was a sordid spot, all the refuse from passing cars and caravans being littered over the ground, with hundreds of empty petrol drums lying around. Some Beduin had built a hut for themselves near the Fort of these petrol drums, which looked quite an efficient habitation.

After Muwaih the route turned due south, running by the Wadi Huwwa for a few miles and then spreading gradually into a gravel plain known as the Ruqba.[116] Over this plain the cars went at great speed, racing three abreast up to seventy miles an hour, although we were steadily rising. On the further side of it our petrol tank was discovered to be leaking and the chauffeur got down and plugged the hole with dates. Another sideline for products of the palm tree. This tank continued to be plugged with dates, renewed from time to time, until we reached Jidda. While this simple operation was being performed, we lunched in the shade of one of the *salam* trees, which here were of considerable height and had long spiny thorns and yellow mimosa-like flowers.

Qai'iya, Afif, Dafina, Muwaih and Ashaira 151

Above The wooded camping ground at 'Ashayrah, on the Hijaz border, was an important junction of the main east–west caravan routes across Najd.

Below Rendezvous at 'Ashayrah: Harry Eyres (left) and Sir Reader Bullard arrived as planned from Jiddah at the same moment as the Rendels from Riyadh.

Not long after we had started off once more, black clouds appeared from the south-west and we were suddenly startled by a loud clap of thunder, and heavy drops of rain. The shower only lasted a few minutes; the sun shone again and we thought no more of it. A little later on the wheel ruts in our track began to be filled with water and, as we went on, the streams deepened until the whole track was waterlogged. Soon there were pools and wide wet areas on each side of the track, and we had to make big detours to find firm dry land. The storm, of which we had only known the fringe, had burst on the high-lying plateau ahead of us and the water was running back in our direction. Camels were being brought by the Beduin to drink in the pools and the women were busy filling water-skins.

Rain is a welcome event to those who dwell in the desert; to travellers, on the other hand, it is often a disaster. Our going became more and more precarious, and finally 'El Box', always the first in trouble, sank into the mud up to the top of its wheels. This was a tougher job than submersion in sand. The car was soon so covered with Arabs endeavouring to lift it out of the slough, that one could see nothing of it but its roof. As they struggled with it they sang in unison. After about twenty minutes of straining and lifting and singing, 'El Box' was extricated from the mud and we were able to continue with great caution across the quagmire. Happily we had only a few miles more of treacherous going before turning south-west to cut across the corner of the large belt of *harra*, which had been lying to the west of us for some thirty miles. *Harra* is volcanic rock of a purplish black colour and the plain we now crossed was strewn with it.[117]

The wells of Ashaira, which we reached about five o'clock that afternoon, are 4,500 feet above sea level and 550 miles from Riyadh.[118] There are two good wells, with a plain obelisk bearing an inscription saying that they were restored by King Ibn Saud. Ashaira is one of the favourite camping grounds of the King and is a green and pleasant spot with many bushes and small trees.

Here we were met by Sir R. Bullard and Mr Eyres of the British Legation at Jidda.[119] They also had adopted Arab dress to come into the desert and the meeting of the four pseudo-Arabs had its humorous moments. Fresh equipment had been sent by our kind and thoughtful hosts to replace what we had left behind us on our way, and we found mess tent, reception tent and sleeping tents prepared for us. We had tea, and much pleasant talk. I felt as if I had been in the desert for months instead of weeks and it seemed strange to be speaking with Europeans again. I felt oddly sentimental too about the approaching end of our journey and found myself wishing

Right George Rendel on the morning of departure from 'Ashayrah.

Qai'iya, Afif, Dafina, Muwaih and Ashaira 153

that we were going to accompany Sheikh Hafiz when he made his return journey to Kuwait in a few days' time. A beautiful dinner of seven courses was served to us by a Meccan cook, with several special Meccan dishes, to which I am afraid we none of us really did justice. Our light desert suppers had put us out of the way of dealing with a heavy evening meal.

A camel caravan makes its way along the Najd–Hijaz route on the morning of the Rendels' departure from 'Ashayrah.

11

Taif

Taif, the summer capital of the Hedjaz, was our next objective. It lies about fifty miles from Ashaira in a southerly direction. The track led over upland plateau with many bushes and a few Beduin tents, on to broken granite country, with fine tors of reddish granite. There were many large *talh* trees: a biggish thorn this, not unlike the olive in shape and colour, but of a more bluish and silvery grey, with very long thorns.[120] We passed stretches where the ground was covered with patches of white creeping convolvulus, and a small yellow mullein, only a few inches high; and there were clumps of white gold-centred flowers, not unlike the cistus, which grew in great profusion.

High mountains began to show ahead. Our first village was Umm Hamdha, thirty-five miles from Ashaira.[121] The houses here were built mostly of stone, and a row of fine dark-coloured tamarisks was a distinguishing feature. There were gardens and a few cornfields and palms, the first since we left Riyadh. Shabha was the second village just before Taif; an ugly hamlet this, without personality, lying on the eastern side of the hills.[122] Its most prominent building was a big Turkish-built house erected by the father of King Hussein, which looked rather like an inferior hotel in a Riviera town, and which Sheikh Hafiz said was in the *Dolma Bagche* style.[123] We saw a prickly pear here in great luxuriance for the first time on the journey.

Taif itself has a fine natural situation in a wide valley on the north-eastern slopes of low mountains.[124] The approach from the north is rather disappointing. One enters the town through a district of ruined houses, the debris of the devastation of two wars – the Saudi–Hashimite and the Great War.[125] The approach from the south-east, which we made later, is more beautiful, showing

one the town in its natural setting of mountains. Taif has some fine buildings, including a large mosque of Turkish origin, and many houses with beautiful gardens. It is famed for its grapes and pomegranates, and roses are grown in large quantities for distillation at Mecca, whence attar of roses is distributed throughout the Moslem world.

As the guests of the Amir of Taif we were lodged in a summer pavilion belonging to some highly placed but absent official. It was an attractive house, with a curious high *diwan* shaped like the apse of a church, completely open at one end to the terrace above the garden. Steps led down into a walled garden full of scarlet geraniums and jasmine. A stone fountain stood in the centre of the garden and paths radiated from it. The bedrooms were in a separate wing, approached from an inner garden, full of fruit trees in flower. The entrance to this wing was protected by a wall built across the door, but a few feet away from it, so as to conceal it. The accommodation was excellent: large rooms, comfortable beds and plenty of hot water.

Almost directly after our arrival we received a formal call from the Amir. Abdul Aziz bin Muammer, Amir of Taif, was a good-looking young Nejdi, with a fringe of black beard on his chin, a weak but attractive face, and a sad but charming smile.[126] He had at one time been Amir of Jidda, but had never cultivated the art of small talk. He appeared to be completely tongue-tied, and conversation, when it flourished at all, was one-sided. He livened up a little when riding and shooting were spoken of, but otherwise initiated nothing. We were told that he was a very fine horseman. He certainly sent us some lovely ponies for our expedition into the Shafa Hills, later that day.[127] He had apparently supreme authority under King Ibn Saud over the whole district of Taif, an immense area extending pretty well to Asir. There had been some doubt as to how the Amir of Taif would receive a lady, the Nejdi being extremely rigid in his outlook towards the female sex. He resolved it by ignoring me altogether. I sat in a corner like a child in disgrace and did not even get coffee offered to me.

An hour later we set out for the Shafa Hills, an expedition which had been organised for our benefit by the Amir. We were to motor to the Shagra Valley,[128] about one hour from Taif, lunch there and go on by donkey, or pony, to the top: a four hours' climb, where, at eight thousand feet, we should camp, see the sunrise, and enjoy a superb view of the Tihama, the coastal plain between the mountains and the Red Sea, returning to Taif the following morning in time to lunch with the Amir. It was simply a picnic, they said, and it sounded a most attractive programme.

We started southwards in the cars, passing gardens and cornfields and wells, and it was pleasant to see so much fertility after the aridity of the desert. The track was incredibly bad and, as the valley narrowed between the granite hills, it disappeared altogether. There was only the dry *wadi* bottom, and our guides

Above The Rendels were accommodated in this pleasant garden pavilion in Taif.

Below Their sleeping quarters were in this separate wing. The picture shows Fakhri Shaykh al-'Ard, who accompanied them throughout their trans-Arabian journey.

Geraldine explores the gardens south of Taif.

were afraid to risk the soft sand in this. They took us instead up over the lower slopes of the mountains, amongst boulders and bushes and over steep banks and fallen tree trunks. Among the many astounding feats I had seen cars accomplish in this country, it was an outstanding performance. It was my first experience of mountain-climbing by car, and it did not seem to me the ideal method of approach. Even the Fords jibbed at some of the boulders. The guides walked in front of the cars and selected what appeared to them to be the easiest way, not always with the happiest results. I was just wondering how long it would take before my bones would be as jelly, and the car disintegrate completely, when suddenly we heard the jingling of little bells, and saw a train of horses and donkeys cantering down the mountainside to the floor of the valley. They made a picturesque troop with their gay saddles and trappings, and their romantic-looking riders armed with rifles and daggers. There must have been some twenty little white donkeys and six lovely Arab horses sent by the Amir of Taif as mounts for us, with the warning that donkeys were really better on mountain paths.

Although I had abandoned full Arab dress for this expedition, my clothes did not lend themselves to equestrian exercise. They were a compromise between East and West and like most compromises combined many of the disadvantages of both. So I opted for a donkey. G., however, chose a white horse and looked very fine with his *'aba* spread out over the back of his steed. The horses had no bits, only a rope bridle on one side of the mouth, and no stirrups. Some of the Arabs rode them in patent leather pumps and curvetted about showing off their horsemanship in great style.

Geraldine starts out from Shagra (Shaqra') on a donkey after lunch.

We pressed on to Shagra, where we found a vast camp in the making. Only a favoured few of our vast convoy were to accompany us to the summit of the Shafa Hills. The others were to remain in the valley and await our return on the following day. An elaborate lunch had been prepared for us and a tent erected in which to serve it. Not quite our idea of a picnic; but nevertheless an excellent meal.

As we ate, I watched through the door of the tent one of the lorries come over the top of the hillside and descend into the valley. Carrying kitchen stuff and bedding, with cooking utensils slung around it like a travelling tinker's cart, it reared its bonnet proudly up on to the brow of the hill, paused for one breathless second on the summit, and then plunged down the mountainside full-tilt ahead over rock, boulder and bush. It arrived on the floor of the valley scattering its contents far and wide but, incredibly, right side up. Never have I seen the like. Yet nobody appeared to think it in the least unusual.

By the time we had finished lunch, food, bedding and the personal belongings of the whole party had been strapped on to the donkeys and it only remained for us to mount our steeds. I found to my dismay that a huge mass of bedding had been laid across the saddle of my donkey upon which I was expected to

sit. The width of the pack made riding astride far from comfortable or secure, condemned as I was to a skirt; but it would have been impossible to stick on the beast side-saddle with that pack up a steep mountain track; so I made the best of it and covered up gaps by laying my *'aba* across my knees. By the time everyone was mounted, we had a train of at least twenty donkeys in addition to the six horses, and must have looked rather like a travelling circus. It was already a quarter past four in the afternoon.

We set off on a pleasant winding way, the track mounting slowly through fine valleys with small villages, each with its watchtower and gardens enclosed by stone walls. Then we began to climb more steeply among granite boulders and fine juniper trees in full berry. The mountainside was covered with great bushes of dark and pungent scented lavender, big clumps of a golden daisy, and another small white flowering shrub which I cannot name, making a marvellous pattern of purple and white and gold on the hill face. As we mounted, the views behind us grew ever grander and we looked back over ridge after ridge of red granite hills and juniper forests. The track grew more precipitous and difficult for the beasts as we went on, and they slithered on the slippery granite rocks. Our chief guide fell off twice, and many of the party preferred to dismount and walk.[129]

George Rendel (second from left) and Hafiz Wahba (centre) set out on horseback for the mountain expedition.

At sunset, we found ourselves still two hours from the top. It was not the kind of track to be lightly attempted in the dark and, as our guides were already disagreeing about the way, we decided that the only prudent course was to make for a tiny hamlet about a quarter of a mile to the south-east of us and spend the night there. We reached the village just before dark and found about fifteen to twenty stone-built houses in a little street. We were received with the usual overwhelming hospitality of the Arabs. I couldn't help wondering what would have happened in an English village in, say, the Lake District, if a train of twenty donkeys, six horses and some forty souls had arrived out of the blue at sundown and proposed to spend the night. I am afraid English hospitality would not have stood the test. These folk took it quite as a matter of course. They cheerfully admitted our party to share their little homes, and prepared to kill and roast sheep to feed us all.

The best house in the village was placed at our disposal. Opening on to a terrace with a low wall round it, from which the hillside descended steeply, it had a lovely view of the mountains. The house itself consisted of one good-sized room, which was spotlessly clean, with a depression in the centre of the earthen floor for a charcoal fire. Ancient rifles hung on

The terrace of the village below the summit of the Shafa (Shifa) Hills. From right: Geraldine Rendel, Reader Bullard, Hafiz Wahba, Harry Eyres.

The peaks of the Shifa Hills near Taif rise to some 9,000 feet.

the walls, and a large, ill-cured sheepskin, from which emanated a sour and oppressive odour. No means of ventilation existed except the door and a hole in the roof.

We supped on the terrace, sitting in a row with our backs to the wall on the Persian carpet which had accompanied us on one of the donkeys. Two courses and coffee were served by Muktar with his usual suave perfection by the light of one kerosene lantern set on the doorstep of the house. The only disturbers of our peace were a host of large winged beetles, who buzzed drunkenly round the light and threatened constantly to invade our meal, but happily never quite did.

As we were finishing, G. made the paralysing discovery that our joint suitcases, blankets and warm coats had not come up on any of the donkeys. As we were 7,000 feet up and the night was already beginning to be chilly, this was something of a blow. For the first and only time we fell upon Muktar and tore him to shreds with our sarcasm. He explained with a smile of perfect serenity that he had been obliged to take some of the luggage off the donkeys because their loads were too heavy, and had sent a man back to the Shagra Valley to fetch a camel to bring all the things on. I asked how he expected a camel to come up the track we had followed in the dark; to which he replied with simple

dignity that the camel was coming and would be with us, he was confident, before we were ready to sleep. Sheikh Hafiz, to whom as ever I turned in my distress, said: "It is incredible what these people and their camels can do. He will arrive, Inshallah."

Sure enough, he did. Shortly before ten o'clock he came lumbering up the slope and was tethered for the night on the side of the hill just below our terrace, where the horses and donkeys were already stabled.

While we sat on the terrace, the sound of the beating of drums came from the little village and roused my curiosity. I asked Sheikh Hafiz what this might mean and he told me the headman of the village had asked permission to have singing in honour of our visit. I thought again of an English village, and wondered whether, supposing they had been persuaded to take us in, they would have had any urge to get up a singsong in our honour after all the trouble they had already been put to. Arab hospitality is a wonderful thing.

I imagine that this musical jaunt would not have been possible at all in Nejd, where Wahhabism is strictly practised and music among the forbidden things. But the Hedjazis are not quite so rigid in their observance of discipline; though even here permission had to be obtained.

I asked Sheikh Hafiz whether I should be allowed to go and listen to the singing and he said he was sure they would be very pleased if I did. G. said he would like to come too and we all three set off to the village. About halfway up the main street, we were admitted to a very low, dark room in one of the houses, lit by a single lantern on the earthen floor. In the centre of the floor in a shallow depression a coffee pot was warming amongst charcoal embers, and the combined light of brazier and lantern shed a warm romantic glow over the assembled company.

A semi-circle of two rows of young men stood on one side of the room. In front of them were the three poets of the village, who improvised verses as inspiration seized them, and sang turn and turn about, while the young men clapped their hands, bent their knees and stamped their feet in rhythm to the beating of the drums. When a verse was finished the young men repeated it in chorus. Two drummers sat cross-legged on the floor, opposite to the young men, with the charcoal fire between them. They had open drums like gongs, which they beat with their hands and warmed at the fire from time to time, when the skins of the drums got slack. Behind them a large carpet was suspended on a pole, separating the living room from the sleeping quarters.

When one of the poets had composed a new couplet, he raised his staff as an indication that the spirit was working and he was ready to sing another verse. One of the three was less versatile than the others and got forestalled several times, to his chagrin; they would spring forward excitedly and begin their compositions before he had a chance to get in. It was up to the poets to change the chant when

they wished, much as cantors change the tone when starting a new psalm at the singing of office.

When we arrived we were taken to the far end of the room where a strip of carpet and cushions were spread for us to sit on. The Sheikh, or Headman, of the village was present listening with his young son, a remarkably good-looking boy wearing the attractive Hedjazi hillman's dress in saffron and rust colour, with a wide turban and red sash. For nearly an hour we listened, while Sheikh Hafiz whispered translations of some of the more apt verses. Several of them were about our unexpected arrival at the village. They boasted that they always had bread and coffee for all who might come. The dark, handsome faces with gleaming teeth and vivid eyes, seen dimly in the deeply shadowed spaces outside the circle of light in the centre of the room, had the rich bronze effect of a Rembrandt interior.

At eleven o'clock we left them still singing, and went back to our house to find the indefatigable Muktar putting the finishing touches to our camp beds. I elected to have my bed outside on the terrace, leaving the inside of the house for the three Englishmen of the party.[130] Sheikh Hafiz had found quarters for himself in the village, where he could rise to pray at dawn without disturbing anybody.

I lay long awake that night, watching the pageant of the Milky Way above me and the line of the distant mountains silvery blue under the tender light of stars. The chanting and beating of drums rose and fell in the stillness until at last it died away and the village slept; and the only sound to break that charmed silence was the occasional stirring of one of the beasts tethered below the terrace.

 Uber alle gipfeln ist ruh
 Warte nur balde ruhest du auch.[131]
And I slept also.

When I awoke, the waterproof valise which covered my blankets was drenched with dew. I felt as one can only feel after a night spent in the open: that wonderful sense of exhilaration and wellbeing, and an immediate readiness to be up and doing, which is so foreign to the sleeper in a bedroom. Rising was a little complicated. Although, like the Evangelists in the nursery rhyme, I had gone to bed in some of my clothes, I felt distinctly self-conscious about getting out of bed on that open terrace.[132] I understood what the undergraduates of Somerville College who slept in the garden during the summer term must have felt when undergraduates of an adjoining men's college took to giving breakfast parties to see the Somerville girls getting up.[133] I need not have worried. Arab courtesy did not allow of 'Peeping Toms'. The camel and horses and donkeys tethered below the terrace were my only observers.

Our breakfast consisted of tea and biscuits, which I found sadly inadequate after my open-air night. The breakfast of our party, which they brought to show

us, is worthy of description. It consisted of an immense loaf baked in a tin like a cake, still hot from the oven, and a large bowl of liquid fat (ghi[134]). Pieces were taken from the loaf with the fingers and dipped into the fat. Though I did not particularly want it, it certainly looked a warm and comforting meal for a brisk early morning in the mountains.

While I was packing our suitcases on the terrace, I was visited by an inhabitant. The ancient dame came sidling quietly onto the terrace and sat down on the ground beside the suitcase and watched me in silence. The contents of that suitcase were evidently of absorbing interest to her and her black eyes sparkled as I showed her the working of an electric torch. She simply could not keep her fingers from my rather gay sponge bag and the things I put inside it convulsed her with discreet mirth. When you come to think of it, a sponge bag has an element of the grotesque about it. Mine was fitted with different-sized pockets for all my washing apparatus, and she treated it as a kind of lucky dip, extracting the contents of each one with her terribly thin hands. Her laughter was like the reedy piping of a small bird. We played this game for some time and then as a diversion I tried her with a few words of Arabic. She immediately became extremely voluble, and I gathered was telling me about all her sons and grandsons. When the spate of words ceased, she hurried away as swiftly and silently as a wisp of mist and I did not think to see her again. She reappeared, however, just as I was closing the suitcase, with three small boys, whom she presented me with much pride as her grandsons. She pressed me to visit the wretched hovel on the hillside which she inhabited, and let her give me coffee; but time did not allow of this.

The Amir of Taif's invitation to lunch that day precluded any possibility of going on to the summit of the hills, which was disappointing. But I confess, that though I regretted not seeing the view from the top, I should have been very sorry to miss our night at this village, which was one of the unique experiences of our journey.

The return was by a different and much less steep track, and the views were not so fine. On arriving in Taif I found that the Amir's invitation to lunch had been extended to include me; an '*amende honorable*' for his neglect on the previous day. I was hot and tired after the ride down from the hills and decided to let the men of the party go without me. Muktar served me a dainty three-course lunch on the wash-stand in my bedroom, using the towels as table cloth and napkin. Who but Muktar could have risen above circumstances so convincingly? We might have been at Boulestin.[135]

When the men returned from their lunch with the Amir, Sheikh Hafiz took us out to see the Liyah Valley, some fifteen miles from Taif.[136] We skirted the town by its south wall, passing a large white mosque, and crossed a wide dry sandy *wadi* to the east of the town. From here a very good view of Taif is obtained, making it look far more attractive than from any other aspect. From

Above After a night in the village, the party gets ready to make the descent back to Taif.

Below Making the descent from the Shifa village through granite boulders.

Above The Liyyah valley, 15 miles from Taif, is a long and fertile agricultural area.

Below An impressive view of Taif taken from the east of the town.

Taif 167

the *wadi* we crossed a stretch of plain with flowers and shrubs and then the track climbed and wound for perhaps ten miles, the scenery growing finer and the hills steeper as we went on. Finally we passed through a very narrow rocky pass, and dropped from the crest into the long, fertile Liyah oasis, which runs north and south for nearly thirty miles.

We were entertained on a terrace belonging to two charming houses overlooking the whole valley. Below us lay vast fruit gardens of pomegranate, quince and apples: and beyond stretched vineyards and fields of corn and maize. The gardens were irrigated by shallow wells of not more than four feet deep. The valley itself is narrow, little more than half a mile wide and bounded on the east by a wide river bed said to be a rushing torrent after rain. On the far side is a strip of rising ground with mountains beyond it of five or six thousand feet, where the Amir Feisal likes to pitch his summer camp.

We left Taif next morning for Jidda.

Through Mecca the route from Taif to Jidda only takes five hours, but this route was closed to us as non-Moslems. The route by the Wadi Fatima, known as the Darb-an-Nasara, or Nazarenes' Way, which takes seven or eight hours, was reported impassable owing to recent rain. We were obliged, therefore, after returning to 'Ashaira, to make a big detour to the north, where we could intercept the Arabian Gold Mining Syndicate's new road; and spent twelve hours on the way as a result.[137]

We set out from Ashaira the second time soon after nine a.m. and, leaving the Muwaih track to the east bore northwards towards Birka. Almost at once we were on *harra*, and had it not been for the cleared and in places metalled road made by the Gold Mining Syndicate, the cars would here have met their Waterloo.

This new road had been recently constructed by the Saudi Arabian Mining Syndicate from the coast to the mining camp at Mahd al-Dhahab. Metalled in parts, it traversed mile upon mile of barren, lava-strewn desert

The plain is so thickly strewn with lava rocks that it would be impossible even for Arab-trained cars to negotiate it. Very grateful for that road we were, as it enabled us to cross this desperately dreary stretch of desert with comparative speed.

About thirty miles due north of Ashaira we turned westwards, where the track branched off at Birka, and came on to the metalled part of the road. This is marked by a stone curb and little cairns at short distances apart, and has a surface of dark-coloured sand. Another ten miles on and we rose to the crest of the *harra*, a height of over 4,000 ft, where we found road repairs in progress. Here we turned sharply westwards and began dropping from the edge of the plateau on a well-engineered road by graded curves from shelf to shelf of broken foothills and valleys. A south wind was blowing and the heat when we got down into the valleys was intense. We stopped to eat at Madraqa, a beautiful palm grove, through which a shrunken stream not so much flowed as meandered.[138] Still it was water and just the bare idea of it made one feel cooler. Lunch under the palm trees was extremely consoling. Muktar cooled the tinned peaches and the Evian bottles in the stream in the most approved Western manner; and though it did not make them any cooler, the stream being, if anything, hotter than they were, it was a gesture in the right direction.

After the meal, G. and I walked some way up the bank of the stream and found branching palms for the first time. We also met three little Beduin boys carrying

The party stopped for a picnic at the shady little oasis of Madrakah.

bags, who were coming to see what the picnicking party might have to spare for them. We photographed them and sent them on to the kitchen, where I have no doubt their bags were generously filled by Abdurraman.

On again in the cars over granite country, still dropping through wild rocky valleys, crossing a *wadi* with water in it and a big plain with palm groves and a village amongst surrounding hills. It got hotter and hotter as we dropped lower and lower over each pass to the valley below it, until at last we reached the Tihama, the semi-tropical coastal plain which stretches from the foothills of the mountains to the Red Sea.

As we approached Jidda night fell; a hot and suffocating night. The Governor and an Under-Secretary from the Ministry of Foreign Affairs with a small escort of police met us just outside the city walls. We got out of our car and listened to a short speech of welcome in the name of King Ibn Saud.

Madrakah provided a welcome rest before the final run to Jiddah.

12

To Jidda to Meet the King

JIDDA IS THE PORT for Mecca and the clearing house for thousands of pilgrims who pass through on their way to the Holy Cities year by year. It stands on the shores of the Red Sea and the Tihama sweeps away from its walls to the foothills of the mountains. Inside the walls there are high, imposing buildings in wide streets, side by side with little humble houses of squalid appearance, huddled without plan in narrow lanes. There are fine business offices and foreign legations which would not be unworthy of a European capital. There are big hostels for the accommodation of pilgrims, who have to be housed for considerable periods while waiting for accommodation on the overcrowded ships to return to their own countries. It is not uncommon, when these hostels are full, to find pilgrims camping in the streets under the walls of the houses for lack of better shelter. But this is no particular hardship as far as weather goes, for Jidda has a tropical climate.

The British Legation, where we stayed, is a tall house, rising directly from the street without garden or enclosure, close to the walls of the town. It has a pleasant roof terrace on the seaward side and would enjoy a fine view of the sea did not a vast and blackened water condenser, like a suburban gasometer, and the local prison stand directly between it and the seashore.[139] The house, like most of the buildings in Jidda, is built of wood and coral and has carved wooden balconies to all floors. Inside there are three flights of steep stairs, with very high treads, and large and pleasant rooms furnished in excellent English taste.

The climate of Jidda is bad. Even in mid-March, which is the cool season, the air is heavy and moist and the mosquitoes many and ravenous. I counted fifty bites round my ankles after the first two days. The residents wear light Wellington

Above Two views of Jiddah from outside the walls: from the east (top); and from the north, with a gate, and the sea in the background.

Below Inside Jiddah, looking towards one of the city gates.

Above Hijazi troops marching past the British Legation, 19 March 1937.

Below Jiddah seen from the roof of the British Legation.

Two views of Jiddah from the roof of the British Legation: looking eastwards (above) and towards the harbour (below).

174 *Arabian Journey*

Above and below Jiddah's buildings were the finest expression of the distinctive Red Sea style of architecture, as shown by this beautiful example photographed on 22 March 1937. The style combined influences from Egypt and Yemen.

To Jidda to Meet the King

boots as part of their dinner dress in the evening to protect their legs from this pest. Tropical clothing is worn all the year round. Later in the season the heat is so great that even the mosquitoes cannot survive. Then the flies come. We arrived with a south wind, which made the contrast from the dry breezes of the desert all the more trying.

There was a mosque immediately outside my bedroom window and I had an excellent view of the Imam giving the call to prayer from the minaret. The court was also the playground of the boys' school attached to the mosque. These lads afforded me considerable entertainment; how fundamentally alike are the natures of small boys in East and West. These youths appeared to play the same games, to have the same methods of tormenting each other, and the same ideas of what is funny, as the school boys who take their recreation in a school yard a hundred yards from my house in Chelsea. The Arabian *thaub* is tucked up round the waist and the legs twinkle along just as rapidly and climb walls with the same agility as the sturdier and more muscular legs in shorts in Chelsea. I think perhaps the Imam got a little less attention and respect when he attempted to collect them from their recreation for their lessons than the school master in Chelsea gets when he blows the whistle which ends the morning break; but I saw little other difference.

In the bazaar, Jiddah: tossing kapok for matresses.

Above Jiddah's tall buildings provided shade from the blistering sun.
Below The bustling scene in a wide street by the market.

To Jidda to Meet the King

178 *Arabian Journey*

Opposite and right On the morning following his arrival in Jidddah, George Rendel was presented to King 'Abd al-'Aziz in his *majlis*, and was given the opportunity to take these portraits of him.

The bazaar in Jidda is full of interest and colour, and seems endless in its ramifications to the stranger. Bazaars, like the poorer quarters in big cities, have a great fascination for me. I can spend hours wandering about them and I frankly admit that dirt and smells, which at other times I shrink from, in bazaars leave me quite unmoved. I spent a happy morning getting lost in the Jidda bazaars with a tireless friend.[140] We looked at silver- and goldsmiths' work: belts made in the form of straps in gold or silver metal; heavy bangles such as I had seen on many ladies' wrists; rings to be worn through one nostril; fine heavy chains and ankle bracelets; and finger rings with precious stones. We watched the wool carders working at their frames. We saw wooden chests studded with brass nails, with carved locks. We stood spellbound by the variety and colour in the spice merchants' bowls. We were filled with amazement, but not desire, by the piles of sweetstuff of many kinds on the stalls of the sweetmeat sellers. We looked into the bakers' ovens, where the flat round loaves like immense water biscuits were being cooked in open fires.

King Ibn Saud was paying his annual visit to Jidda, on his way back from the Pilgrimage. On the morning following our arrival, Sir R. Bullard was to present his credentials to the King, and it was arranged that G. should be presented to him also directly after this ceremony.

The King's palace lies about a mile and a half outside the walls to the south-east of the town where, according to King Ibn Saud, there are breaths of desert air to be had. It is a modest two-storeyed building approached by a reasonably good desert track. G. was met at the entrance to the palace by Sheikh Hafiz and one of the secretaries and escorted up a stairway between rows of armed Nejdis to a wide sunbaked terrace with more retainers standing to attention. At the far end was a large *diwan* with a square open bay at its furthest side where, on a high settee, cross-legged and shoeless, sat Abdul Aziz Ibn Saud, the great King of Arabia. Open, lightly barred windows were round and behind him, and when later G. sat with him in this bay, he said the effect was as though they were talking in the open air.

As G. walked alone across the sunlit terrace and then through the dark *diwan*, he felt himself being narrowly scrutinised. But this was his only ordeal. The King came halfway down the *diwan* to meet him and received him with the utmost friendliness and cordiality.[141]

To Jidda to Meet the King 179

I saw King Ibn Saud on two occasions. The first was on a Friday morning, when he attended the mosque in the bazaar for prayers. I watched him pass on his way from one of the balconies of the British Legation. I only got a distant and interrupted view, as he went in a closed car, with a negro in scarlet on either step. Troops escorted him, and a Ford brake with a machine gun entrained on the royal car went immediately in front of it.

The second occasion was when I was presented to the King at a tea party given by Abdullah Suliman, the Minister of Finance, in the Government Building, which serves for all departments in Jidda except the Foreign Office.[142] The permanent ministries are in Mecca. We were received by Abdullah Suliman and taken into a long room with a gilt throne on a dais at one end. Here we waited while one or two other guests, including an Englishman who was also to be presented, arrived one by one. Presently a stir in the vestibule outside announced the arrival of the King. He entered the room where we were with two of his bodyguard, raising his hand in a gesture of general greeting to those assembled. The presentations were made, he shook hands with us, seated himself on the throne, and we all sat down.

Hijazi troops line up in a guard of honour in Jiddah, 19 March 1937.

Abdul Aziz Al Feisal Al Saud, who has been called the Napoleon of Arabia, is well over six feet in height, broad-shouldered and upright, and has great dignity of carriage. His face, though massive and cast in the same generous mould as the rest of his person, is finely proportioned and full of vitality and mobility of expression. He has a well-shaped aquiline nose and a curiously disarming smile. From his photographs I had expected someone grim and stern. What I found was a combination of sweetness and strength, for which I was wholly unprepared.[143] I understood how he might be loved as well as feared by his subjects. The large scale of his mind and outlook is at once apparent as he talks. He dislikes the irrelevant, the pernickety or the tedious – though he can at times lose himself a little in reminiscence, especially to a new listener. Like other large-minded men, he seems to bring fresh air into any discussion, to brush away trivialities and to inspire in others a similar method of approach to any subject. He is a man of simple habits; moderate in state, puritan in dress, frugal in food. Many of his slaves are better dressed than he is. In short, he has great charm of personality and one felt instinctive liking for him at a first meeting. This King is completely accessible to all his subjects. Anyone of them can claim audience with him to state a case, or plead a cause, and be sure of a fair hearing and justice. He is prepared to listen to reason from anyone. On the other hand, his word is law. Once he has given a decision, there is not one of his subjects, not even his own son, who would venture to disobey him. "The King does not allow it" is final for everyone. Punishments are severe. The sentence for theft is the cutting off of the hand. Executions, the severance of the head from the body by a sword, are not uncommon.

The King enquired about our journey. G. told him how impressed we had been by the complete security we had found in the desert, which we had crossed practically unarmed and where, although for centuries there had been insecurity, conditions now seemed more peaceful than in many European States.

Ibn Saud replied that this was not his doing. It was due to the people in his Kingdom being united by their religion and true to their principles and knowing that he was devoted to the welfare of all, even the humblest, and that there was justice for everybody. Then he turned to me and expressed the hope that I had not found the journey too tiring. I said I had found it of absorbing interest. He answered that he feared it was a poor country, ill-repaying a visit. To this I replied that I should look back on my Arabian journey with the keenest pleasure all my life.

Coffee was brought and served first to Sir R. Bullard, the British Minister, who was present. The King turned to me with his sweet smile and apologised for this lapse of good manners, saying that his slaves were not accustomed to the presence of ladies. But since my experience with the Amir of Taif, I knew my place and should not have expected anything else.

After coffee, the King got up and led the way into a dining-room, where an immensely long table was spread for about thirty people. Cakes, biscuits and fruit were set on a tea service of Japanese glaze. The King sat at the head of the table. The Amir Feisal, his second son and Minister for Foreign Affairs, sat at the bottom. I sat on the King's right hand, the only woman present. There must have been at least thirty seated; Sir R. Bullard, St John Philby, G. and one other Englishman being the only foreigners.[144]

Standing round the walls behind those seated at table were rows of retainers, men-at-arms, and slaves. Those at table had their attention diverted by food and drink. Those who stood, on the other hand, having no distraction, paid me their undivided attention. I had cast off Arab garments with relief when we approached Jidda; but I confess that on this occasion I should have been thankful to be back in them. After three weeks as a veiled woman, the scrutiny of forty or fifty pairs of eyes made me feel extremely self-conscious.

The meal was much enjoyed by all the

This group photograph was taken by George Rendel after the lunch party given by Sir Reader Bullard at the British Legation on 19 March 1937. Front row, left to right: Shaykh Hafiz Wahba, Geraldine Rendel, Sir Reader Bullard and Shaykh Yusuf Yasin. Eyres, Judd and Fakhri Shaykh al-'Ard stand in the back row.

guests and the cakes were done full justice to. The King himself, however, only took one very plain biscuit with his tea. After it was over, we moved back to the little throne-room and, with many speeches and compliments on both sides, took our leave.

That evening we dined with Mr Philby in his attractive house just outside the walls of the town. This house, which was originally intended for a royal residence, was so badly constructed that it started cracking before it was finished and it proved impracticable to complete it.[145] The King lent it to Mr Philby rent-free for ten years on condition that he kept it in repair. This he loyally endeavours to do, as was evidenced by the wooden columns shoring up the roof in the entrance hall; but I don't think he ever expects to find it standing when he returns to Jidda after an absence. It is a fine house, with a double stone staircase to a half landing, continuing in a single flight to the tiled open court from which all the living rooms open. The locally made green and blue tiles were extremely decorative.

We spent a pleasant evening; a company of twelve, of which I was, as usual, the only woman.[146] An excellent dinner of roast bustard and other succulent dishes was accompanied by much agreeable talk, and it was nearly midnight before the party broke up.

Small as the British colony at Jidda is, it has yet succeeded, true to the traditions of isolated Britons abroad, in constructing a small golf course with sand-greens. I was taken out across this the following afternoon to a beach of fine golden sand strewn with branches of white coral and lovely shells. The shore was inhabited by a host of exquisite salmon-pink crabs with wicked eyes, who rose at our approach on the longest legs that I have ever seen on crabs, and scurried in rhythmic drifts across the sand to the edge of the waves, looking for all the world like a miniature *corps de ballet*. There must have been many hundreds of them. The beach ended abruptly in low sandy cliffs, and I was told that a little further on there was a pool protected by reefs from the invasion of sharks where it was considered safe to bathe.

That evening I dined alone and passed a pleasant evening browsing in Sir R. Bullard's extensive library. He and G. attended a dinner given by the Amir Feisal at the Foreign Office.

13

The Queens' Palace at Jidda

The Royal Palace of King Ibn Saud's Queens lies a short distance outside the walls of Jidda: a low, white building standing in a walled garden with formal flower beds and a fountain basin in the centre.

On Sunday morning, the day before our departure, I was invited to visit Queen Umm Mansur and Queen Umm Tallal, and was taken to the palace shortly after 10 o'clock.[147]

A portico with a flight of very steep steps leads to the entrance, and at the top of this staircase stood three small boys with Dr Midhat, the King's Syrian physician, who was waiting to receive me.[148] He introduced the boys as some of the King's younger sons and they all shook hands with me. The two elder, Tallal and Mish'al, looked about eight years old. The third, Nawaf, was only four, and wore a white *thaub* and a gay little skull cap embroidered in colours. They all bore a strong family resemblance.

Behind them stood the Amir Feisal, the King's second son and his Foreign Minister, who brought me to a small room furnished with the usual velvet settees and chairs and a round table in the centre. Here two more small boys joined us and an older one who might have been twelve or thirteen years old.[149] The Amir Feisal talked for a few minutes in his uncertain English, about our previous meetings on several occasions in London.[150] He alluded with special pleasure to a visit to Windsor Castle which he had made in the company of my husband and son, who had then and ever since been called by them Sheikh Da'ud (David).[151] Then he left me, to return almost immediately bringing Umm Mansur, King Ibn Saud's chief wife, with him.

Slight, graceful and remote, perhaps five feet in height, Queen Umm Mansur seemed to float rather than walk over the ground with her draperies trailing about her like a figure in a dream. She was completely veiled by the wide sleeves of her *deraya* of black chiffon embroidered in a close design of golden leaves. When she unveiled, a *thaub* of magenta silk showed at the neck and at the wrists, where it was clasped by heavy gold bangles.

Queen Umm Tallal followed her into the room. Of the same height but of a slightly more generous build, she also wore a black gold-embroidered *deraya*. Her *thaub* was green; but for this difference they were dressed alike. On their feet they had black patent leather slippers of the English variety known as pumps, and grey woollen socks. Other ladies I had met had worn no hosiery of any kind and I wondered whether this European display of footwear was for my special benefit.

Umm Mansur seated herself on a sofa and indicated by a gesture of her hand that I was to sit beside her. Umm Tallal sat on another sofa at right angles to us, so that by turning my head I could speak comfortably to both. It was a little complicated because, although it was not necessary for them to be veiled in the presence of their husband's son, the Amir Feisal, veiling was necessary before Dr Midhat, who was needed as interpreter. The problem was solved by Dr Midhat sitting at the far end of the room, so that the two Queens could each unveil one cheek to turn to me and keep the other veiled for the Doctor. Several times during our visit Dr Midhat left the room, thus enabling my hostesses to unveil completely.

Umm Mansur's face was a pure oval, olive-skinned, with slightly prominent cheek bones, heavy-lidded black eyes and a sensitive full-lipped mouth. She had an air of lassitude and an exotic look suggesting a hothouse flower that has not known much of the sunshine and breeze. Her thin brown hands had long attenuated fingers on which diamonds gleamed. The palms of her hands were blackened with a species of dye, known I believe as '*wasm*',[152] and the nails and up to the first joint on the outside of the fingers were treated in the same way. Her eyes were deeply outlined in kohl, or antimony – both are used – and her lips were slightly hennaed. Rumour has it that Queen Umm Mansur was a Christian girl from the Lebanon who was sent to King Ibn Saud by the Turks during the Great War. Be that as it may, she certainly gave me the impression of a mind that had had experience beyond the straitened opportunities for women in Arabia. Although the King has married thirty new wives since his alliance with Umm Mansur she still remains his favourite wife, though no longer young according to the standards of her country, which seems to show that it must be for qualities of mind and spirit as well as personal charm that she retains her first place in her husband's harem.

Umm Tallal appeared to be a good deal younger than Umm Mansur. Two, if not three, of the small boys playing in and out of the room were her sons; whereas

the sons of Umm Mansur are already grown up with families of their own. In Arabia mothers are named after their eldest sons. *Umm* means mother in Arabic, and Mansur was the son of Umm Mansur and Tallal the son of Umm Tallal.

I expressed my pleasure at meeting Arabian ladies, saying how sadly I had missed the society of my own sex whilst crossing Arabia. At this they laughed, the ice was broken and we talked freely.

Umm Mansur apologised for the noise and restlessness of the boys, who were playing about and running in and out of the room as we talked. I told her I had children of my own and was well used to their perpetual motion and sound. I added, though I am not sure that I believe it, that when they are too quiet it usually meant they were not well. Upon this came many questions about my children: their ages, sex, and names. They asked whether they were with me in Arabia and expressed surprise to hear that I had left them behind in England. Dr Midhat explained for me that, after a certain age in England, it was the custom for children to go away to school, only returning to their homes in the holidays. This I saw was obviously completely outside their experience. They were too polite to express in words the astonishment, if not horror, they felt at such a barbarous practice, but it showed plainly in their faces.

One of the boys, Mitab, now came and showed me a beautiful little Mauser pistol with which he was playing.[153] It was a formidable weapon, and one which we should not dream of entrusting to a lad of seven or eight years old in England. I was relieved to see that he did not appear to have any ammunition for it; at any rate not to his hand at the moment. I asked whether their boys played at soldiers like ours. This met with immediate response. Their boys were military enthusiasts of the first order and spent much time drilling and firing and the rest. One of them was pointed out to me as the leader, who gave the word of command. They were in the habit of lining up, I was told, for the arrival of the King, their father, when he visited the harem, and giving him a military salute, to his great satisfaction.

The Amir Feisal sat playing with the boys, joining in the conversation occasionally. He was gay and very friendly.

Children of course are the major interest. Each wife considers herself as a mother to all the children. They love and look after them jointly and it appears a very harmonious arrangement. We talk of babies. I was told that the milk of the camel and the goat is too rich to be given to infants. When the babies are weaned from their negress foster mothers, which usually takes place about two years old, they are given Swiss evaporated milk. I did not see any of the babies; but the children certainly looked as if their early upbringing had agreed with them. They were fine, well-grown, sturdy specimens.

Dr Midhat, who has studied in Europe, is allowed in the harem to attend to the children. There is also a woman doctor and a midwife.

King Ibn Saud had twenty-five sons at that time. I believe now there are more than thirty. The youngest when we were in Arabia was three months old, the eldest thirty-five. The number of one's daughters is merely expressed by the raising of the hands and an apologetic smile. Who can trouble to keep count of his daughters?

All the same Gomasha, Umm Mansur's daughter, a girl of fourteen and already veiled, was brought in by the doctor to see me. She was taller than her mother and like her in face. She sat behind her mother's sofa and had a good look at me behind the Queen's back. I was afterwards told that Gomasha was being taught to read and write, a privilege rare for women in Saudi Arabia. The feeling against even the most elementary education for women is still strong. An Arab said to a friend of mine: "But if my wife could read and write, some man might write her a love letter and what then?" What then, indeed? I am afraid it would go badly with both the wife and the writer of the love letter.

As I have indicated, there are exceptions. In 1928, the Director of Education opened a school for girls in Mecca, where some four thousand girls have been taught to read and write by women teachers from Palestine. When the school was first opened the pupils only worked for one hour in the morning and one hour in the afternoon, the rest of the time being occupied in play. The parents then objected that too much time was being wasted and hours were able to be increased. The same experiment was tried later in Jidda, but failed through prejudice and the school had to be closed.

When one remembers what the position of women in Arabia was before the eleventh century, when seclusion and veiling were first imposed, the present position seems a tragic waste. Before that date, the women attended the universities, lectured, practised the arts, devoted themselves to charitable and social work and mixed openly with the men. They submitted to no greater restriction of liberty than was common to all women at that date. Nor is there anything apparently in the teaching of the Prophet to justify the present subjection of women. On the contrary, Muhammad preached the rights of women; he gave them power over their own property, rights of inheritance and juster marriage laws, all of which are still in force. The deterioration of women's position dates from the days of Caliph Al-Qadir Billah who, in the eleventh century, passed a law enforcing the veiling of women whenever they appeared in public places, or where men were present. And since that date, for nearly a thousand years, the harem system has been in force.[154]

Yet they appear happy and give one a real feeling of peace and content. What is more, a sense of dignity; a feeling that they are right with their world and suffer from no sense of inferiority. It was I who felt at times at a disadvantage and conscious of being somewhat blatant and out of place. What one has never known, one does not miss. They have, at any rate, the greatest and most satisfying

experience of woman – motherhood – even if they have to share their husband with other wives. There are points as well as drawbacks to every system. I can imagine it might be very convenient to feel, when one wanted a holiday, that there was someone else who could rightfully take over and keep the home fires burning until one returned.

Clothes are another absorbing interest. There is much visiting and many parties given in the harems, both for the grown-ups and the children, which necessitate beautiful clothes. Much time is passed in the choosing and fitting of dresses. There is always a dressmaker attached to the harem who, with her assistants, makes and embroiders the lovely garments worn by Arabian ladies of high degree. I asked whether they did any embroidery themselves, and was told that some crochet lace was done at times, but little else. I got the impression that needlework was considered beneath their dignity, being done for them by their slaves.

Both ladies grumbled about the heat of Jidda. I gathered that the climate of Mecca had been little better and they were longing to get back to Riyadh, where the nights were cool and they could be out in the gardens.

Orange and lemon drinks were served, and afterwards coffee, by a waiting woman who appeared to be on intimate if not affectionate terms with her mistresses. She had a frank and humorous countenance with merry eyes and might have sat as a model for a Franz Hals portrait.[155]

When I got up to take my leave, they asked me many questions about my homeward journey and pressed me to come back again and visit them. I said there was nothing I should like better, and if and when I came again it would be with a sufficient knowledge of Arabic to speak to them in their own language. They accompanied me to the door, leading me by the hand across the threshold, where they stood veiled to watch me go.[156]

14

Departure

THE DAY FOLLOWING my visit to the ladies of the King's household we were due to leave Jidda, after what had in the end proved an all too short visit.[157]

As I watched the faithful Muktar pack our camp equipment for the last time, while G. went and said goodbye to the King, I thought regretfully of our days in the desert and, with a great reluctance, of the sophisticated journey before us by steamer and train which would take us back to our pedestrian life in England. For the first time Muktar's cheerfulness was dimmed and his smile had a sorrowful angle; and when I gave him a small present as a souvenir of our common experience I think we both had a lump in our throats.

At the Custom House on the quay many of our Arab friends had assembled to see us off. The final farewells were said as we left the quay in a new fast launch belonging to the Saudi Government, with the older and slower British Legation launch ploughing through the waves behind us with our luggage. We passed the harbour for dhows with its forest of masts, and threaded the reefs to the anchorage where our little Italian steamer was waiting to carry us on to Suez. The British ships at this season were still carrying pilgrims returning from Mecca to their own countries and so were subject to delays for quarantine. But we were warmly welcomed and made most comfortable by the Captain and officers of the *Massaua*.

When we boarded her we found a cheerful party in the Saloon consisting of our friends of the California Arabian Oil Company, who had come out in their own launch to give us a send-off.[158] Much beer was consumed and, as is apt to

happen with liquid farewells, time slipped away until our Captain hinted broadly that it was time to weigh anchor, and the party reluctantly broke up.

We steamed through the gap in the outer reef and past the burnt-out pilgrim ship *Asia*, lying on her side over the rocks.[159] The tall white houses of Jidda, standing out sharply against the background of rose and violet mountains, began to shrink into the horizon, till they appeared only a line of light in the surrounding desert.

My Arabian holiday was over – three weeks of unique experience which had more than justified my most exaggerated hopes and expectations. As I leaned over the taffrail and looked back across the water to the fast-fading mainland, I thought of the widened horizons of time and space and mentally registered a determination – "*inshallah*" – to return.[160]

NOTES

NOTES TO INTRODUCTION

1. The handwritten diary, entitled 'Diary of Arabian Journey, February–March 1937, by G.E. and G.W. Rendel' (henceforth cited as Rendel 1937a), is preserved in the Rendel Papers in the archives of the National Library of Wales, ref. P13. Roughly two-thirds of this diary were written by Geraldine, the remainder by George.

2. Geraldine Rendel's 158-page typescript (henceforth cited as Rendel *ca.* 1938) is in the National Library of Wales, Rendel Papers K2, entitled 'Arabian Journey: Three Weeks Crossing Saudi Arabia'. The 18-page article published in *The Geographical Magazine* No. 6, 1938, is entitled 'Across Saudi Arabia'.

3. The Rendel pictures of Saudi Arabia, comprising more than 280 images, form part of the collections of the Royal Geographical Society, London, ref. G9, boxes I and II. A selection of 185 of the same images is also held in the Middle East Archive, St Antony's College, Oxford.

4. Athlone 1966: 224–42; also, unpublished letters to her daughter May.

5. Philby 1948: 302. For Harry St John Bridger Philby, aka Ḥajjī ʿAbdallāh Philby's conversion to Islam, see Facey 2013: 128–9; Philby 1943.

6. David (1918–2001), Anne (1920–77), Rosemary (1923–2011), and Peter (1925–2004).

7. The priest who conducted the wedding, Father Basil Maturin (1847–1915), was a convert from Anglicanism to Catholicism and was also, from 1913, Catholic chaplain in the University of Oxford (Rendel 1957: 9–10).

8. Rendel 1957: e.g. 12, 27, 90, 163, 199, 247.

9. *ODNB*, entry George Wightwick Rendel. One of his brothers, Stuart Rendel (1st Baron Rendel, 1834–1913), was a prominent Liberal, industrialist and philanthropist. He was a close associate and friend of W.E. Gladstone, and one of his daughters married Gladstone's son Henry. Although not a Welshman, as member of Parliament for Montgomeryshire (1880–94) he championed various Welsh causes, as a result of which he was nicknamed 'the member for Wales'. He was a benefactor of the University College of Wales at Aberystwyth, and played a part in founding the National Library of Wales – which explains why Sir George Rendel's papers were deposited there. He lived in Surrey at Hatchlands Park, which passed to the National Trust in 1945 and is open to the public. (*ODNB*, entry Stuart Rendel.)

10. George's lifelong commitment to Catholicism is shown by the dedication of his 1957 memoir to the Abbot and Community of Downside Abbey (Rendel 1957: v).

11. The house was called Broadlands. It has since been demolished.

12. The Ward residence, Weston Manor, at Totland Bay near the Needles, was until recently a home for mentally disabled men and is now an up-market bed-and-breakfast establishment. It was built in 1870 for the prominent Catholic intellectual William George Ward (1812–82) and inherited by his sons Edmund Granville Ward (1853–1915) and Wilfrid Philip Ward (1856–1916). Wilfrid Ward wrote on, among other subjects, G.K. Chesterton and the Oxford Movement. Geraldine became close friends with his daughter, Mary Josephine 'Maisie' Ward (1889–1975), who also wrote biographies (of G.K. Chesterton, Cardinal Newman, her father Wilfrid Ward, and Robert Browning) and went on to be a prominent speaker and publisher. (https://historicengland.org.uk/listing/the-list/list-entry/1209416, last consulted 7 February 2018; Mrs Lindy Wiltshire, personal communication; Wikipedia entries on Wilfrid Philip Ward and Maisie Ward, last consulted 22 January 2018.)

13. Geraldine's date of birth, 17 January 1885, full name, and address of her parents (88 Cornwall Gardens) are given on her birth certificate (General Register Office, district Kensington, sub-district Brompton). Her father's occupation is given as 'Gentleman'. A handwritten note attached to a picture of her silver-gilt christening mug (sold at Christie's on 20 March 1990, lot no. 364), which is inscribed "From Philip Antoine de Teissier, III Baron de Teissier", her godfather, confirms the birth date (Rendel family papers). The other FitzGerald siblings were: Mary Susan Beresford, b. 1882; Charles Robert Lewis, b. 1883; Mabel H.A., b. 1886; and George [illegible], b. 1888. (FitzGerald Family Tree, n.d.)

14. Rendel 1957: 9.

195

15. The family myth may stem from the historical fact that the mediaeval castle at Maynooth, in north Kildare not far from Dublin, had for centuries been a FitzGerald stronghold. However, it was abandoned by the family in the 18th century and fell into ruin. Rosemary Rendel, daughter of George and Geraldine, used to pay occasional visits to Maynoooth's St Patrick's College, a large Pontifical University and Ireland's chief Roman Catholic seminary. This association may have planted the seed of the idea of a castle in or near Dublin that had to be disposed of by the FitzGeralds.

16. Revd Gerald Stephen FitzGerald (1811–79) was born in Haverfordwest, Pembrokeshire, and GBF was born in Southampton: see www.highfieldhistory.co.uk/rev-gerald-stephen-fitzgerald/4539613063 (last consulted 5 March 2018). Susan Anne Beresford (d. 27 December 1881) was the daughter of the Revd Hon. George Beresford, son of William Beresford, 1st Baron Decies, and Susan Gorges. She married Matthew O'Reilly (d. 1841) in 1830, and GBF's father Revd Gerald Stephen FitzGerald in 1842. The couple also had a daughter, Susan Jane (born in Ireland in 1847), who married a vicar. See the FitzGerald Family Tree (n.d.), and www.thepeerage.com, last consulted 9 January 2018.

17. The FitzGerald Family Tree (n.d.) shows that Vice-Admiral Sir Robert Lewis FitzGerald was also father of the archdeacon of Wells, Augustus Otway FitzGerald. R.L. FitzGerald lived and served in England, and was buried in Bath, Somerset. His wife was Jane Welch, daughter of a former Chief Justice of Jamaica, by whom he had five sons and four daughters; the following are listed on the memorial in St Swithin's Church, Bath: Caroline Geraldine, d. 1822; Charlotte Mary d. 1823; James Lewis Robert, d. 1835; Georgina Favell, d. 1841; George Milner, d. 1843; Maria Philippa, d. 1845. The remaining five children were still alive after 1845, including Revd Gerald Stephen FitzGerald; Revd Augustus Otway FitzGerald, Archdeacon of Wells; and Charles Robert FitzGerald (for whom, see note 22 below).

18. Wikipedia, article 'FitzGerald dynasty', last consulted 3 January 2018.

19. According to Loeber 2006 (entry sub Fitzgerald, Gerald Beresford), the branch of the FitzGeralds to which GBF belonged claimed Coolanowle in Co. Laois, west of Dublin, as its family seat, but no source is given for this. The Revd Gerald Stephen FitzGerald's seat is also identified as Mount Ophaly, Co. Kildare, Ireland (www.thepeerage.com, last consulted 9 January 2018). There is a Mount Offaly House in the village of Athy, Co. Kildare; it is the large, white, possibly Georgian mansion next to the Church of Ireland church on Carlow Road, and is now used for the care of homeless people in Athy (http://www.athycofi.ie/Mount-Offaly-House.htm#, consulted 31.01.2018). The obituary of Vice-Admiral Sir Robert Lewis FitzGerald (1776–1844) in the *Gentleman's Magazine*, vol. XXI of Jan.–June 1844, p. 319, also states: "This officer was descended from a younger branch of the very ancient and noble house of Leinster, seated at Mt. Ophaly, Co. Kildare." However, we can find no evidence that Mount Offaly House in Athy ever belonged to the FitzGeralds (Clement Roche, personal communication). The claim of Mount Ophaly as their 'family seat' by these later FitzGeralds seems to have been merely the continuation of a time-honoured family custom.

20. *Bath Chronicle and Weekly Gazette*, Thursday 13 June 1867: "Mr Gerald A.R. Fitzgerald, B.A., Scholar of Corpus, Oxford, (son of Archdeacon Fitzgerald of Wells), has been elected a Fellow of St John's. He was educated at Sherborne School." Gerald Augustus Robert FitzGerald (1844–1925) attended Sherborne 1855–62. After a period as fellow of St John's College, Oxford, he became a barrister and Justice of the Peace (Pickering Pick 1950: 71).

21. *Balliol College Register 1832–1914* (1914): 108. *Transactions of the Royal Historical Society*, New Series, Vol. VI (1892): 6, lists him as a Fellow, and gives his address as 63 Eaton Square, SW.

22. *Leeds Mercury*, Friday 30 July 1880; *Manchester Courier and Lancashire General Advertiser*, Saturday 31 July 1880; *Reading Mercury*, Saturday 7 August 1880: "The will (dated Aug. 18, 1879) of Mr Charles Robert FitzGerald, late of No. 17, York-street, Portman-square, who died on the 2nd ult., was proved on the 5th inst., by Gerald Beresford FitzGerald and Gerald Augustus FitzGerald, the nephews, the executors, the personal estate being sworn under £60,000. The testator leaves legacies to his brother, nephews, nieces and servants, and the residue of his real personal property to his said nephew, Gerald Beresford FitzGerald. – *Illustrated London News*." At his bankruptcy hearing in 1904 (see pp. 6–8), GBF confirmed that he had

been left £50,000. Charles Robert FitzGerald (1803–80) was a brother of GBF's father and of the Archdeacon of Wells, and had no children (FitzGerald Family Tree, n.d.).

23. *Morning Post*, Monday 20 December 1880: "A marriage will take place in January between Miss Lucy Wickham, second daughter of Mr and Mrs Francis Wickham, and Mr Gerald Beresford Fitz-Gerald." Lucy Adelaide Wickham (1858–1944) was one of three children of Francis Wickham, a barrister, and his wife Natalie (or Melanie) Lahon, of Belgian–Dutch parentage, who as a child had been given piano lessons by Franz Liszt (Rendel family papers: undated handwritten notes by Rosemary Rendel). Four Wickham boys are recorded as having attended Sherborne School in the 1700s (Pickering Pick 1950).

24. The full list of novels published by GBF is as follows (* = a copy in possession of Jonathan Rendel): *As The Fates Would Have It: A Novel* (1873); *Lilian: A Story of the World* (1877); *Never Found Out: A Novel* (1881); *Clare Strong* (2 vols., London: F.V. White, 1889); *An Odd Career* (1896); *A Fleeting Show* (1897); *The Stigma* (1898); *The Fatal Phial* (1898); *Beyond These Dreams* (1899); *The Minor Canon* (1900); *Dear Paul* (1902); *The Kingdom That Never Came* (1903); *A Faithful Love* (1904). There was one further late novel: *The Marriage Maze: A Study in Temperament* (with Olive Lethbridge. London: Eveleigh Nash, 1911)

25. Under the heading 'New Novel by G. Beresford Fitzgerald', the *St James's Gazette* (Thursday 16 November 1899) advertised the publication of *Beyond These Dreams* in 1899, quoting this passage from a review in *The Scotsman*. Review excerpts on *Clare Strong* quoted in Fitzgerald 1896: ii.

26. See Loeber 2006, entry Fitzgerald, Gerald Beresford.

27. Olive Lethbridge was the pen name of Olive Ada Lethbridge Banbury (1885–1971). Born in Co. Wexford in Ireland, she pursued a literary career in London. She and GBF collaborated on a play, *The Blind God*, the plot of which centres on two guilty parties in a divorce case who are to marry once the case is resolved; however, the man then falls in love with someone else (Wearing 2014: entry 11.152). *A Lioness that Sleeps: A Novel of Africa*, was published by Mills and Boon in 1931.

28. *Morning Post*, Friday 10 June 1904.

29. See e.g. the *Liverpool Mercury*, Friday 27 October 1899: "The will (dated Aug. 17, 1897), with two codicils (of March 2, 1898, and May 19, 1899), of Mrs Sarah Anna Elizabeth FitzGerald, of Shalstone House, Buckingham, and formerly of 22 Portland-place, who died on July 19, was proved on Oct. 10 by Gerald Beresford FitzGerald, Richard Biddulph Martin, and Archibald Hanbury, the executors, the value of the estate being £28,540. The testatrix gives to the National Portrait Gallery a marble bust of William Pitt, £30 to the Aylesbury Infirmary, £25 to the National Benevolent Institution, £50 to the Nurses' Home at Buckingham; and £200, upon trust, for the poor of Shalstone."

30. The *Globe*, Friday 10 June 1904; *Morning Post* Friday 10 June 1904.

31. *London Evening Standard* Tues 19 July 1904: sale of furniture and effects of Mr Gerald Beresford FitzGerald of 63 Eaton Square.

32. *West Sussex County Times*, Saturday 27 January 1906: wedding on 22 January of Mary Susan Beresford, daughter of Gerald Beresford Fitz-Gerald of Kensington, to John Maurice Coppen of Ascot. John Maurice Coppen was possibly a stockbroker, born in 1850, whose first wife had died in 1905.

33. *The Times*, 5th October 1915: "FITZ-GERALD. – On the 3rd Oct. at 14, Kensington Court-mansions, GERALD BERESFORD FITZ-GERALD, only son of Gerald Stephen Fitz-Gerald, and grandson of Sir Robert Fitz-Gerald, aged 66 years." Lucy Wickham lived on until 1944, most probably supported by a family trust set up by Sir George Rendel for the upkeep of Fitzgerald relatives (Jonathan Rendel, personal communication).

34. Lindy Wiltshire, personal communication from Rosemary Rendel.

35. An anonymous handwritten itinerary covering the years 1900–11 shows that a member of the Rendel family was paying regular visits to Sandown (Rendel family papers).

36. Rendel 1957: 10. The villa was at Menton (see Rendel family photograph albums).

37. Rendel 1957: 12–13, 26–7, 29.

38. Leatherdale (1983: 16–23, 80–3) gives an excellent description of this structure.

39. Leatherdale 1983: 2.

40. A frontier with Iraq and Kuwait was first agreed at the al-'Uqayr Conference of 1923 by Sir

Percy Cox and Ibn Saʿūd. In 1925, frontiers with Iraq and Transjordan were negotiated by Sir Gilbert Clayton at meetings at Bahra' and Hadda between Makkah and Jiddah. See Dickson 1956: 262–80; Clayton 1969.

41. Leatherdale 1983: 64–74. For Rendel's role in getting the treaty finalized, see Leatherdale 1983: 66 n. 64.

42. For the Ikhwan Revolt, see Dickson 1956: 281–330; Glubb 1960; Habib 1978; Al-Rasheed 2002: 62–71.

43. Rendel 1957: 60; Leatherdale 1983: 147–8.

44. Ryan 1951: 260–1.

45. Shaykh Ḥāfiẓ Wahba (1889/90–1967/8) was the Saudi Arabian government's first diplomatic representative in London, appointed in 1930 when diplomatic relations were established between Britain and the Kingdom of Najd and the Hijaz. He began his career as a schoolteacher in his native Egypt, moving during the First World War to Kuwait, where he was outspoken in his opposition to British rule. In the early 1920s he moved to Najd and became the country's first director of education. When in September 1932 the Kingdom of Saudi Arabia was formally proclaimed, Wahba remained in London as Ibn Saʿūd's minister plenipotentiary. He was formally appointed Ambassador to the Court of St James during the Second World War. During the 1950s, Wahba inevitably had to lend support to Saudi Arabia's case against Britain in the Buraymi Dispute. In 1956, when Saudi Arabia along with the other Arab states except Lebanon broke off diplomatic relations with Britain and France as a result of the Suez crisis, he was withdrawn from London. Like Philby, Wahba wrote a book in English entitled *Arabian Days* (1964), as well as at least three in Arabic about Saudi Arabia and his life. See Rendel 1957: 117–18 for a warm tribute; Bullard 1993: 140 n. 1; Rush 1987: 105 n. 12.

46. See for example Wahba's foreword to Lady Evelyn Cobbold's *Pilgrimage to Mecca* (Cobbold 2008: 20, 32, 37, 87, 102; Athlone 1966: 224–7).

47. Rosemary Rendel, verbal information given to W. Facey, 15 January 1987.

48. Philby 1946: 15. Sir Andrew Ryan puts the total number of pilgrims at the Standing at ʿArafat on Tuesday, 4 April 1933, at about 50,000: see Saudi Arabia: Annual Report, 1933, paragraph 164, in Jarman 1998. Lady Evelyn Cobbold estimated the number at around 100,000 (*Pilgrimage to Mecca*, pp. 159–60 and 237) but this figure is not to be taken seriously.

49. In 1931: Philby 1948: 291.

50. www.bbc.co.uk/news/blogs-magazine-monitor-29954567, consulted 31.01.2018. The Amir Fayṣal was accompanied by his deputy, Fu'ād Ḥamzah.

51. See Ryan 1951: 283 for a brief description of Fayṣal's visit, though even he does not mention the discussion about mineral concessions. Both George and Geraldine had met Fayṣal in London in 1932: see Rendel 1937b: 58. Fayṣal had already made two visits to the UK, in 1919 and 1926 (Leatherdale 1983: 62–3).

52. See for example de Gaury's journeys in 1934, 1935 and 1939, described in de Gaury 1946 (1935 journey), 1951 (1939 journey) and 1975 (1934 journey). For other journeys, see Ryan 1951: 301–13; Dickson 1956: 370–415; Kedourie 1980a: 67–74 for Dickson's 1937 journey to Riyadh; Philby 1948: 302–3; and Bullard 1961: 200–4, 214. Previous notable visitors to Najd include Dr Paul Harrison in 1917 (Facey 1992: 213–15); H. St J. B. Philby in 1917–18 (Philby 1922 and 1928); Ameen Rihani in 1922 (Rihani 1928); and Leopold Muḥammad Weiss, aka Muḥammad Asad, in 1929 (Asad 1954).

53. E.g. Karl Twitchell, Max Steineke and Tom Barger (Twitchell 1953; Barger 2000; Facey 1992: 277, 279–88, 293). For the medical missionaries in Najd, see Armerding 2003.

54. Rendel 1957: 57–64. For the intricacies of British government departments' responsibilities for Arabian matters, see Leatherdale 1983: 79–83. See also Rendel 1957: 83–4, where he describes the transfer of relations with southern Arabia from the Government of India to the Colonial Office and Foreign Office.

55. Leatherdale 1983: 2–4.

56. On Rendel's character, and on his desire to meet Ibn Saʿūd half way on the matters of south-east Arabian frontiers, Italian designs on Arabia, and Palestine, see Kedourie 1980b: 113–20.

57. In the Middle East as a whole, however, Britain's nerve was clearly in decline, as cogently argued in Monroe 1963: 131–50.

58. Rendel 1957: 64–74.

59. Ibid.: 66.

60. Ibid.: 82–3.

61. Ibid.: 76.
62. Ibid.: 76.
63. Ibid.: 76–7; Leatherdale 1983: 122–3.
64. Ibid.: 66, 76.
65. Ibid.: 78–82, 85–96. A major episode was the 1936 Montreux Straits Conference, convened in order to establish rules for international access via the Dardanelles and Bosporus to the Black Sea. Geraldine was unable to accompany George to this, as she had broken a leg while skating! (Rendel 1957: 90)
66. Philby 1948: 304–5. The full story is told in detail by Philby in *Arabian Highlands* (1952). See also Kelly 1988.
67. Ryan 1951: 288–90.
68. The intricacies of the SE Arabia frontier negotiations are set out in Kelly 1964: 122–9. See also Bullard 1951: 204–5.
69. Monroe 1963: 104.
70. Rendel 1957: 82. The full story of the south-east Arabia frontier negotiations up to Rendel's time is told in Kelly 1964: 107–31, and Leatherdale 1983: 221–58.
71. Rendel 1957: 84–6.
72. Ibid.: 97.
73. Ibid.: 85.
74. Ibid.: 97.
75. Rendel 1956: 143. The FO discouraged foreign visits by its staff, and various other pressing issues crossed Rendel's desk in 1936.
76. Ryan 1951: 303.
77. Loch was father of the celebrated Old Etonian and Scottish Labour Party MP, Tam Dalyell (Sir Thomas Dalyell of the Binns).
78. Ryan gives a lively account of the journey in Ryan 1951: 301–13.
79. For the handwritten diary, see Rendel 1937a. The few significant omissions from the Arabian section of the handwritten diary are quoted in the notes to Geraldine's published version, below.
80. Rendel 1937b (TNAUK, file E 2312/2312/65). See also Chapters 8, 10 and 11 of George Rendel's memoirs, *The Sword and the Olive* (Rendel 1957: 78–86, 96–118).
81. Rendel 1957: 99.
82. See above, p. 64.

83. See above, p. 126.
84. Rendel 1957: 106–18.
85. Cobbold 2008: 126–8, 156–8, 191–2, 219–26, 241–4.
86. Rendel 1937b: 16.
87. Rendel 1957: 102.
88. Dickson 1956: 370; Rendel 1957: 100–1.
89. Rendel 1937a: 21–30.
90. George Rendel's account of the Persian trip is in Rendel 1937b: 19–24; see also Rendel 1957: 102–4.
91. Rendel 1937b: 20. For Rendel's history of the issue of moving the Residency from Bushire to Bahrain, and on the nascent Gulf air route, see Rendel 1966 in the Middle East Archive, St Antony's College, Oxford.
92. Rendel 1937b: 24.
93. Rendel 1937b: 26–8; 1957: 105. Kelly (1964: 107–31) and Leatherdale (1983: 221–58) tell the convoluted story of the inconclusive SE Arabia frontier negotiations.
94. As resident adviser to successive rulers from 1926 to 1957, Charles Belgrave (1894–1969) was a unique and influential figure in Bahrain, running the administration and putting in hand various reforms. See his memoir, *Personal Column* (London 1960).
95. Rendel 1937b: 28–9.
96. Ḥāfiẓ Wahba apparently took many photographs during the Rendels' visit. It is believed that these were left to his daughter, who subsequently deposited them at the American University in Cairo (verbal information given to W. Facey by Rosemary Rendel, 15 January 1987).
97. Rendel 1937b: 36. See also Ryan 1951: 306. Saʿūd Ibn Jiluwī also had an unnerving squint. In the Rendels' handwritten diary the following limerick is scribbled in George Rendel's handwriting: "There was a young man of Hofuf, Whose manners were strangely aloof; They said, 'Tell us why'; He replied, 'It's my eye – I'm looking at you, not the roof." This is attributed to "A.R. and R.W.B", undoubtedly Andrew Ryan, who was known to be fond of composing limericks, and Reader Bullard. (Rendel 1937a: 42v–43.)
98. Rendel 1937b: 37. It is curious that Rendel makes little mention until his arrival in Jiddah of the Saudi blockade of Kuwait, which had been in

force since 1921 and prevented trade between Najd and Kuwait well into the 1930s. It had come about because Kuwait's rulers refused Ibn Saʿūd's requests to collect and hand over customs dues on trade to Ḥāʾil. It was partially resolved in 1937 but not fully so until 1943.

99. Rendel 1957: 109.
100. Rendel 1937b: 45–6; Eric Kennington being the artist who supplied many of the illustrations for T.E. Lawrence's *Seven Pillars of Wisdom*. Interesting comments on local vernacular architecture are to be found in Rendel 1937b: 30–1, 43, 46, 67–8; and 1957: 110–11. Rendel advocated the adaptation of local styles for new buildings and disapproved, for example, of the new British Agency in Kuwait, designed by the Lutyens office in New Delhi.
101. Rendel 1957: 112.
102. It has been argued by some that it was dawning on the Saudis that the American relationship, at that time confined to business and unencumbered by political complexity, was preferable to the old relationship with Britain. Leatherdale 1983: 198–9 cogently debunks this view.
103. De Gaury 1950: 58. Bullard (1951: 200) agreed: "Relations with Saudi Arabia have not been good during the last few years [the 1930s], and it is easy to forget the days when Ibn Saud was well-disposed towards Britain, whose interests seemed to coincide at first with his own. He used to say in principle that he did not like having any foreigners in his country, but of the foreigners he had known … the British were the least objectionable."
104. Rendel 1937b: 51–2. Geraldine was the first Western woman to visit al-Ṭāʾif and write about it. At least one other had been there before her: Nora Twitchell, with her husband Karl, in 1931 (Twitchell 1953: 140–1).
105. Rendel 1957: 114–15. He overestimates the King's stature at 6 feet and 6 inches.
106. Kelly 1964: 128–9.
107. In the handwritten diary (Rendel 1937a: 132v), Geraldine records this conversation with Philby: "Had long talk with Philby about Palestine. He says that the Arabs are only waiting for the report of the [Peel] Commission. If it does not give them justice, then the revolt will start again, probably with a massacre of the Jews. Certainly with assistance of the Italians in money and arms. He says they helped the first revolt. Told me that Ibn Saud had said only a few days before: 'We don't like British imperialism, but we realize that it is better than Italian or German imperialism, cleaner and fairer. But the British policy in Palestine is an outrage.' Philby says if we repress the revolt, we shall start a Holy War."
108. Rendel 1937b: 55–64: this, Rendel's official report of the journey, gives a much longer and more detailed version of discussions than appears in his published memoir, *The Sword and the Olive* (1957: 115–16), as well as giving references to Bullard's official reports of the discussions: Bullard despatches nos. 40 and 41 of 23 March; no. 42 of 23 March, no. 47 of 27 March, nos. 50, 52 and 54 of 1 April 1937. See also Kedourie 1980b: 112–20. For Anglo-Italian relations in the Red Sea, see Leatherdale 1983: 136–66, 293–317.
109. Bullard 1993: 148–9.
110. Rendel 1937b: 58; 1937a: 122v.
111. Rendel 1936b: 64. Philby does not mention Rendel's visit. He was just back from his Saudi–Yemeni frontier-drawing exploits in ʿAsir and his excursion through uncontrolled territory to Ḥaḍramawt (McLoughlin 1993: 138–9), which he carried out between March 1936 and February 1937. For his detailed account, see Philby 1939 and 1952. For an amusing analysis of the political aspects, see Kelly 1988.
112. Rendel 1937b: 64–5.
113. Rendel 1937b: 64; 1957: 116.
114. Rendel 1957: 117.
115. For the chance meeting with Lampson, see also the handwritten diary, Rendel 1937a: 134–134v.
116. Rendel 1937b: 68–70.
117. Rosemary Rendel, verbal information given to W. Facey, 15 January 1987.
118. Rendel 1957: 118.
119. Kedourie 1980: 115–16.
120. Rendel 1957: 119–25.
121. Rendel 1957: 129–36; Leatherdale 1983: 297–8.
122. Leatherdale 1983: 300–11.
123. Rendel 1957: 139–195.
124. Ibid.: 199.
125. In February 1946 (Rendel 1957: 246).
126. Rendel 1957: 300–11.
127. George Rendel was buried with Geraldine in

1975. The misspelling of their surname on the inscription, as 'Rendall', was never rectified. They were not buried in the Rendel family vault, built by George's mother Licinia Pinelli in Kensal Rise cemetery, because of its dilapidated state.

128. These negotiations are mentioned in a letter from Sir George Rendel to Sir Colin Crowe, dated 29 December 1964 (Rendel 1964b in the Middle East Archive, St Antony's College, Oxford). No other record of them has been found.

129. For the Buraymi Dispute at this time, see Holden and Johns 1981: 244, 276–7, 377.

130. Holden and Johns 1981: 228.

131. Sir Colin Crowe (1913–89), was HM Ambassador to the Kingdom of Saudi Arabia from 1963 to 1964 (*ODNB*, sub Crowe, Sir Colin Tradescant).

132. For the power struggle, see Sir Colin Crowe's report from Jiddah dated 5 January 1964 entitled The Struggle for Power in Saudi Arabia (TNAUK FO 371/174671, BS 1015/2). See also Holden and Johns 1981: 222–40; Vassiliev 1998: 354–62, 366–8. Saʿūd eventually went into exile in January 1965, stripped of his title and all his powers.

133. Holden and Johns 1981: 176–84. See also, for example, José Arnold's entertaining account of palace extravagance in Saʿūd's time, *Golden Swords and Pots and Pans*.

134. See for example Sir Colin Crowe's report entitled The Struggle for Power in Saudi Arabia (Crowe 1964a in TNAUK). Also Crowe's Valedictory Despatch, dated 30 September 1964, from Jiddah (Crowe 1964b in TNAUK).

135. See Crowe 1964a in TNAUK. A handwritten note by the Foreign Office official T.F. Brenchley at the bottom of a covering page, dated 18 February 1964, reads: "It is clear that King Saud has made a surprising recovery in health. Sir G. Rendel, who saw them both last month, thinks he may well outlive Faisal."

136. The series of 41 colour slides of this journey is held by the Middle East Archive, St Antony's College, Oxford. They are erroneously ascribed (by Rosemary Rendel) to February rather than January 1964. For Rosemary Rendel's reminiscences of the trip, thanks are due to Jonathan Rendel (personal communication).

NOTES TO GERALDINE RENDEL'S *ARABIAN JOURNEY*

1. The recovery of Riyadh actually took place in January 1902. Until then the Āl Rashīd of Ḥāʾil, in northern Najd, had been the dominant force in central Arabia during the nadir of the Second Saudi State in the late 19th century, and had taken control of Riyadh itself in 1887 (Facey 1992: 174–80).

2. The US company was CASOC (the California-Arabian Standard Oil Company), created in November 1933 by Standard Oil of California (SOCAL), which had signed the oil concession for al-Ḥasāʾ in Jiddah in May 1933 (Holden and Johns 1981: 119–20).

3. Geraldine Rendel is probably correct to say that she was only the second foreign (viz. non-Muslim) woman to cross Arabia from coast to coast via Najd. However it is possible that she had been preceded by female medical staff of the Dutch Reformed Church in America, some of whom may have accompanied Dr Louis Dame in 1932 and Dr Harold Storm in 1935–36 on their trans-Arabian journeys (Armerding 2003: 56–65, 150; Storm 1938: 73–6). Her statement in the previous sentence that *two* women had preceded her is a confusing error. As far as she knew, there had only been Dora Philby, whose crossing, from Jiddah to Kuwait via Riyadh, took place in 1935 in the company of her husband, Harry St John Philby, aka Ḥajjī ʿAbdullah Philby (Philby 1948: 302–3).

4. Al-Zubayr functioned as a focus of tribal and commercial contact in the frontier zone between desert Arabia and Iraq, and had a sizeable Najdi community.

5. 21 February 1937, the day the Rendels left Baṣra, coincides with 10 Dhū al-Ḥijjah 1355. The first ten days of Dhū al-Ḥijjah are the time of the pilgrimage to Mecca. The ʿĪd al-Aḍḥāʾ, or Feast of Sacrifice, which marks the ending of the pilgrimage, takes place from the 10th to the 13th of the month.

6. The ʿabā: the long, all-enveloping black cloak worn by women in public to conceal their entire head and body; also, ʿabāyah.

7. Ṣafwān is still today the frontier post between Kuwait and Iraq.

8. The British Political Agent at Kuwait from 1936 to 1939 was Capt. Gerald de Gaury, a notable figure in the history of Kuwait who also wrote two interesting travel books about Saudi Arabia (Gaury 1946 and 1950). He had previously served under Sir Andrew Ryan at the Jiddah Legation and visited King ʿAbd al-ʿAzīz in Riyadh on diplomatic business in 1934 and 1935 (Facey 1992: 272–5). Probably out of deference to her husband's political mission, and to maintain the holiday character of her narrative, Geraldine Rendel never mentions British officials by name, with the exception of Sir Reader Bullard and Harry Eyres in Jiddah.

9. Geraldine was evidently an amateur botanist, an interest she shared with Violet Dickson (Dickson 1955). The 'Star of Bethlehem' is perhaps not a species of *Ornithogalum* at all, but *shaḥḥūm*, *Gagea reticulata*; the marigold is probably a species of *Calendula*, perhaps *ḥanwah*, *C. tripterocarpa*; the vetch a species of *Vicia* or *Lathyrus*; the iris perhaps ʿ*unsayl*, *Gynandriris sisyrinchium*. (Mandaville 1990: 192–3; 306–7; 400–1; 405.)

10. The black tent cloth is in fact woven by the Beduin women from goat's and not camel's hair. In the handwritten diary, Geraldine had described the journey to Kuwait in a little more detail:

 > We passed many Beduin hair tents, and saw the men guarding their flocks and camels with guns over their shoulders. The baby camels are too adorable. Some snow-white, and others golden-coloured, and some dark; all with lovely irresponsible legs that they fling about in all directions when disturbed. We saw Kuwait long before we got to it. A strip of sapphire sea on the edge of the desert and, beyond, the mud walls and small towers of the town. As we drew nearer a picturesque caravan met us. Three camels, gaily decorated with many-coloured cloths. On one, with a sort of 'howdah' on it, sat the woman and her baby. The howdah was covered half-way up with scarlet cloth; the woman of course in black. She drew her veil across her face as we passed. (Rendel 1937a: 12–13.)

11. The Shaṭṭ al-ʿArab is the great river formed by the confluence of the Tigris and Euphrates at Qurna, connecting them with the head of the Gulf.

12. In fact, fresh water was fetched in specially built

Kuwaiti dhows from the Shaṭṭ al-'Arab, and not from Baṣra itself.

13. This was Hughe Knatchbull-Hugessen (Rendel 1957: 101–2).

14. Shaykh Mubārak, 'Mubārak the Great', ruled Kuwait from 1896 to 1915 and is credited with establishing it as an independent sovereign state under British protection.

15. The 'American Mission' comprised medical missionaries of the Dutch Reformed Church of America, who instituted the first healthcare services in Kuwait. They began visiting Kuwait in 1909 and, in 1911, Shaykh Mubārak provided premises for a hospital. In 1913, construction was completed of the first purpose-built facility (Facey and Grant 1999: 56–9).

16. The town walls have long since disappeared. They were thrown up hastily in 1920 during the reign of Sālim bin Mubārak (r. 1917–21) to protect Kuwait from the Ikhwān of Najd, who were threatening nearby Jahrah (Facey and Grant 1999: 20).

17. In the handwritten diary, Geraldine describes her first close encounter with Arabian women:

> The women press up close to the car window on my side to have a look at me through their heavy black veils. I can just see their large, dark eyes alive with curiosity and wonder, and I smile at them. (Rendel 1937a: 13v.)

18. The imposing new Agency building was completed in 1935, having been designed by the New Delhi office of the distinguished British architect Edwin Lutyens. It was first occupied by Harold Dickson until his retirement as Agent in 1936, when he handed it over to Gerald de Gaury (for a photograph, see Villiers 2006: 189). George Rendel disapproved of the building: see his short essay on what he considered to be appropriate architecture for the Gulf and Arabia in Rendel 1937b: 30–1. Both the Rendels were interested in traditional architecture, and particularly appreciated the building style of Riyadh.

19. Shaykh Aḥmad bin Jābir bin Mubārak Al-Ṣabāḥ, ruler of Kuwait 1921–50.

20. In the handwritten diary, Geraldine expresses her embarrassment thus:

> For the first time in my life, I felt self-conscious about my legs. In all that huge, crowded circle, mine was the only pair of legs visible (male or female). I think I will take quite kindly to Arab clothes while I am in this country. (Rendel 1937a: 14v.)

21. The war dance known as *al-'arḍah*.

22. In fact the Rendels went not to Bahrain but to Bushire (Bushehr) on the Persian coast, the location of the British Gulf Residency, as Sir George had political matters to discuss with the Resident, Trenchard Fowle (see Introduction pp. 24–27). The Resident was responsible for all the Political Agents on the Arabian side of the Gulf. Though Geraldine gives a full description of this interesting Persian tour in the handwritten diary (Rendel 1937a: 20–31), which took in Shiraz and Persepolis as well as Bushehr, she omits all mention of it here. The Persian tour is also described at length by Sir George in his official report to the Foreign Office (Rendel 1937b: 17–24). The Royal Geographical Society holds the Rendels' excellent collection of photographs of this trip (Album G9 II). The Rendels left Bushire for Bahrain on 2 March 1937.

23. The Rendels arrived on Bahrain from Bushire on 3 March 1937.

24. The Financial Adviser was Sir Charles Belgrave (1894–69), who served both Shaykh Ḥamad bin 'Īsā Al-Khalīfah (1872–1942) and his successor, Shaykh Salmān bin Ḥamad Al-Khalīfah (1895–61), from 1926 to 1957, and played a pivotal role in Britain's relations with Bahrain (see Belgrave 1960). The Political Agent was Lt-Col. Percy Gordon Loch (father of Tam Dalyell, the famous Labour MP).

25. Properly, Muḥarraq.

26. Wilson 1928: 28–32. Since the Rendels' visit, the Bahrain tumulus fields have been investigated and published by numerous archaeological teams and have been central to the rediscovery of the ancient Dilmun civilization.

27. In the handwritten diary, Geraldine describes this visit to the Shaykhah as having taken place on 4 March and therefore before, rather than after, their meeting with Shaykh Ḥamad on the 5th (Rendel 1937a: 33–5). She also adds a little more detail about the Shaykhah's appearance:

> Heavy gold bangles, and a gold ornament on one side of her nose (a gold-starred ornament fastened through the nostril like

an earring; called *khusam* in Arabic), and a chain of big golden beads. ... The palms of her hands were stained with henna and antimony, and her nails with henna. She wore slippers embroidered in silk. Her mother was with her. (Rendel 1937a: 32v–33r.)

28. Mrs Loch, wife of the Political Agent on Bahrain, Lt-Col. Percy Gordon Loch (Rendel 1937a: 33).

29. Al-'Uqayr functioned as the port of Hasa Oasis before the rise of Dammām and al-Khubar in the oil era.

30. Rep: a ribbed furnishing fabric.

31. Ras Sayia: properly Rā's Ṣayyāḥ, the tip of the long spit of mainland sheltering al-'Uqayr from the open sea.

32. For a good photograph, by the American oil geologist Max Steineke, of al-'Uqayr at about the time of the Rendels' visit, see Facey 1994: 84.

33. George Rendel in the handwritten diary describes their arrival thus: "Found Hafiz with a dozen local personalities on the quay waiting to welcome us. Hafiz took several photographs of us as we approached." (Rendel 1937a: 39.)

34. This European doctor and nurse are not identified by name, but they were possibly Mrs Elizabeth Dame and Mrs Josephine Van Peursem who, with other female nurses, had visited Riyadh in 1933 and 1935; or else female medical staff with Dr Wells Thoms, who was in Riyadh in the early part of 1937 (Armerding 2003: 82–97, 151). Touring medical missionaries of the Dutch Reformed Church of America had been active in southern Iraq and the Gulf from the late 19th century (see Scudder 1998). Bahrain was the base for those visiting al-Ḥasā' and Riyadh. Dr Paul Harrison was the first such doctor to visit Riyadh, in 1917 (Facey 1992: 213–14; Scudder 1998: 315). He was followed by other medics and nurses in the years following, well into the 1930s: for example, Dr Louis Dame paid several visits to Riyadh from 1923 and went to Taif in 1932, while Dr Harold Storm was in Riyadh and Taif in 1935–36. (Storm 1938: 73–6; Dickson 1956: 397–8 on Drs Dame and Thoms; Armerding 2003: 56–65, 146–51; Lippmann 2004).

35. Sabkhat Shatar: this name has not been identified; it was probably in fact the large salt flat known as Sabkhat Murayqib, just east of al-Ḥasā' Oasis, which was crossed by the track from al-'Uqayr.

36. Jisha and Jafar: properly, al-Jishshah and al-Jafr.

37. Actually the largest in Saudi Arabia, and one of the most extensive in the world, with two big towns (al-Hofūf and al-Mubarraz) and more than fifty villages (see Vidal 1955).

38. This form of carved plaster decoration was common to the other Gulf shaykhdoms, notably Bahrain and Qatar.

39. Berberine: that is, Berber, from North Africa, used loosely in this case to embrace Egypt, as the three servants, Mukhtār, 'Abd al-Raḥmān and Muḥammad all came from Upper or southern Egypt, as the author goes on to explain.

40. Tweeny: term for a lowly servant who assisted the cook and housemaid.

41. Sa'ūd bin 'Abdullāh Ibn Jiluwi was not as formidable a governor of al-Ḥasā' as his father had been, but stayed in post until 1967. During the 1950s he played a role in the Buraymi Dispute between Saudi Arabia and Britain.

42. The reference here is to the Ikhwān rebellion of 1929–30, an extremist attempt to break away from Saudi rule and set up a fundamentalist Wahhābī state in Najd and eastern Arabia (see Introduction p. 13–14; Dickson 1956: 281–330; Glubb 1960; Habib 1978; al-Rasheed 2002: 59–71).

43. See Vidal 1955: 91 for a photograph of the Amir. George, in the handwritten diary, says on the contrary that the Amir gave no speech of welcome, and describes him as having an "extreme inward spirit".

44. The Mosque of Ibrāhīm, built in the Ottoman style during the first Ottoman occupation of al-Ḥasā' in the 16th century, still stands today. For a brief outline of the Ottoman occupation and photographs of the Qaṣr and Mosque of Ibrāhīm, see Facey 1994: 51–3.

45. The al-Quṣaybī (aka al-Gosaibi, Algosaibi) family were the wealthiest merchant house in al-Ḥasā' and also represented King 'Abd al-'Azīz's interests in Baḥrain. 'Abd al-Raḥmān was father of the celebrated writer, intellectual, technocrat, minister and diplomat, Ghazi Algosaibi (1940–2010).

46. This building was known as the Qayṣariyyah. The market as a whole was known as the Sūq

al-Khamīs, or Thursday Market, and was famed throughout eastern Arabia (Facey 1994: 56–7, 72–4). Geraldine Rendel uses the Persian word 'bazaar' for market, rather than the more appropriate Arabic term *sūq*, which would have been less familiar to her readers.

47. Short for "*dīr bālak*", literally "pay your attention".

48. The large citrus fruit known as *tranj*, or *atranj*, a common fruit in the Arabian oases: the citron, *Citrus medica*.

49. *Deraya*: a term given as *dera'ah* in the Glossary to Dickson's *The Arab of the Desert* (1949: 627), where it is defined as a 'woman's frock'. A long, loose, light kaftan-like outer garment, with voluminous sleeves and a slit down the front, worn by women over the *thawb*. Properly, *durrāʿah*, pl. *darārīʿ*.

50. Properly, ʿAyn al-Khudūd, one of the largest of many such springs of natural artesian water feeding al-Ḥasāʾ Oasis. See Vidal 1955: 114–31 for a full list of them.

51. Properly, ʿAyn Najm, a medium-sized spring of hot, sulphurous water, with a domed roof.

52. Properly, ʿAyn al-Ḥarrah, a very warm spring.

53. His name is more likely to have been ʿAbd al-Salām (as opposed to Abū Salām) Ghālī.

54. The reference to the USA is an error. Since he allegedly learned French while studying agriculture, Fakhrī Shaykh al-Arḍ is more likely to have studied at the University of Montpellier in the south of France, where there was and is a prominent school of agriculture. This is confirmed by the Rendel's handwritten diary (Rendel 1937: 42). He was a brother of the well-known Dr Midḥat Shaykh al-Arḍ, physician to the Saudi royal family, who had accompanied the Saudi princes on their visit to London in 1935, and who appears later in this narrative.

55. According to George Rendel in the handwritten diary, the convoy foregathered at ʿAyn Najm before setting out again (Rendel 1937a: 57).

56. Properly, al-ʿUrayʿirah.

57. *Arfaj*: properly, *ʿarfaj*, *Rhanterium epapposum*, the national flower of Kuwait.

58. Hawkweed cannot be identified.

59. N'ala: George Rendel identifies this as "Na'la on Philby's map", referring to the fold-out map in Philby 1922, vol. 2, entitled Route from the Persian Gulf to the Red Sea, in which he in fact spells it 'al Nala'. (Rendel 1937a: 58.)

60. Umm As Sigyan: properly, Umm al-Siqyān, 'Mother of Waterings' – though, as de Gaury notes, it was a very bumpy, sterile valley (Gaury 1946: 47).

61. A quotation from the Bible: *Isaiah* 35: 1. The scabious was probably *fānī*, *Scabiosa palaestina*; the woodspurge perhaps *labnah*, *Euphorbia granulata* Forssk.; the 'small brown hyacinth' perhaps the parasitic *dhanūn*, *Orobanche aegyptiaca*; and the lily perhaps *bayraq*, *Asphodelus tenuifolius* (Mandaville 1990: 203; 281–2; 398–9). The mauve nettle and the daisies have eluded identification.

62. Sabkhat al ʿUraira: the *sabkhah*, or salt-flat, of al-ʿUrayʿirah.

63. Ajman: properly, ʿUjmān. Ibn Jimma: properly, Māniʿ Ibn Jumʿah. The settlement or *hijrah* of al-ʿUrayʿirah could once send out more than 1,000 fighting Ikhwān, so very little of it was left by 1937. (Gaury 1946: 47–8; Habib 1978: 175, 178.)

64. See Habib 1978; for short accounts of their foundation, see Facey 1992: 192–5 and Al-Rasheed 2002: 59–62.

65. Shaykh Muḥammad bin ʿAbd al-Wahhāb, founder of the reform movement, was born in al-ʿUyaynah, just north of al-Dirʿiyyah in the Wādī Ḥanīfah, in 1703/04. His religio-political pact with the *amīr* of al-Dirʿiyyah, Muḥammad bin Saʿūd, in 1744 marked a decisive point of departure in Saudi Arabian history. He went on to direct the development of the First Saudi State, dying in 1792. His movement remains a fundamental influence in the Kingdom today. See Rentz 2004 and especially Crawford 2014 for his biography; see also Facey 1992: 96–117 and 1997a, and Al-Rasheed 2002: 14–23, for brief accounts of the rise of the First Saudi State.

66. These Beduin were of the Al Murrah tribe, according to Geraldine in the handwritten diary (Rendel 1937a: 62v).

67. The Amir Muḥammad entered al-Madīnah on 6 December 1925 after a long siege by the Ikhwān under the command of the Muṭayr chief, Fayṣal al-Dawīsh (Vassiliev 1998: 264–5).

68. For desert truffles, *faqʿ*, *Tirmania* and *Terfezia*, see Mandaville 1990: 117; and 2011: 120–8, 131. In the handwritten diary, Geraldine adds the remark: "What is one man's meat is another's

luxury, I reflected, thinking what one paid for truffles at the Ritz or Savoy." (Rendel 1937a: 62v.)

69. The Ṣummān is the stony desert region to the east of the longitudinal north–south dunes of the Dahnā' sand strips. For the latter, see also Gaury 1946: 52–3.

70. *Nussi*: properly, *nuṣī*, *Stipagrostis plumosa* (Mandaville 1990: 360).

71. Arwaq al Nadhim: properly 'Arūq al-Nadīm, or al-Nāẓim (the meaning of which is obscure). *'Arq* or *'irq*, pl. *'arūq*, lit. root, tendon, is the term applied to the long sand strips of the Dahnā' (Dickson 1956: 589). This place was situated "about the middle of the Dáhana", according to George Rendel (Rendel 1937a: 64).

72. *Salam* tree: an acacia, either *Acacia ehrenbergiana* (*salm*) or *A. gerrardii* (*ṭalḥ*) (Mandaville 1990: 169–71). Dickson (1949: Sheet 3, Sketch Map showing Motor Road from Kuwait to Riyadh) actually marks this tree on his map as "Single Talha (Acacia) Tree", in the Dahnā' about 20 miles east of Rumāḥ. George Rendel calls it "de Gaury's solitary tree" (Rendel 1937a: 64).

73. These are the wells of Rumāḥ, an important watering place on the route between Riyadh and al-Ḥasā', and Riyadh and Kuwait.

74. Properly, Rumḥiyyah, also known as Rumayḥiyyah. The Amir Sa'ūd bin 'Abd al-'Azīz would succeed his father, 'Abd al-'Azīz Ibn Sa'ūd, as King in 1953. He was already well known to the Rendels, having visited London in 1935 (see Introduction pp. 18–19).

75. Imperial moustaches: a style of moustache with curled ends.

76. Thamama: al-Thumāmah, the area north of King Khalid International Airport today.

77. The 'Armah plateau and its cliff forms one of the west-facing escarpments that run more or less north–south through central Arabia, of which Jabal Ṭuwayq is the longest, highest and best-known. Al-Buwaib: 'the little gateway', signifying an accessible gap in the escarpment.

78. George Rendel names this "distant line of flame-coloured hills" as Araj Binban, i.e. the sand dunes known as 'Arq (or 'Irq) Banbān (Rendel 1937a: 71).

79. Muḥammad Shilḥūb was a well-known figure in the management of the Saudi court, and is described by other foreign visitors to Najd, notably Rihani (1928: 152–8) as the Chief Steward, in charge of incoming goods and distribution, palace hospitality, and general logistics. George Rendel describes him as having "a fine presence and attractive personality. Said to be very old but with still vigorous face, and beard, moustache and eyebrows carefully dyed black (like the Sheikh of Kuwait)." (Rendel 1937a: 71.)

80. As the Rendel photographs show, the two palaces and mosque at al-Badī'ah were fine examples of traditional Najdi architecture. Al-Badī'ah is situated on the west bank of the Wādī Ḥanīfah a few miles south of al-Dir'iyyah, and within easy reach of Riyadh. Harold and Violet Dickson also visited it in October 1937, and a long description of their visit can be found in Dickson 1956: 370–415, complete with colour sketches of the interior decoration (for which, see also Violet Dickson 1949).

81. The adobe techniques used to construct buildings of this type are described in detail in Facey 1997b.

82. Princess Nūrah bint 'Abd al-Raḥmān was an important influence on King 'Abd al-'Azīz throughout his life, and he frequently sought her advice. Sa'ūd al Arafa: the nickname Arayf, a Beduin term (of uncertain spelling) meaning camels lost to another tribe in a raid and subsequently returned to the fold, was given to a dissident faction of Ibn Saud's paternal cousins who had sided with his opponents after his recovery of Riyadh in 1902. Their loyalty was ensured by intermarriage, the chief among them, Sa'ūd al-Kabīr (aka Sa'ūd al-Arafa), being given Princess Nūrah as bride. (McLoughlin 1993: 32, 181.)

83. *Sic*; properly, Thumayrī. This gate was effectively the main gate into the city, giving direct access (along the line of today's Thumayrī Street) to the Palace square in the centre. For plans of the old city, see Facey 1992: 218–19, 228, 273 and 276. There are colour photographs of this street in 1938 in the collection of Princess Alice, Countess of Athlone, in the King 'Abd al-'Azīz Public Library in Riyadh.

84. The Amīr Sa'ūd's visit to England took place in June 1935 at the invitation of the Foreign Office to attend the Jubilee celebrations of King George V and Queen Mary and also to continue the ongoing discussion of frontiers (see Introduction

pp. 18–19). It was in the following year, at Ascot, that he extended his invitation to HRH Princess Alice, Countess of Athlone, and her husband the Earl of Athlone, to visit Saudi Arabia. This they did in 1938, Princess Alice becoming the third European woman to cross the country from coast to coast (Athlone 1966: 224–42).

85. The introduction of firearms and motor vehicles did indeed bring about the rapid near-extinction of Saudi Arabia's gazelles, not to mention the Arabian Oryx, until more recent efforts dating from the 1980s to create reserves around the country.

86. The Fort: Qaṣr al-Maṣmak, now restored as a national monument. The old Great Mosque, a masterpiece of traditional earthen architecture, was demolished in the 1950s. See Facey 1992: 185–6, 199, 220, 224, 251 and 306–7 for early photographs of both structures.

87. Properly, al-Dirʿiyyah, capital of the First Saudi State (*ca.* 1745–1818). See Facey 1997a for a history of the site. Having been granted Unesco World Heritage status, the entire site has recently been developed by a comprehensive programme of building restoration, new museums and visitor facilities.

88. Muḥammad ʿAlī Pasha, de facto independent Ottoman governor of Egypt, sent a military expedition against the Saudi State in 1816–18 led by his son, Ibrāhīm Pasha. A brutal and dramatic campaign culminated in the siege and destruction of al-Dirʿiyyah in 1818–19. Riyadh had already emerged as a substantial rival to al-Dirʿiyyah during the 18th century, and in 1824 the resurgent Saudi dynasty installed itself there. (Facey 1992 and 1997a.)

89. A colour sketch of what seems to be this very same cloth appears in Dickson 1956: facing p. 404.

90. At this point the following passage, omitted here, appears in the handwritten diary:

> Talk and coffee and then George presented him with the combined clock, thermometer and barometer, and the Coronation spoon which we had brought for him. He seemed very pleased and specially interested in the spoon, which was a copy of the anointing spoon used at the Coronation of the English kings. (Rendel 1937a: 85.)

91. At this point the following snippet, omitted here, appears in the handwritten diary: "The Amir asked George for information about what was happening in Spain." (Rendel 1937a: 86.)

92. Witchballs: hollow spheres of coloured glass originally used as fishermen's floats, and later manufactured as decorations.

93. The Nafūd al-Sirr is a north–south sand strip running parallel with and to the west of the Ṭuwayq escarpment.

94. The Amir Saʿūd gave the Rendels presents: a dagger and ʿabā for George, and a *thawb*, *durrāʿah* and ʿabā for Geraldine, as well as a valuable string of pearls which, though embarrassing to receive, "was impossible to refuse". (Rendel 1937a: 89–90.)

95. ʿAwaina: properly, al-ʿUyaynah. For this place and Shaykh Muḥammad bin ʿAbd al-Wahhāb, see note 65 above.

96. Sabkhat Al Awaina: properly, Sabkhat al-ʿUyaynah, the salt-flat of al-ʿUyaynah. The salt flats were good for driving, and Geraldine notes: "We got up to 120 kilometres an hour on some of them." (Rendel 1937a: 91.)

97. This is the Ḥaysiyyah Pass, the main route down the escarpment of Jabal Ṭuwayq, the largest and longest of the west-facing escarpments that curve north–south through central Arabia. The cliffs at this point, known to modern tourists as the Edge of the World, are especially spectacular, rising some 800 feet from the plain below and affording spectacular views. *Salam* shrub: *Acacia ehrenbergiana*. The Rendels were driven through the valley popular with tourists today known as Acacia Valley.

98. Properly, Khashm al-Ḥisyān, *khashm* meaning an outcrop or 'nose', and *hisyān* being the plural of *hisiy*, a seasonally dug well (Groom 1983: 107, 113). It is also sometimes known, perhaps incorrectly, as Khashm al-Ḥiṣān, 'the horse's muzzle' (e.g. in Gaury 1946: 102).

99. Asharr bushes: *ʿushar*, *Calotropis procera* (Mandaville 1990: 236–7).

100. ʿAwainid: properly, al-ʿUwaynid. A note in George Rendel's handwriting states that the route passed through Barrah and then ʿAwainid (Rendel 1937a: pages inserted between 110v and 111). Actually, it was the other way round, as al-ʿUwaynid is two miles south-east of Barrah.

101. Marāt: an old town and oasis in al-Washm district. For a fine photograph by Wilfred

Thesiger of the whole settlement in 1945, see Facey and Grant 1996: 72–3.

102. Nafud Ṭurayf Al Habl: properly, Nafūd Ṭurayf al-Ḥabl; *ṭurayf* in the sense of a protruding area, and *habl* having the meaning of both rope and a tract of sand dunes (Groom 1983: 97). The name applies to the area of sand lying NW–SE between Jabal Ṭuwayq and the oasis towns of the Washm district (Ushayqir, Shaqrāʾ, al-Qarāʾin, Uthaythiyyah, Tharmidāʾ and Marāt).

103. Qunaifida Sands: properly, Nafūd Qunayfidhah, the most easterly of the long sand strips west of Jabal Ṭuwayq, trending NW–SE. *Thamam*: *thumām*, *Panicum turgidum*, a desert grass growing in dense clumps (Mandaville 1990: 29–30).

104. Nafud Al Sirr: properly, Nafūd al-Sirr. Geraldine is even more lyrical in the handwritten diary:

> The sun was setting as we neared the Nefud Sirr. Half an hour before sundown, a wonderful violet light spread over everything. Absolutely flat desert on all sides as far as the eye could see; and then gold and flame colour as the sun went down. It died to dull rose, with blue, which rapidly turned to purple, and then the stars began to show. Then night, with the new moon on her back, and Venus in attendance …. (Rendel 1937a: 92v.)

105. Al-Duwadmī was an important government fort and the sole reprovisioning stop until al-Muwayh on the route between Riyadh and the Ḥijāz. See also Gaury 1946: 107–11.

106. Ataibe: the large ʿUtaybah tribe of central Najd played a leading role in the Ikhwān Revolt against Saudi authority. See note 42 above.

107. The reference is to Fayṣal bin Turkī, the second and greatest of the Imams of the Second Saudi State, who died in 1865. ʿAbd al-Raḥmān, father of King ʿAbd al-ʿAzīz, was his fourth and youngest son.

108. The 'Arab friend' was Ḥāfiẓ Wahba, as is clear in the handwritten diary (Rendel 1937a: 95v, 97).

109. The Genii, properly *jinn* (sing. *jinnī*), are not just figments of fairytale-writers' imaginations, but are mentioned frequently in the Qurʾān. Their existence is an integral part of Muslim belief.

110. Qaiʿiya: properly, al-Qāʿiyyah, an important well on the main route. Not to be confused with al-Quwayʿiyyah (the diminutive of al-Qāʿiyyah), wells on the southern pilgrim route across Najd. The handwritten diary is less detailed at this stage and makes no mention of al-Qāʿiyyah, instead ascribing the incident of the three shepherd boys to ʿAfīf, some miles farther on (Rendel 1937a: 99–100). It seems, therefore, that Geraldine later checked her typed account for accuracy with Shaykh Ḥāfiẓ. A photograph of the lonely well of al-Qāʿiyyah appears in de Gaury 1946, between pp. 112 and 113 ('Gaaiya').

111. Afif: properly, ʿAfīf.

112. Dafinah: properly, Dafīnah.

113. The date was Sunday 14 March (Rendel 1937a: 102v, 103).

114. Khabra Khal: a *khabrāʾ* being a level plain where water collects and stagnates.

115. Al-Muwayh was tucked in close to the eastern edge of the lava flow of Ḥarrat Kishb.

116. Wādī Huwwa: perhaps *hūwah* meaning a trench or chasm, or else *hawāʾ* meaning air, breeze. Ruqba: perhaps properly *Rukbah*, having the connotation of [good] riding.

117. Ḥarrah: the Arabic word for volcanic lava. They were now crossing the southern tip of the lava field known as Ḥarrat Kishb.

118. The relatively lush vegetation at ʿAshayrah or ʿUshayrah made it an important junction and much-used camping-place where routes to Mecca from al-Qaṣīm and across southern Najd converged. A photograph of the well and inscription appears in de Gaury 1946, between pp. 112 and 113.

119. Sir Reader Bullard, British Minister at Jiddah, and Harry M. Eyres, his head of chancery. Bullard was an erudite Arabist who had previously been consul at Jiddah during the early 1920s. His reports from Jiddah form a remarkable archive of Britain's relations with Saudi Arabia during his two postings there in 1923–25 and 1936–39 (Bullard 1993). For his version of meeting the Rendels at ʿUshayrah, and of their visit in general, see Bullard 1993: 144–9.

120. *Talḥ* tree: *ṭalḥ*, *Acacia gerrardii* (Mandaville 1990: 170).

121. Umm Hamdha: Arabic spelling uncertain.

122. Shabha: Arabic spelling uncertain.

123. King Hussein: Ḥusayn bin ʿAlī was Sharīf of Mecca 1908–16 and King of the Ḥijāz from 1916,

when he instigated the Arab Revolt against the Turks, until his abdication in 1924 in favour of his son ʿAlī. ʿAlī was deposed the following year, when ʿAbd al-ʿAzīz Ibn Saʿūd annexed the Ḥijāz. Dolma Bagche: a reference to the Dolmabahçe Palace (Turkish: *Dolmabahçe Sarayı*), built in ornate 19th-century French style in the Beşiktaş district of Istanbul, which served as the main administrative centre of the Ottoman Empire from 1856 to 1887 and 1909 to 1922.

124. Al-Ṭāʾif and its gardens, and the routes between it and Mecca, were visited in February 1926 by Eldon Rutter and described in graphic detail in his classic work, *The Holy Cities of Arabia*, first published in 1928 (Rutter 2015: 293–312).

125. The Saudi–Hashimite war: the struggle between Ibn Saʿūd and the Hashimite Sharīfs of Makkah for control of the Ḥijāz, which first erupted in 1919 with the Khurmah Dispute, and resumed in 1924 with the capture and sacking of al-Ṭāʾif, followed by the entry into Makkah. It ended with the capture of al-Madīnah and Jiddah in December 1925.

126. Abdul Aziz bin Muammer: properly ʿAbd al-ʿAzīz bin Muʿammar.

127. Shafa Hills: properly al-Shifā hills, south-west of al-Ṭāʾif.

128. Shagra Valley: properly, Shaqrāʾ.

129. Geraldine omits to mention that George too fell off his donkey, a potentially serious accident described in George's handwriting in the diary: "Then up a very steep hillside of granite boulders, my donkey, trying to go up a perpendicular place, fell backwards on to me and cut his leg. I escaped lightly with a bruised elbow. … Country is in the *dira* of the Beni Sufian tribe according to Hafiz. According to Philby we should have seen a great stretch of the Tihama (or coastal plain) and many juniper forests if we had been able to get to the top." What a loss to British diplomacy if George had been badly injured! (Rendel 1937a: 108v.)

130. Bullard and Eyres accompanied the Rendels on this excursion (Bullard 1993: 141, 144–7).

131. This is a quotation of two separate lines from the second poem in the German poet Goethe's famous Wanderer's Nightsong (*Wandrers Nachtlied*), written in 1776. The first half of the poem reads:

> Über allen Gipfeln
> Ist Ruh,
> In allen Wipfeln
> Spürest du
> Kaum einen Hauch;
> Die Vögelein schweigen im Walde.
> Warte nur, balde
> Ruhest du auch.

> Above every summit, it is calm.
> In all the tree-tops you feel scarcely a breath;
> The birds in the forest are silent;
> Just wait, soon you will rest as well.

132. The reference is to a once-popular nursery rhyme that was current in several variants of a more or less scatological nature. A tame version goes:

> Matthew, Mark, Luke and John
> Went to bed with their trousers on.
> John got up in the middle of the night
> And said his trousers were too tight.

133. Somerville College, Oxford: founded in 1879, and a pioneer of women's university education in Britain, along with Lady Margaret Hall, which counts Gertrude Bell amongst its early alumnae.

134. i.e. ghee, clarified butter.

135. Boulestin: the celebrated French restaurant in St James's, London, founded in 1927 by X. Marcel Boulestin, pioneer of fine cuisine and 'culinary ambassador to the English'.

136. Lunch with the Amir of al-Ṭāʾif is described in Rendel 1937a: 114, 138, and in Rendel 1937b: 51–2. Wādī al-Liyyah, south of al-Ṭāʾif, was notable for its fertility and beautiful scenery.

137. The Arabian Gold Mining Syndicate: actually the Saudi Arabian Mining Syndicate Ltd, a company set up by the American Karl Twitchell with the participation of US and British mining groups as shareholders, which obtained the concession to search for minerals in the Hijaz. The brightest prospect was the ancient gold workings at Mahd al-Dhahab ('Cradle of Gold'), near the Darb Zubaydah about 200 miles NE of Jiddah and 100 miles SE of al-Madīnah. One of the company's first tasks was to clear a motorable track between it and Jiddah. (Twitchell 1953: 146–7, 156–62.)

138. Properly, Madrakah, a small oasis lying off the western corner of the Ḥarrat Rahaṭ.

139. The Jiddah condenser, built to convert seawater into fresh, was popularly known as al-Kandasah. An ugly square structure with a tall chimney, it had been installed by the Turks at the turn of the century and supplied much of the city's needs

until the 1940s. (Twitchell 1953: 58, 181; Facey and Grant 1996: 49.)

140. The "tireless friend" was Mrs Dorothy Ousman, wife of Cyril Ousman, the British vice-consul. Both were well-known and popular characters in Jiddah. Cyril Ousman first came there in 1929 as engineer in charge of the seawater condenser, and was much in demand as a mechanic and fixer. He was also popular among Saudis. He was murdered in Jiddah in November 1951 by Prince Mishārī bin ʿAbd al-ʿAzīz, after a row broke out during a party at his house. Dorothy Ousman accepted compensation from the Saudi government and left quietly for South Africa. (Rendel 1937a: 119; Lacey 1980: 285–6.)

141. George Rendel's presentation to the King and the dinner on the same evening are described in detail in Rendel 1937b: 54–60. It was followed by a lunch party at the British Legation, attended by the Rendels, Bullard, Yūsuf Yasīn, Ḥāfiẓ Wahba and other Saudi Foreign Ministry officials. Geraldine was seated next to Yūsuf Yasīn, and he told her "that he looked upon all Arabia as one – Iraq, Syria, Palestine, Transjordan, Saudi Arabia (? and Yemen). He is to accompany the Crown Prince [Saʿūd] to England and spoke with pleasure of our meeting again." Later, Philby came to tea and "was very pleasant and full of interesting information". (Rendel 1937a: 118v–119.)

142. This party, on Saturday 20 March, was rearranged from dinner to tea specifically in order to enable Geraldine to meet the King (Rendel 1937a: 122–4). Shaykh ʿAbdullāh Sulaymān Al-Ḥamdān, from ʿUnayzah in al-Qaṣīm, had been in charge of finance since 1926 and served as Finance Minister 1932–54. He had a brilliant head for figures, and was adept at juggling the Kingdom's finances so as to steer it through the hard times and competing demands of the 1930s.

143. In the handwritten diary Geraldine adds: "He was very gracious to me and made a complete conquest of me." (Rendel 1937a: 124.)

144. The other Englishman was S.L. James (Rendel 1937a: 123), about whom nothing can be discovered.

145. This was the extensive Green Palace, outside Jiddah, Philby's third home there. See Philby 1948: between pp. 224 and 225, for photographs of this and his first home.

146. The party comprised Philby and two of his assistants, the Rendels, Yūsuf Yasīn, Ḥāfiẓ Wahba, Bullard, Eyres, Cyril Ousman and Judd from the Legation, and S.L. James (Rendel 1937a: 124v).

147. Umm Manṣūr's own given name was Shahīda; she bore three sons (Manṣūr, Mishʿal and Mitʿāb) and a daughter (Qumāsha) by King ʿAbd al-ʿAzīz. She died in 1938. Umm Ṭalāl's own given name was Munayyir; she bore two sons (Ṭalāl and Nawwāf) and a daughter (Maḍāwī) by the King (Lees 1980). All five of these boys went on to play prominent roles in public life. Her residence is described in the handwritten diary as "a small palace just outside the walls all in white plaster, with a garden with a fountain and formal flower beds with nothing in them" (Rendel 1937a: 126).

148. Dr Midḥat Shaykh al-Arḍ, was of Syrian origin and brother of Fakhrī Shaykh al-Arḍ, who had accompanied the Rendel party across Arabia. He served King ʿAbd al-ʿAzīz as personal physician and confidant from the early 1920s until the King's death in 1953. He would later become Minister of State in Saudi Arabia, before serving as ambassador to Spain, Switzerland and France. He also served as Saudi Arabia's ambassador to the United Nations in Geneva until 1990.

149. One of these two boys was Mitʿab, aged seven or eight (Rendel 1937a: 127).

150. Geraldine's handwritten diary is more specific: "He said he remembered meeting me in England in 1925 [*sic*; actually 1926] and in 1932" (Rendel 1937a: 126–7). Hence the Rendels must have first met Faysal during his UK visit in 1926.

151. It is unclear whether this took place in 1926 or 1932. But it was probably in 1932, when the Rendels' eldest child David (b. 1918) would have been thirteen.

152. *Wasm*, lit. 'design', is also the usual term for tribal marks branded on camels.

153. Amir Mitʿab bin ʿAbd al-ʿAzīz (b. 1928), third son of Umm Manṣūr, went on to enjoy a long career as a minister and in business.

154. This unexpected historical snippet most probably came from Ḥāfiẓ Wahba or Reader Bullard, as there is no indication that Geraldine herself had done any background reading on Islam – though she may have been aware of Lady Evelyn Cobbold's *Pilgrimage to Mecca* (1934), which however contains no such reference to

this Caliph. Al-Qādir Billāh (947–1031 CE) was the 25th Caliph of the ʿAbbāsid dynasty in Baghdad. He was noteworthy for leading the Sunnī struggle against Ismāʿīlī Shīʿism, and for enforcing the doctrines of the Ḥanbalī school of law, the strictest of the four Sunnī *madhhab*s (to which Saudi Arabia's Wahhābī movement also belongs).

155. Frans Hals the Elder (*ca.* 1582–1666), the celebrated Dutch painter noted for his lively portraiture, epitomized by his *Laughing Cavalier* of 1624, which hangs in the Wallace Collection in London.

156. The royal ladies presented Geraldine with an embroidered *thawb* and *daraya*, a black ʿ*abā*, and a beautiful pearl necklace which, "though I could not refuse it at the moment will, I think, have to be returned somehow". "Saw Hafiz and told him that I could not keep so splendid a present as the King's gift of pearls. Hafiz said I had better write to the King and leave letter and pearls with Bullard to be returned after our departure." Then she adds, ruefully: "Have wanted fine pearls all my life. Seems a bitter fate to have to return them when they have actually been given to me." (Rendel 1937a: 131v–132). Bullard records the problems caused by this issue:

> Ibn Saud has a great fault: he *will* give British officials presents. I have escaped this so far, but he gave Rendel a gold-handled sword and his favourite wife gave Mrs Rendel a necklace of pearls. We had an embarrassing time explaining to the Saudis. Eventually Ibn Saud said he would abide by the decision of the F.O. Rendel has made a proposal that his wife should keep the pearls and send to the favourite queen in return some jewellery of hers, recently inherited, of about the same value. This would be an unpleasant precedent for me, but Rendel's visit was a special affair, so I shall not take a very strong line. Rendel says in a letter that he hopes whatever is done will not embarrass me.

The issue of what to do about presents from the King rumbled on for some time. In the end, the FO made an exception for these gifts and the Rendels were allowed to keep them (Bullard 1993: 159–60; 172–3; G.W. Rendel, letter to King ʿAbd al-ʿAzīz dated 14 July 1937 from the Foreign Office, in the Middle East Archive, St Antony's College Oxford, Rendel Papers GB165-0238, Correspondence and Reports, File no. 3.)

157. Yūsuf Yasīn and Ḥāfiẓ Wahba came to the Legation on this morning of departure to present George with a sword of honour (Rendel 1937a: 133). The three men went to see the King to explain once more that presents could not be accepted, and both sword and pearl necklace were left at the Legation pending a decision from the Foreign Office in London. The sword is still in the possession of the Rendel family.

158. Geraldine makes no previous mention of meeting American oil company personnel in Jiddah. George, however, explains in the handwritten diary:

> The American colony [in Jiddah] consists mainly of the headquarters staff of the American oil company, which is endeavouring to find oil in Hasa. This is a branch, known as the California-Arabian Oil Company [CASOC], of the Standard Oil Company of California [SOCAL], and works in close association with the Bahrein Oil Company. … Mr Thornburg and Mr Davies, two directors of the American parent company [SOCAL], and Mr Hamilton, their London representative, were also in Jedda. We had already met them in Bahrein and they had followed us across Arabia in rapid stages in two light Ford cars. They were extremely friendly and when we left gave us a great send-off on board our ship. It is doubtful, however, whether oil will be found in Hasa in commercial quantities. … If the enterprise fails, it will be a great blow for Ibn Saud. (Rendel 1937a: 133v; 1937b: 65.)

159. The reference is to the French liner *Asia*, which sank in Jiddah harbour after a catastrophic fire on 21 May 1929. See also Cobbold 2008: 104, 285.

160. These last two sentences were handwritten over the original typescript. The typescript sentences originally read: "As I leaned over the taffrail and looked back across the water to the mainland, I thought regretfully of the widened horizons of time and space which I was leaving in a country to which I had completely lost my heart, and to which I mentally registered the determination – *inshallah* – to return.

SOURCES AND REFERENCES

Abbreviations

NLW	National Library of Wales, Aberystwyth
ODNB	*Oxford Dictionary of National Biography*. Online edition. Oxford University Press
TNAUK	The National Archives, United Kingdom, Kew, Richmond, Surrey TW9 4DU

UNPUBLISHED SOURCES

Papers in the National Library of Wales, Aberystwyth

RENDEL, Geraldine and George (1937a), handwritten personal diary entitled 'Diary of Arabian Journey, February–March 1937, by G.E. and G.W. Rendel'. NLW, Rendel Papers P13.

RENDEL, Geraldine (*ca.* 1938), 158-page typescript entitled 'Arabian Journey: Three Weeks Crossing Saudi-Arabia'. NLW, Rendel Papers K2. [Forms the text of this publication]

RENDEL, George (1956), Full-length unedited typed MS entitled 'Sir George Rendel's Memoirs', as submitted to the Foreign Office for approval, later published in edited form as *The Sword and the Olive: Recollections of Diplomacy and the Foreign Service* (London: John Murray). NLW, Rendel Papers S11.

Papers in The National Archives, United Kingdom, Kew

RENDEL, George (1937b), 71-page typescript entitled 'Report by Mr Rendel on his Tour in the Persian Gulf and Saudi Arabia, Feb.–Mar. 1937'. TNAUK, file E 2312/2312/65

CROWE, Sir Colin (1964a), The Struggle for Power in Saudi Arabia. Dated 5 January 1964, from Jiddah. TNAUK FO 371/174671, Arabian Department, BS 1015/2

—— (1964b), Sir Colin Crowe's Valedictory Despatch, dated 30 September 1964, from Jiddah. TNAUK, FO 371/174676, BS 1051/2

Photographs in the Royal Geographical Society, London

RENDEL, George and Geraldine (1937), 283 black and white photographs taken during their journey across Arabia in February–March 1937. Royal Geographical Society Picture Library, ref. G9, Boxes I and II. [Note: *ca.* 27 of these images are missing, see Facey 1998 (unpublished catalogue) below. 185 images from this series are also held by the Middle East Archive, St Antony's College, Oxford.]

Papers and photographs in the Middle East Archive, St Antony's College, Oxford

RENDEL, George (1937c), letter to King ʿAbd al-ʿAzīz, dated 14 July 1937 from the Foreign Office. Rendel Papers GB165-0238, Correspondence and Reports, File no. 3

—— (1964a), 41 35mm colour slides of a journey across Saudi Arabia, taken by himself and his daughter Rosemary, January 1941

—— (1964b), letter from Sir George Rendel to Sir Colin Crowe, dated 29 December 1964. Rendel papers, GB165-0238, folder no. 5 (item DS 24453)

—— (1966), 'Memorandum by Sir George Rendel: Bushire and Bahrain', dated 13 July 1966. Rendel papers, GB165-0238, folder no. 6 (item DS 42.4/DS 315)

Rendel family papers

ANON. (n.d.), handwritten note attached to a picture of Geraldine Fitzgerald's silver-gilt christening mug (sold at Christie's on 20 March 1990, lot no. 364), which is inscribed "From Philip Antoine de Teissier, III Baron de Teissier", her godfather.

BERESFORD FAMILY TREE (n.d.), handwritten 1-page chart showing Beresford and FitzGerald descent from Marcus Beresford, Earl of Tyrone in the 18th century

FITZGERALD FAMILY TREE (n.d.), 'The Geraldines of the Queen's County, AD 1546 to AD 1882'

PHOTOGRAPH ALBUMS (1920s and 1930s), containing many pictures of holidays in England, at Menton, and at the Rendels' chalet at Villars, Switzerland

RENDEL, Rosemary (n.d.) handwritten notes on Lucy Wickham, one entitled 'Louis Lahon', the other untitled.

Papers in possession of William Facey

FACEY, William (1998). Unpublished catalogue of the Rendel negatives and photographs of Saudi Arabia in the Royal Geographical Society, London.

RENDEL, Rosemary, correspondence with William Facey: letter to WF dated 2 February 1987; letters from WF dated 16 December 1986, 4 and 23 February 1987; notes of conversations with William Facey, 1987

PUBLISHED SOURCES AND FURTHER READING

ALGOSAIBI, Ghazi (1999), *Yes, (Saudi) Minister! A Life in Administration*. London: London Centre of Arab Studies

ARMERDING, Paul (2003), *Doctors for the Kingdom: The Work of the American Mission Hospitals in the Kingdom of Saudi Arabia*. Grand Rapids, Michigan: William B. Eerdmans

ARMSTRONG, H.C. (1934), *Lord of Arabia. Ibn Saud: An Intimate Study of a King*. London: Arthur Barker

ARNOLD, José (1964), *Golden Swords and Pots and Pans*. London: Gollancz

ASAD, Muhammad (1954), *The Road to Mecca*. London: Max Reinhardt

ATHLONE, HRH Princess Alice, Countess of (1966), *For My Grandchildren*. London: Evans

BARGER, Thomas C. (2000), *Out in the Blue: Letters from Arabia – 1937 to 1940*. Vista, California: Selwa Press

BELGRAVE, Charles (1960), *Personal Column: Sir Charles Belgrave's Autobiography*. London: Hutchinson

BULLARD, Reader (1961), *The Camels Must Go*. London: Faber

—— (1993), *Two Kings in Arabia*. Reading: Ithaca

CLAYTON, Gilbert (1969), *An Arabian Diary: Sir Gilbert Falkingham Clayton, KCMG, KBE, CB, CMG*. Introduced and ed. by Robert O. Collins. Berkeley and Los Angeles: University of California Press

COBBOLD, Lady Evelyn (2008), *Pilgrimage to Mecca*. Introduced by William Facey and Miranda Taylor. London: Arabian Publishing. [First published in 1934, London: John Murray]

CRAWFORD, Michael (2014), *Ibn 'Abd al-Wahhab*. London: Oneworld

DICKSON, H.R.P. (1949), *The Arab of the Desert: A Glimpse into Badawin Life in Kuwait and Saudi Arabia*. London: George Allen & Unwin

—— (1956), *Kuwait and Her Neighbours*. London: George Allen & Unwin

DICKSON, Violet (1949), Artistic House Decoration in Riyadh. In *Man* no. 97, July 1949: 76–7

—— (1955), *The Wild Flowers of Kuwait and Bahrain*. London: George Allen & Unwin

FACEY, William (1992), *Riyadh, the Old City: From Its Origins to the 1950s*. London: Immel. Also published in Arabic (1999) as *Al-Riyāḍ: al-madīnah al-qadīmah*. Riyadh: King 'Abd al-'Aziz Public Library

—— (1994), *The Story of the Eastern Province of Saudi Arabia*. London: Stacey International

—— (1997a), *Dir'iyyah and the First Saudi State*. London: Stacey International. Also published in Arabic (1999) as *Al-Dir'iyyah wa-'l-dawlah al-Su'ūdiyyah al-ūla*. Riyadh: Al-Turath

—— (1997b), *Back to Earth: Adobe building in Saudi Arabia*. Riyadh: Al-Turath

—— (2013), Pilgrim Pioneers: Britons on Hajj before 1940. Chapter 16 in *The Hajj: Collected Essays*, eds. Venetia Porter and Liana Saif. London: British Museum

FACEY, William, and GRANT, Gillian (1996), *Saudi Arabia by the First Photographers*. London: Stacey International

—— (1999), *Kuwait by the First Photographers*. London: I.B. Tauris

FITZGERALD, Gerald Beresford (1889), *Clare Strong*. 2 vols. London: F.V. White

—— (1896), *An Odd Career*. London: Digby, Long & Co.

FITZGERALD, Gerald Beresford, and LETHBRIDGE, Olive (1911), *The Marriage Maze: A Study in Temperament*. London: Eveleigh Nash

GAURY, Gerald de (1946), *Arabia Phoenix: An Account of a Visit to Ibn Saud, Chieftain of the Austere Wahhabis and Powerful Arabian King*. London: Harrap

—— (1950) *Arabian Journey and Other Desert Travels*. London: Harrap

—— (1975), Memories and Impressions of the Arabia of Ibn Saud. In *Arabian Studies* II: 19–32

GLUBB, John Bagot (1960), *War in the Desert: An R.A.F. Frontier Campaign*. London: Hodder & Stoughton

GRAFFTEY-SMITH, Laurence (1970), *Bright Levant*. London: John Murray

GROOM, Nigel (1983), *A Dictionary of Arabic Topography and Placenames*. Beirut: Librairie du Liban/London: Longman

HABIB, John S. (1978), *Ibn Saud's Warriors of Islam: The Ikhwan of Najd and Their Role in the Creation of the Sa'udi Kingdom, 1910–1930*. Leiden: Brill

HOLDEN, David, and JOHNS, Richard (1981), *The House of Saud*. London: Sidgwick and Jackson

HOWARTH, David (1964), *The Desert King: A Life of Ibn Saud*. London: Collins

JARMAN, Robert L., ed. (1998), Saudi Arabia: Annual Report, 1933, paragraph 164. In *Political Diaries of the Arab World: Saudi Arabia,* Vol. 5: *Annual reports 1930–1940*. Farnham: Archive Editions

KEDOURIE, Elie (1980a), Ibn Sa'ud on the Jews. Chapter 5 in *Islam and the Modern World*, pp. 67–74. London: Mansell

—— (1980b), Great Britain and Palestine: The Turning Point. Chapter 8 in *Islam and the Modern World*, pp. 85–170. London: Mansell

KELLY, J.B. (1964), *Eastern Arabian Frontiers*. London: Faber

—— (1988), Jeux sans frontières: Philby's Travels in Southern Arabia. In *The Islamic World from Classical to Modern Times: Essays in Honor of Bernard Lewis*. Eds. C.E. Bosworth et al. Princeton: Darwin Press

KIERNAN, R.H. (1937), *The Unveiling of Arabia: The Story of Arabian Travel and Discovery*. London: Harrap

LACEY, Robert (1981), *The Kingdom*. London: Hutchinson

LEATHERDALE, Clive (1983), *Britain and Saudi Arabia, 1925–1939: The Imperial Oasis*. London: Cass

LEES, Brian (1980), *A Handbook of the Al Sa'ud Ruling Family of Saudi Arabia*. London: Royal Genealogies

LIPPMANN, Thomas (2004), The Pioneers. In *Saudi Aramco World* Magazine, May/June

LOEBER, Rolf and Magda (2006), *A Guide to Irish Fiction, 1650–1900*. Dublin: Four Courts Press

MANDAVILLE, James (1990), *Flora of Eastern Saudi Arabia*. London: Kegan Paul International

—— (2011), *Bedouin Ethnobotany: Plant Concepts and Uses in a Desert Pastoral World*. Tucson: University of Arizona Press

MCLOUGHLIN, Leslie (1993), *Ibn Saud: Founder of a Kingdom*. London: Macmillan

MEULEN, Daan van der (1957), *The Wells of Ibn Sa'ud*. London: John Murray

MONROE, Elizabeth (1963), *Britain's Moment in the Middle East, 1914–56*. London: Chatto & Windus

—— (1973), *Philby of Arabia*. London: Faber

Oxford Dictionary of National Biography (*ONDB*). Online edition. Oxford University Press

PHILBY, H. St J. B. (1922), *The Heart of Arabia: A Record of Travel and Exploration*. 2 vols. London: Constable

—— (1928), *Arabia of the Wahhabis*. London: Constable

—— (1939), *Sheba's Daughters, being a Record of Travel in Southern Arabia*. London: Methuen

—— (1946), *A Pilgrim in Arabia*. London: Robert Hale

—— (1948), *Arabian Days: An Autobiography*. London: Robert Hale

—— (1952), *Arabian Highlands*. Ithaca, New York: Cornell University Press

PICKERING PICK, B. (ed.) (1950), *The Sherborne Register, 1500–1950*. Sherborne: Old Shirburnian Society

AL-RASHEED, Madawi (2002), *A History of Saudi Arabia*. Cambridge: Cambridge University Press

RENDEL, George (1957), *The Sword and the Olive: Recollections of Diplomacy and the Foreign Service*. London: John Murray

RENDEL, Geraldine (1938), Across Saudi Arabia. In *The Geographical Magazine*, no. 6: 163–80

RENTZ, George S. (2004), *The Birth of the Islamic Reform Movement in Saudi Arabia: Muḥammad bin 'Abd al-Wahhāb (1703/4–1792) and the Beginnings of Unitarian Empire in Arabia*. Edited and introduced by William Facey, London: Arabian Publishing

RIHANI, Ameen (1928), *Ibn Sa'oud of Arabia: His People and His Land*. London: Constable

—— (1937), In Ibn Saud's Palace: Glimpses of Life as Subject or Guest of an Arab Sultan. In *Asia* 37: 215–18

RUSH, Alan (1987), *Al-Sabah: History and Genealogy of Kuwait's Ruling Family, 1752–1987*. London: Ithaca Press

RUTTER, Eldon (2015), *The Holy Cities of Arabia*. With a biographical introduction by William Facey and Sharon Sharpe. London: Arabian Publishing. [Reprint of the 1928 first edition]

RYAN, Andrew (1951), *The Last of the Dragomans*. London: Geoffrey Bles

SCUDDER, Lewis R. (1998), *The Arabian Mission's Story: In Search of Abraham's Other Son*. Grand Rapids, Michigan: Wm B. Eerdmans Publishing Co.

STORM, Harold (1938), *Whither Arabia? A Survey of Missionary Opportunity*. London and New York: World Dominion Press

TIDRICK, Kathryn (1981), *Heart-beguiling Araby: The English Romance with Arabia*. Cambridge: Cambridge University Press

TWITCHELL, Karl S. (1953), *Saudi Arabia, with an Account of the Development of Its Natural Resources*. 2nd edition. New Jersey: Princeton University Press

VASSILIEV, Alexei (1993), *The History of Saudi Arabia*. London: Saqi Books

VIDAL, F.S. (1955), *The Oasis of Al-Hasa*. Dhahran: Arabian American Oil Company

Villiers, Alan (2006), *Sons of Sindbad: The Photographs*. With a biographical introduction by William Facey, Yacoub Al-Hijji and Grace Pundyk. London: Arabian Publishing

Wahba, Hafiz (1964), *Arabian Days*. London: Arthur Barker

Wearing, (2014), *The London Stage 1910–1919: A Calendar of Productions, Performers, and Personnel*. Plymouth: Rowman & Littlefield

Williams, Kenneth (1933), *Ibn Sa'ud: The Puritan King of Arabia*. London: Jonathan Cape

Wilson, Arnold T. (1928), *The Persian Gulf: An Historical Sketch from the Earliest Times till the Twentieth Century*. Oxford: Clarendon Press

PICTURE CREDITS

The publisher is grateful to the following for permission to reproduce images of which they own the copyright:

Jonathan Rendel

Frontispiece

pp. 2, 6, 8, 9, 10 (both pictures), 11, 22, 35, 36

Christopher Rendel

pp. 4, 30

Private collection

p. 19

Middle East Archive, St Antony's College, Oxford

p. 31

p. 38: Rendel 1964 nos. 025 (top) and 029

The Royal Geographical Society, London

Images from the Rendel Collection (Boxes G9 I and G9 II), identified here by their negative numbers:

p. xii: D 863-04

p. 25: D 870-01 (top); D 864-16

p. 26: D 865-13 (top); D 865-21

p. 48: D 864-02

p. 49: D 864-04

p. 50: D 863-16 (top); G 009/356

p. 52: D 870-16

p. 53: D 1518 (top); D 872-07 (middle); D 1519

p. 54: D 870-12

p. 56: D 1511

p. 57: D 1501

p. 58: D 1512

p. 64: D 601-01

p. 66: D 601-03

p. 67: D 601-04

p. 68: D 601-05

p. 69: D 601-06

p. 70: D 871-02 (top); D 602-06

p. 71: D 601-12

p. 74: D 601-09 (top); D 601-10

p. 75: D 601-08 (top); D 601-11 (middle); D 601-07

p. 77: D 874-13

p. 78: D 601-17 (top); D 601-20

p. 79: D 601-19 (top); D 601-18

p. 80: D 602-02

p. 81: D 602-03

p. 82: D 602-04

p. 83: D 602-05

p. 86: D 602-08 (top); D 602-11

p. 88: D 602-13 (top); D 602-12

p. 89: D 602-10

p. 90: D 873-02

p. 93: D 602-14 (top); D 873-12

p. 94: D 872-03

p. 95: D 602-17
p. 96: D 602-18
p. 97: D 602-19 (top); D 602-20
p. 100: D 603-02 (top); D 603-04
p. 103: D 871-19
p. 105: D 603-11
p. 108: D 603-15 (top); D 871-06
p. 109: D 603-20
p. 110: D 603-21
p. 111: D 604-06
p. 112: D 604-17 (top); D 874-02
p. 113: D 604-18 (top); D 604-19
p. 114: D 605-01
p. 115: D 870-20 (top); D 605-02 (middle); D 605-05
p. 116: D 871-07
p. 117: D 607-11
p. 118: D 604-04
p. 119: D 604-03
p. 120: D 604-05
p. 121: D 862-10
p. 124: D 604-07 (top); D 604-08
p. 127: D 604-09 (top); D 604-10 (bottom left); D 604-13
p. 128: D 604-11
p. 130: D 605-09 (top); D 605-10
p. 131: D 870-18
p. 132: D 605-11 (top left); D 605-12
p. 136: D 871-09
p. 138: D 873-06 (top); D 605-15 (middle); D 605-14
p. 139: D 874-10
p. 140: D 605-19

p. 142: D 605-20 (top); D 605-21
p. 143: D 606-01
p. 146: D 606-02 (top); D 606-03
p. 148: D 873-13
p. 149: D 873-16 (top); D 606-06
p. 150: D 871-04
p. 151: D 606-10
p. 152: D 606-12 (top); D 606-13
p. 153: D 867-13
p. 154: D 606-14
p. 157: D 867-21 (top); D 872-05
p. 158: D 869-05
p. 159: D 868-08
p. 160: D 871-15
p. 161: D 873-05
p. 162: D 605-08
p. 166: D 866-08 (top); D 873-14
p. 167: D 873-17 (top); D 867-06
p. 168: D 607-09
p. 169: D 607-03
p. 170: D 870-15
p. 172: D 863-02 (top); D 607-16 (middle); D 870-08
p. 173: D 865-03 (top); D 607-18
p. 174: D 607-19 (top); D 866-07
p. 175: G 009/250 (top); D 870-05
p. 176: D 606-05
p. 177: D 864-20 (top); D 607-17
p. 178: D 607-12
p. 179: D 607-13
p. 180: D 607-20
p. 182: D 862-13

Jacket front: D 604-11
Jacket back: D 602-17
Back flap: D 686-20

INDEX

In alphabetizing, al- and variants of the definite article, Āl, and b. (bin), are ignored.

Proper names used by Geraldine Rendel are listed according to her spelling of them. Where necessary, a correct standard transliterated version is added in brackets, e.g. 'Awaina (al-'Uyaynah); Rumaya (al-Rumḥiyyah). Other entries are presented in standard transliterated form.

Abadan 16, 21
Abdul Aziz Al Feisal Al Saud, King ('Abd al-'Azīz b. 'Abd al-Raḥmān b. Fayṣal Āl Sa'ūd, King, aka Ibn Sa'ūd) 1, 17, 21–2, 28–32, 47–8, 69, 110, 144, 153, 156, 170, 203
 campaigns to create Saudi Arabia 13–15, 47, 155, 210
 description of, by Geraldine Rendel 181
 and dress code for foreigners in Najd 65–6
 and frontier negotiations 17–18, 30, 198
 and gifts to Rendels 30–1, 208, 212
 invites Rendels to visit Saudi Arabia 18, 48
 invites Andrew Ryan to visit Saudi Arabia 18–19
 and Italy 30–2, 34
 meets and is photographed by George Rendel 178–83
 meets Geraldine Rendel 180–3
 order of Knight Grand Cross (GCB) conferred upon 18–20
 and Palestine 34
 and sister Nūrah 116–18
 and sons 187–8
 wives 185–9
 See also Anglo-Saudi relations
Abdul Aziz bin Muammer ('Abd al-'Azīz b. Mu'ammar, Amīr of al-Ṭā'if) 156, 165, 181, 210
'Abdullah b. Ḥusayn al-Hāshimī (Amīr of Transjordan) 16–17
Abdullah Suliman ('Abdullah b. Sulaymān al-Ḥamdān, Shaykh, Finance Minister) 32, 180, 211
Abu Dhabi 18, 27
Abu Salam Ghali ('Abd al-Salām Ghālī) 92, 206
acacia trees 103, 207
Achaemenids 24, 26
Aden 12, 47
Afif ('Afīf) 20, 30, 147, 209
Ahmed, Sheikh, of Kuwait (Aḥmad b. Jābir Al-Ṣabāḥ, r. 1921–50) 23, 51, 54–6, 61, 204
air communications 16–17, 21, 23, 27, 48
 Imperial Airways 17
Ajman tribe (al-'Ujmān) 97, 206
Aleppo 16
Alexandria 17
Algosaibi, Ghazi 205. *See also* Qusaibi, Abdurrahman
'Alī b. Ḥusayn al-Hāshimī, King of the Ḥijāz (r. 1924–25) 210
Alice, HRH Princess, Countess of Athlone 2, 14, 19, 30, 207–8

America, Americans *see* United States of America
American Mission *see* Dutch Reformed Church in America; missionaries, medical
Anacreon 6
Anglo-Persian Oil Company (APOC) 16–17, 23
 See also Abadan
Anglo-Saudi relations 1, 12–15, 17–20, 28–34, 39
Anglo-Saudi treaty (of Jiddah, May 1927) 13, 20
Ankara 16
Arab Revolt 13, 16, 210
Arabian Gold Mining Syndicate (Saudi Arabian Mining Syndicate Ltd) 30, 168, 210
architecture 204
 Gulf /Ḥasā' 69–71, 80–2, 111, 205
 of Jiddah 171, 175, 177
 Najdi 111–21, 132, 143, 207
al-'arḍah (war dance) 204
'Armah plateau and escarpment 109, 207
Arwaq al Nadhim ('Arūq al-Nadīm/Nāẓim) 102–3, 207
Ashaira ('Ashayrah/'Ushayrah) 20, 30, 152–55, 168–9, 209
Asia, wrecked pilgrim ship 192, 212
Asir ('Asīr) 13, 47, 156
Ataibe ('Utaybah) tribe 144, 209
Athens 3, 9–10, 17
'Awaina (al-'Uyaynah) 30, 97, 137–9, 206, 208
'Awainid (al-'Uwayniḍ) 30, 139, 208

Badia Palaces (al-Badī'ah), Riyadh 38, 110–16, 122–3, 129, 132, 207
Baghdad 16, 20, 21
Bahrain Petroleum Co. (Bapco) 61
Bahrein (al-Baḥrain) 12, 16, 20, 22–4, 27–8, 32, 59–64, 72, 76, 104, 204–5, 212
 ancient Dilmun 204
 ancient tumuli 61, 204
 Britain and 59–60
 fish 59
 fresh water from the sea 60
 oil on 27–8, 60–1
 pearling 60
 Rendels on 59–64
Banbān 207
Barger, Tom 198
Barrah 30, 208
basalt see *ḥarrah*
Basra (Baṣra) 16, 21, 48–9, 203
Beduin 51, 56, 67, 80, 100–2, 118, 129, 145–8, 150–1, 169–70, 203

flocks and herds 51, 100–2, 107–9, 145, 153
hospitality 100–1, 148–50
life 100–2
tents 51, 94, 100, 102, 145, 203
Beirut 16
Belgium 37
Belgrave, Charles 22, 27, 59, 64, 199, 204
Bell, Gertrude 1, 210
bellam 48
Berbers 205
Beresford, Susan Anne 4
Berlin 3
Birka (al-Birkah) 30, 168–9
Blunt, Lady Anne 1
Bombay 12
Boris, HM King, of Bulgaria 35
Boulestin, Marcel 210
Brindisi 20
Britain
 Admiralty 12
 Colonial Office 12
 Committee of Imperial Defence 12
 Diplomatic Service 3, 10
 Foreign Office 1, 10–12, 14, 16, 24, 39
 Eastern Dept 11, 14, 16, 33–4
 India Office 12, 18, 23
 War Office 12
 adapts to emergence of Saudi Arabia 12–15
 and Arab Revolt 13
 and Arab world 11–12
 and the Gulf 12, 16, 21, 23, 204
 and Gulf Shaykhdoms 12, 18, 23–4
 and Ikhwān Revolt 14
 and Saudi Arabia 1, 12–15, 17–20, 28–34, 39, 200
 and Bulgaria 35–6
 and Italy 30–2, 34
 and Palestine 30, 33–3
 and Red Sea route to India 30–2
 See also ʿAbd al-ʿAzīz b. ʿAbd al-Raḥmān Āl Saʿūd (Ibn Saʿūd), King
British travellers in Arabia 1
Broadlands, Sandown 8, 195
Bulgaria 35–6
Bullard, Reader 15, 20–1, 30, 32, 151–2, 161, 179, 181–3, 199, 203, 209–12
Buraymi Dispute 18, 39, 198, 205
Bushire (Būshehr) 12, 24–5, 27, 204
Buwaib (al-Buwayb) 109, 207

Cairo 20, 33, 71, 106
California Arabian Standard Oil Company (CASOC) 32, 48, 191, 203, 212
camels 56, 59, 65, 67, 69, 73, 77, 80, 94, 100–2, 107–9, 123, 153, 162–4
 caravans 147, 154
 milk 100–2, 150
cars *see* motor transport
Catholics, Catholicism 3, 8, 195

Chelsea 11
Clayton, Gilbert 15
clothes 50–1, 54–6, 61–2
 See also dress in Saudi Arabia; veiling
Cobbold, Lady Evelyn 1, 14, 23, 198, 211
Congo, Belgian 37
Coronation of HM King George VI (May 1937) 33
Cox, Percy Z. 13, 198
Crane, Charles R. 14
Crete 9
Crowe, Colin 39, 201
Cyprus 20

Dafina (Dafīnah) 20, 30, 148–50, 209
Dahana Sands (al-Dahnāʾ) 102, 207
Damascus 16, 20–1
Dame, Elizabeth 205
Dame, Dr Louis 203, 205
al-Dammām 28
Daraya (al-Dirʿiyyah) 13, 30, 98, 129–32, 137, 206–8
Darb Zubaydah 210
date gardens, dates 69, 89–90, 129, 151
Davies, Fred A. 32, 212
Demidoff, Princess 10
Dhahran (al-Ẓahrān) 40
dhows 56–8, 60, 63–6
Dickson, Harold R.P. 15, 23, 54, 204, 207
Dickson, Violet 54, 207
al-Dirʿiyyah *see* Daraya
donkeys 77, 158–61, 163–4, 210
Downside, Benedictine abbey and school 3, 8, 11
dress in Saudi Arabia 22, 65–7, 76–7, 84–5, 104, 132, 153, 186, 189, 203, 206
Dublin 4, 196
Dutch Reformed Church in America 203–5. *See also* missionaries, medical
al-Duwadmī 20, 30, 141–5, 209

Eastbourne 11
Egypt, Egyptians 13, 17, 33, 36–7, 39, 175
 Rendels' three Egyptian servants 71, 73, 91–2, 95, 98, 102–3, 106, 115, 123, 132, 137, 141, 147, 162–5, 169–70, 191, 205
Eyres, Harry 21, 152–3, 161, 182, 203, 209–11

falconry, falcons *see* hunting
Fāṭimah, Wādī *see* Wadi Fatima
Fayṣal al-Duwīsh 206
Feisal, Amīr (Fayṣal b. ʿAbd al-ʿAzīz b. ʿAbd al-Raḥmān Āl Saʿūd, later King, 1964–75) 14, 32, 39, 168, 182–3, 185, 187
 appointed Foreign Minister 17
 struggle for power with King Saʿūd 39
 visits to England 185, 198, 211
Feisal (Fayṣal I b. Ḥusayn al-Hāshimī, King of Iraq) 12, 16
Feisal (Fayṣal b. Turkī Āl Saʿūd, Imām, d. 1865, grandfather of King ʿAbd al-ʿAzīz) 144, 209
firearms, impact of 208

First World War 3, 12–13, 155
FitzGerald, Revd Augustus Otway (1813–97) 4, 196–7
FitzGerald, Charles Robert 5, 196–7
FitzGerald, Gerald Augustus Robert 4, 196
FitzGerald, Gerald Beresford (1849–1915) 3–8
 bankruptcy 6–8, 197
 career as civil servant and novelist 4–8
 death 8, 197
 marriage to Lucy Adelaide Wickham 5, 197
 novels by 5–6, 197
 upbringing of daughter Geraldine 5–8
 views on marriage 6
FitzGerald, Revd Gerald Stephen (1810–79) 4, 196
FitzGerald, Mary Susan 8
FitzGerald, Vice-Admiral Sir Robert Lewis (1766–1844) 4, 196
FitzGerald, Sarah Anna Elizabeth 197
Forbes, Rosita 1
Fowle, Trenchard 20, 24, 27, 204
France, French 12, 16, 21
Frome 5
frontiers, Arabian 16–18, 20, 24, 27, 30, 198

Galilee 20–1
Gaury, Gerald de 15, 20, 23, 27, 29–30, 207
 journeys in Arabia 20, 198
 Political Agent, Kuwait 51, 54–5, 203
 as writer 20
Geographical Magazine 1
George V, HM King 18
Germany 3, 16, 34–6, 129
 German–Soviet Non-Aggression Pact (1939) 35–6
Goldie, George 3
Gomasha (Qumāsha) bint ʿAbd al-ʿAzīz Āl Saʿūd 187, 211
Greece 9–10, 17
Gulf, the 21, 47, 51
 British in 12, 16, 21, 23
Gulf Shaykhdoms 12, 16–18, 23–4

Hadhramaut (Ḥaḍramawt) 32
Haifa 20
Ḥāʾil 13, 203
Hals, Franz 189, 212
Ḥamad b. ʿĪsā b. ʿAlī Al-Khalīfah, Shaykh of Baḥrain (r. 1932–42) 59, 60–2, 204
 palace of 61–2
 Sheikha, wife of 62
Hamilton, Lloyd 15, 32, 212
Hamza, Fuad (Fuʾād Ḥamzah) 18, 20
Hamza, Tawfiq (Tawfīq Ḥamzah) 20
*ḥarīm*s 23, 32–3, 40, 62, 84–5, 133–4
ḥarra (*ḥarrah*, volcanic rock) 30, 153, 168–9, 209
Ḥarrat Kishb 209
Ḥarrat Rahaṭ 210
Harrison, Dr Paul 198, 205
Hasa (al-Ḥasāʾ) 13, 28, 47–8, 98, 102, 203, 205, 207
Hasa Oasis 28, 30, 40, 68–94, 205
 Ain Al Harra (ʿAyn al-Ḥarrah) 85–8, 206
 Ain Khodud (ʿAyn al-Khudūd) 82, 85–7, 206
 Ain Naim (ʿAyn Najm) 85, 206
 Ain Umm Saba (ʿAyn Umm Sabʿah) 87–8
 donkeys 77
 rice 85
 spring pools and irrigation 76, 82, 85–9
 textiles 77
Hashimites 12–13
Ḥaysiyyah Pass 208
Ḥawār Island 27
Hedjaz (al-Ḥijāz) 13, 17, 21, 98, 121, 142, 151–2, 154–5, 163, 180, 209–10
 Kingdom of the Ḥijāz and Najd and Its Dependencies 13
 See also Jidda; Mecca; Taif
Hendaye 11
al-Ḥijāz *see* Hedjaz
al-Hofuf (al-Hufūf) 28, 69–94, 205
 bazaar (Sūq al-Khamīs; Qayṣariyyah market) 76–80, 205–6
 Mosque of Ibrāhīm Pasha 73, 205
 Palace and Guest House 69–72, 75–6
 Qaṣr al-ʿAbīd 93
 See also Kut
horses 72, 92–3, 156, 158–61, 163–4
al-Ḥudaydah 17
Humphrys, Francis 16
hunting 72, 84, 103–6, 123, 156, 208
Hussein, King (Ḥusayn b. ʿAlī al-Hāshimī, Sharīf of Makkah and, from 1916, King of the Ḥijāz, r. 1908–24) 13, 16, 155, 209–10

Ibn Abdul Wahhab, Muhammad (Shaykh Muḥammad b. ʿAbd al-Wahhāb) 97–8, 137, 206
Ibn Jiluwī, Amīr ʿAbdullāh (d. 1934) 72
Ibn Jiluwī, Amīr Saʿūd b. ʿAbdullāh 28, 71–2, 89, 92–3, 95, 199, 205
Ibn Jimma (Māniʿ Ibn Jumʿah) 97, 206
Ibn Rifāda 17
Ibn Saʿūd *see* Abdul Azīz Al Feisal Al Saud, King
Ibrāhīm Pasha 208
ʿĪd al-Aḍḥā celebrations 50–1, 54–5
Ikhwān 97, 204, 206
 Revolt 14, 17, 72, 144, 205, 209
India 12, 15, 16–17, 23–4, 47, 56, 60
Iran *see* Persia
Iraq 12–14, 16, 17, 21, 23, 24, 47–50, 72, 197, 203, 205
 Anglo-Iraqi Treaty (1922) 12
 Anglo-Iraqi Treaty (1930) 12, 16
Ireland, Irish 4–6
Islam 15
Istanbul 16, 36
Italy 3
 in Arabia 30–2, 34
 Radio Bari 32
 Red Sea steamer service 33, 191

Jabal Juda (Jabal Jūdah) 96
Jafar (al-Jafr, Hasa Oasis) 68, 205
Jahrah 204
James, S.L. 182, 211
Japanese goods 129, 182
 cultured pearls 57
Jerusalem 16, 106
Jews 16, 33–4
 See also Palestine
Jidda (Jiddah) 14–15, 18, 20, 30, 32–3, 39–40, 153, 156, 168, 170–92, 203, 210–12
 bazaar/*sūq* 179
 British community in 32, 183
 British Legation at 14, 32, 171, 173–4, 180, 182, 191, 211
 climate 171, 176
 condenser (al-Kandasah) 171, 210–11
 description of 171–9
 Green Palace 183, 211
 King's Palace 179
 Queens' Palace 185
 Rendels' departure from 191–2
 Treaty of (May 1927) 13, 20
jinn 209
Jisha (al-Jishshah, Hasa Oasis) 68, 205
Jīzān 17
Jowett, Benjamin 4
Jubaila (al-Jubaylah) 137
Jubilee celebrations (London 1935) 18
Judd 182–3, 211
juniper forests 160, 210

Kennington, Eric 29, 200
Kensington, London 3, 5, 7
Khabra Khal (Khabrā' Khāl) 150–1, 209
Al-Khalīfah, Ḥamad b. 'Īsā, Shaykh of Baḥrain 27
Khashm Al Hisan (al-Ḥiṣān/al-Ḥiṣyān), 139, 208
Khawr al-'Udayd 27
Khurmah Dispute (1919) 210
Kildare, Ireland 3–4, 196
Kirkuk 16
Knatchbull-Hugessen, Hughe 52, 204
Konya 16
Koran (al-Qur'ān) 98
Kut (al-Kūt, citadel of al-Hufūf) 68, 73–5, 78, 93
Kuwait 13–14, 20, 21, 23, 27, 154, 203–4, 207
 1939 constitutional crisis 23
 blockade (by Saudi Arabia) 20, 23–4, 28, 30, 72, 199–200
 British Political Agency in 54, 200, 204
 fresh water 52, 203–4
 frontier with Iraq 197–8
 Kuwait Oil Company (KOC) 23
 as maritime society 52, 54, 56–8
 markets 53, 57
 pearling 52, 54, 56–7
 smuggling 21, 23–4, 30, 72
 Rendels' visit to 49, 51–8
 walls of 52–3, 204

Lampson, Miles 33
Landseer, Thomas 7
Lawrence, T.E. 13
League of Nations 12, 17
Lebanon 12, 186
Leighton, Frederick 7
Leinster 4
Lethbridge, Olive 6, 197
Lisbon 10
Liyah Valley (Wādī Liyyah) 30, 165, 167–8, 210
Loch, Percy Gordon 20, 22, 27, 59, 64, 204–5
 father of Tam Dalyell 199, 204
 Mrs Loch 62, 205
Longrigg, Stephen 15
Loxley, Peter 27
Lutyens, Edwin 54, 204

Maḍāwī bint 'Abd al-'Azīz Āl Sa'ūd 211
al-Madīnah *see* Medina
Madraqa (Madrakah) 30, 169–70, 210
Madrid 10
Mahd al-Dhahab 30, 168, 210
Mahomet Ali (Muḥammad 'Alī Pasha, of Egypt)
 invasion of Najd (1816–18) 13, 132, 208
Makkah *see* Mecca
Manama (al-Manāmah) 22, 59, 64
Mandates, League of Nations 12
Māni' Ibn Jum'ah *see* Ibn Jimma
Manṣūr b. 'Abd al-'Azīz Āl Sa'ūd 185, 211
Marāt 20, 30, 139–40, 144, 208–9
Mary, HM Queen 18
al-Maṣmak, Qaṣr 110, 129, 208
Mecca (Makkah), Meccans 13–16, 23, 30, 47–8, 92, 129, 133, 139, 141, 143, 147, 154, 156, 168, 171, 180, 189, 191, 203, 209–10
 Darb-an-Nasara (Darb al-Naṣāra) 168
 See also pilgrimage
Medina (al-Madīnah) 15, 23, 47
 siege of (1925) 102, 206, 210
Mediterranean 32
Menton 197
Mish'al b. 'Abd al-'Azīz Āl Sa'ūd 185, 211
missionaries, medical 15, 52–3, 67, 198, 203, 205.
 See also Dutch Reformed Church in America
Mitab (Mit'ab b. 'Abd al-'Azīz Āl Sa'ūd) 187, 211
Montpellier University 92, 206
Mosul 16
motor transport 15, 28, 32, 49, 168
 desert travel by 49–51, 67–8, 91–6, 98–9, 137, 139, 141, 144–5, 147, 149–51
 impact of, on wildlife 208
 in mountains 158–9, 170
 stuck in desert 49, 51, 95, 151, 153
Mubarrak, Sheikh, of Kuwait (Mubārak b. Ṣabāḥ Al-Ṣabāḥ, r. 1896–1915) 52, 204
al-Mubarraz (Hasa Oasis) 94, 205
 Qaṣr Ṣāhūd 94
Muhammad b. 'Abd al-'Aziz, Amīr (Muḥammad b. 'Abd al-'Azīz Āl Sa'ūd) 102, 206

Muḥammad b. ʿAbd al-Wahhāb, Shaykh *see* Ibn Abdul Wahhab
Muḥammad ʿAlī Pasha, of Egypt *see* Mahomet Ali
Muhammad Ibn Saud (Muḥammad b. Saʿūd, Amīr of al-Dirʿiyyah, d. 1765) 98, 206
Muhammarah 21, 49
Muharrak (Muḥarraq) 59, 204
Muktar (Mukhtār, the Rendels' chief servant) *see* Egypt
Al Murrah tribe 100–2, 206
Muscat 12
Musfer (Misfir, Rendels' guide) 92, 135
music 55
Mussolini, Benito 34
Mutair tribe (Muṭayr) 72, 206
Muwaih (al-Muwayh) 20, 30, 144, 150–1, 168, 209

Nafūd Qunayfidhah *see* Qunaifida Sands
Nafud El Sirr (Nafūd al-Sirr) 135, 140–1, 145, 208–9
Nafud Turaif Al Habl (Nafūd Ṭurayf al-Ḥabl) 139, 209
Nairn transport 20
Najd *see* Nejd
Nakhsh, Jabal 27
Najrān 17
N'ala (al-Nala, sandy area north of Hasa Oasis)) 95, 206
Nasser, President Gamal Abdul 39
National Library of Wales, Aberystwyth 195
Nawāf b. ʿAbd al-ʿAzīz Āl Saʿūd 185, 211
Nazis 16, 34
Nejd (Najd), Nejdis 13–15, 21–2, 24, 47–8, 97–8, 102, 151–2, 154, 156, 163, 203, 205, 209
Nisibin 16
Nura, Emira (Amīrah Nūrah bint ʿAbd al-Raḥmān Āl Saʿūd) 116–17, 207

oases 47
Offaly/Ophaly 4, 196
oil 16, 21, 33
 on Baḥrain 16, 27–8
 in Saudi Arabia 14–15, 17–18, 27–9, 32, 34
Oliphant, Lancelot 11, 14
Oman 12, 18
Ottoman Empire, Ottomans 12–13, 16, 74, 210
 Dolmabahçe style 210
 occupation of al-Ḥasā' in 16th century 205
Ousman, Cyril 211
Ousman, Dorothy 179, 211
Oxford 8, 19
 Balliol College 4, 196
 The Queen's College 3
 River Cherwell 18
 St John's College 4, 196
 Somerville College 210

Palestine, Palestinians 12, 16, 30–4, 36, 187
 Jewish immigration 16, 20–1, 30, 33–4
Paris 10
pearls, pearling 52, 54–5, 60, 76, 208, 212

Peel Commission 30, 34
Persepolis 24, 26
 photographs of 24, 26
Persia, Persians 1, 11, 12, 16–17, 21, 24–7, 204
 banning of chador (1936) 24
Peursem, Josephine van 205
Philby, Dora 2, 48, 67, 203
Philby, Harry St John Bridger (aka Ḥajjī ʿAbdullah) 2, 13–15, 17, 32, 182–3, 198, 200, 203, 210–11
 conversion to Islam 2, 195
pilgrimage to Makkah, pilgrims 14, 50, 147, 171, 179, 191, 209
 ʿĪd al-Aḍḥā' (10–13 Dhū al-Ḥijjah 1355 AH) 50–1, 54–5, 203
 numbers 198
 quarantine 191
Pinelli, Licinia (1846/7–1934) 3
protectorate treaties (in Gulf) 12
Pugin, Peter Paul 3
Putney Vale cemetery 37, 40

al-Qādir Billāh, Caliph 187, 211–12
Qaiʿiya (al-Qāʿiyyah) 30, 145, 209
al-Qarāʾin (al-Washm) 209
al-Qaṣīm 209, 211
Qatar 27, 205
Qunaifida Sands (Nafūd Qunayfidhah) 140, 209
al-Qurʾān *see* Koran
Qusaibi, Abdurrahman (al-Quṣaybī, ʿAbd al-Raḥmān) 28, 76, 80, 82–90, 205
Qusaibi, Saad (al-Quṣaybī, Saʿd) 76, 84, 90
al-Quṣaybī family 22–3, 66, 205
 house in al-Hufūf 80–2
al-Quwayʿiyyah 209

railway 16
rain 23–4, 30, 47, 52, 55
Ramah (Rumāḥ) wells 103, 207
Ras Sayia (Rāʾs Ṣayyāḥ) 65, 205
Rashīd, Āl/Ibn (of Ḥāʾil) 13, 47, 203
Red Sea 16, 30–2, 34, 47, 156, 170–1, 175
Rendel, Anne (1920–77) 11, 35, 195
Rendel, David (1918–2001) 10–11, 37, 185, 195, 211
Rendel, George Wightwick (1833–1902) 3
Rendel, George William (1889–1975) 1
 birth and background 3
 career 10–12
 Catholic upbringing 3
 character 11, 15
 organizational skills 10, 37
 head of Eastern Dept of Foreign Office 11–12, 14–15
 memoir 16, 33
 first Middle Eastern journey (1932) 16–17
 report on second Middle Eastern journey (1937) 20–1, 23–33
 interest in architecture 204
 in photographs 2, 10, 22, 25–6, 35–6, 38, 115, 153, 160,

Index 225

photography 1–2, 51, 182, 195
and Arabian frontier negotiations 16–18
political business in Arabia and Gulf 21, 24–34, 204
and dress in Saudi Arabia 65–7, 76, 132
falls off donkey 210
gifts to and from King ʿAbd al-ʿAzīz and Amīr Saʿūd 30–1, 208, 212
and Ḥāfiẓ Wahba 14, 33, 39
and King ʿAbd al-ʿAzīz 30–2, 179–83, 211
and naming of Kingdom of Saudi Arabia 14
and Saudis 18, 28–9, 33
scepticism about Saudi oil resources 14, 32
and Treaty of Jiddah (1927) 198
opinion of Philby 32
on position of women 32–3
on Arabs and Persians 24, 27
and Jews 16, 33–4
on Muslims and Christians 28
and Palestine 16, 20–1, 30, 33–4
as minister to Bulgaria 35–7
ambassador to Yugoslav Government in exile (1941–43) 37
knighthood (1943) 37
at UN Relief and Rehabilitation Administration (1943–47) 37
at International Refugee Organization (1947) 37
at Austrian Treaty Commission 37
ambassador to Belgium (1948) 37
chairs German Debts Commission 37
chairs Singapore Constitutional Commission 37
chairs Anglo-Egyptian Financial Agreement negotiations (1959–64) 39
revisits Saudi Arabia (1964) 38–40
chairs Singer & Friedlander Ltd 40
death 40
Rendel, Geraldine Elizabeth de Teissier (1885–1965)
birth and background 3–8, 195
character 3, 8–10, 16, 20–4, 37
children 3, 9–11, 16
conversion to Roman Catholicism 3, 8
Middle Eastern journeys 11, 16–17, 19
first Middle Eastern journey (1932) 16–17
second Middle Eastern journey (1937) 19, 20–33
diary of 1937 journey and typescript 1, 20–4, 46, 195
omissions 20–1, 27, 203
intention to publish 1, 46
interest in architecture 204
interest in desert flora 24, 51, 68, 94, 96, 102, 139–40, 155, 203, 206–7
learns/speaks Arabic 48, 72, 84–5, 189
marriage to George Rendel 2–3, 8–9

meets King ʿAbd al-ʿAzīz 32, 180–2, 211
gift of pearls 212
meets Queen Umm Manṣūr 32–3
in photographs ii, xii, 2, 6, 9–11, 22, 25, 58, 64, 66, 77, 86, 88–9, 114, 149, 152, 158–9, 161, 169–70, 182
photography 1–2, 55, 107, 115, 135, 170, 195
rides a donkey 159–61
as traveller 1, 9–10, 21–3, 61–7, 139–44, 147, 149–50, 153–4, 203
and dress in Saudi Arabia 22, 65–7, 76–7, 119–20, 132–3, 204
and veiling 2–3, 22–3, 28, 29, 50, 67, 123, 126, 133, 182
visits *harīm*s 62, 84–5, 133–4, 185–9
as woman in Saudi Arabia 22–3, 46, 120–2, 126, 133, 156, 182
during Second World War 35–7
awarded OBE 35
journey to Belgian Congo 37
death 37
Rendel, Jonathan (b. 1946) 37
Rendel, Peter (1925–2004) 195
Rendel, Rosemary (1923–2011) 11, 195
visits Saudi Arabia (1964) 39–40
Rendel, Stuart (1st Baron Rendel, 1834–1913) 195
Rihani, Ameen 198, 207
Riviera, French 9
Riyadh (al-Riyāḍ) 1, 15, 18, 20, 28–30, 39–40, 46–7, 103, 109–35, 142–3, 152–3, 189, 203–5, 207–9
Dhumairi (Thumayrī) Gate and Street 117–18, 129, 207
electricity 126
main square 118–19
markets 124, 126–9
mosques 110, 112, 119, 129, 208
Palace 118–22, 125–9, 132–5
Qaṣr al-Maṣmak 110, 129, 208
royal residences in 129
Shamsiya wireless station 116, 118, 135–8
telephone 116
Rome 10
Royal Air Force (RAF) 16, 27, 60
Royal Geographical Society, London 1–2, 5, 24, 204
Royal Navy 27, 60
Rumāḥ *see* Ramah
Rumaya (al-Rumḥiyyah) 103–9, 123, 207
royal hospitality at 103–6
Ruqba 151, 209
Russia 35–6
Rutter, Eldon 210
Ryan, Andrew 14–15, 17–20, 199, 203
crosses Saudi Arabia (1935) 19–20, 30

sabkhah 68, 96
Khabrāʾ Khāl 150–1, 209
Sabkhat al-Dafīnah 149

Sabkhat Maṭṭī 27
Sabkhat Murayqib 205
Sabkhat al 'Uraira (Sabkhat al-'Uray'irah) 96, 206
Sabkhat al-'Uyaynah 139, 208
Safwan (Ṣafwān) 51, 203
St Mary's School, Ascot 11
Sālim b. Mubārak Al-Ṣabāḥ, Shaykh of Kuwait (1917–21) 204
Salmān b. Ḥamad b. 'Īsā Al-Khalīfah, Shaykh of Baḥrain (r. 1942–61) 204
Salonika 10
Sandown 3, 8
Saud b. 'Abd al-'Aziz, Amir (Saʿūd b. ʿAbd al-ʿAzīz b. ʿAbd al-Raḥmān Āl Saʿūd, Amīr and later King, r. 1953–64) 17–19, 21–2, 28–9, 103–6
　appointed Crown Prince 17
　attends 1935 Jubilee, London 18–19, 28, 122, 207–8
　attends 1937 Coronation, London 28, 33, 135
　daughters 133–4
　hosts the Rendels in Riyadh 110, 116–23, 125–9, 132–6
　sons Fahd and Muḥammad 125–6, 135–6
　visits England and Europe 121–2
　visits Oxford 18
　Viceroy of Najd 121
　as king 39–40
　deposed 39
Saud al Arafa (Saʿūd al-Arafa, aka Saʿūd al-Kabīr) 118, 207
Saudi Arabia
　economic hardship 13–14
　emergence of, in 1920s and '30s 15
　frontiers 13–14, 16–18, 20, 24, 27, 30, 197–8
　in 1920s and '30s 12–15, 17–20, 47–8
　independence 13, 19
　and Italy 30, 34
　Kingdom of 1
　and Kuwait 20, 23–4, 28
　National Guard 39
　opening up to foreigners 2–3, 15
　photography of 1–2
　population 48
　See also Anglo-Saudi relations; oil
Saudi Arabian Mining Syndicate Ltd 30, 168, 210
Saudi–Hashimite War (1919, 1924–25) 155, 210
Saudi State
　First (1744–1818) 13, 206, 208
　Second (1824–87) 203, 208
Sayl 20
Second World War 34–7
Serbians 10
Shabha (village near al-Ṭāʾif) 155, 209
Shafa Hills (al-Shifā escarpment, al-Ṭāʾif) 30, 156, 159–66, 210
　music, poetry and dance 163–4
　village hospitality 161–5
Shagra (Shaqrāʾ) Valley, al-Ṭāʾif 156, 159, 162, 210
Shakespear, W.H.I. 13

Shalhoub, Muhammad (Muḥammad Shilḥūb) 110, 207
Shaqrāʾ (al-Washm) 209
al-Sharayi (al-Sharāʾiʿ) 20
Shaṭṭ al-ʿArab 16, 21, 48–9, 52, 203
Shaykh al-Arḍ, Dr Midḥat 185–7, 206, 211
Sheikh-El-Ardh, Fakhri (Fakhrī Shaykh al-Arḍ) 92, 157, 182, 206, 211
Sherborne School 196–7
al-Shifā escarpment, al-Ṭāʾif see Shafa Hills
Shiraz 24–5
slavery, slaves 55, 103, 120, 122, 126, 134–5, 144, 181–2
Sofia 35–6
Somerset 3–4
Southampton 4
Spain 10, 208
Standard Oil of California (SOCAL) 15, 17, 32, 60, 203, 212
Steineke, Max 198, 205
Storm, Dr Harold 203, 205
Suez 33, 191
　Suez crisis (1956) 39, 198
Sumer, Sumerians 16
Summan (Ṣummān) 102, 207
Swanage 11
Sykes–Picot Agreement (1916) 12
Syria, Syrians 12, 17, 21, 36, 92, 185, 206

Taif (al-Ṭāʾif) 30, 91, 144, 155–68, 205, 210
　Amir of see Abdul Aziz bin Muammer
　description 155–6, 165–8
Ṭalāl b. ʿAbd al-ʿAzīz Āl Saʿūd 185, 211
Talhat 'Imr (Ṭalḥat ʿImr) 103
Tehran 27
Thamama (al-Thumāmah) 109, 207
Tharmidāʾ 209
Thesiger, Wilfred 209
Thoms, Dr Wells 205
Thornburg, Max 32, 212
Tiberias, Lake 20
Tihama (Tihāmah) 156, 171
Totland Bay 3, 195
Transjordan 12–14, 16–17, 30, 47, 198
Trucial Shaykhdoms see Gulf Shaykhdoms
truffles, desert 102, 206–7
Turkey, Turks 11, 16, 17, 36, 155–6, 186, 210. See also Ottomans
Ṭuwayq escarpment, Jabal Ṭuwayq 139, 207–9
　Acacia Valley 208
　Ḥaysiyyah Pass 208
Twitchell, Karl S. 15, 198, 200, 210
Twitchell, Nora 200

Umm Hamdha (village near al-Ṭāʾif) 155, 209
Umm Manṣūr, Queen 32–3, 185–9, 211
Umm As Sigyan (Umm al-Siqyān) 95–6, 206
Umm Tallal, Queen (Umm Ṭalāl) 185–7, 211
ʿUnayzah 211

United States of America, Americans 23, 27, 32
 on Bahrain 60
 and Saudi Arabia in the 1930s 200
University College of Wales, Aberystwyth 195
Uqair (al-ʿUqayr) 14, 19–20, 28, 30, 63, 65–8, 72, 205
 1923 Conference of 197–8
Ur 16
ʿUraira (al-ʿUrayʿirah) 94–8, 206
Ushayqir 209
ʿUtaybah tribe *see* Ataibe
Uthaythiyyah 209
al-ʿUwayniḍ *see* ʿAwainid
al-ʿUyaynah *see* ʿAwaina

veiling 2–3, 22–3, 28, 29, 50, 67, 76, 84, 102, 104, 126

Wadi Fatima (Wādī Fāṭimah) 30, 168
Wadi Hanifa (Wādī Ḥanīfah) 110–13, 122, 129–30, 137, 206–7
Wadi Huwwa 151, 209
Wādī Liyyah *see* Liyah Valley
Wādī Yamaniyyah 20
Wahhabis, Wahhabism 97–8, 126, 129, 132, 163, 205, 212
Wahba, Sheikh Hafiz (Ḥāfiẓ) 14, 18–19, 28, 30, 39–40, 46, 65–7, 72, 76–7, 80, 86, 89–90, 92, 96, 98–102, 104–6, 115, 119, 122–3, 132–3, 135–9, 141, 144, 146–7, 149–51, 154–5, 160, 163–4, 182, 209, 211–12
 career 198
 takes photographs 28, 199, 205

Ward, Col. John 21
Ward family 3, 8, 195
al-Washm 140, 209
Weiss, Leopold Muḥammad (aka Muḥammad Asad) 198
Wells Cathedral 4
wells
 desert 97–8, 101, 145, 147–8, 153
 in Wādī Ḥanīfah 123
Wickham, Lucy Adelaide 5, 8, 197
Wight, Isle of 3, 8
Wilson, Arnold 61
women 16, 22–3, 32–3, 77–8, 80, 84–5, 87, 129, 165, 185–9, 204
 Beduin 102, 147, 150, 203
 and education 187
 position of 187–8
 rights of, in Islam 187
 See also dress in Saudi Arabia; *ḥarīm*s
Woolley, Leonard 16

Yasīn, Yūsuf 30, 182, 211–12
Yemen 32, 34, 39, 47, 175
 1934 war with Saudi Arabia 17–18, 121

Zayma 20
Zubair (al-Zubayr) 21, 48, 50–1, 203